**"THE OPPOSITE OF WAR IS NOT PEACE...
IT'S CREATION!"**

- Jonathan Larson

Design by Dan Michman
All text edited by Yoav Litvin
All photographs © Yoav Litvin

All artwork © respective artists and contributors

ISBN: 978-0-7643-5265-2
Printed in China

Published by Schiffer Publishing, Ltd.
4880 Lower Valley Road
Atglen, PA 19310
Phone: (610) 593-1777; Fax: (610) 593-2002
E-mail: Info@schifferbooks.com
Web: www.schifferbooks.com

For our complete selection of fine books on this and related subjects, please visit our website at www.schifferbooks.com. You may also write for a free catalog.

Schiffer Publishing's titles are available at special discounts for bulk purchases for sales promotions or premiums. Special editions, including personalized covers, corporate imprints, and excerpts, can be created in large quantities for special needs. For more information, contact the publisher.

We are always looking for people to write books on new and related subjects. If you have an idea for a book, please contact us at proposals@schifferbooks.com.

Other Schiffer Books on Related Subjects:
From the Platform: Subway Graffiti, 1983—1989,
ISBN: 978-0-7643-3723-9

YOAV LITVIN

2 CREATE

ART COLLABORATIONS
IN NEW YORK CITY

Schiffer Publishing Ltd

4880 Lower Valley Road • Atglen, PA 19310

PROLOGUE

New York City is one big melting pot. The density of its population and its ethnic diversity are unparalleled. Here, a constant flow of people of all colors and creeds invigorates communities, generating a vibrant cultural exchange that promotes innovation and creativity.

Hundreds of languages are spoken in New York. They serve to connect people of similar backgrounds, customs, and traditions, and facilitate support systems for easy assimilation into life in the big city. But in so doing they inevitably uphold cultural barriers, segregating entire populations that may neighbor each other but are worlds apart.

Within this sea of divisions one language unites: the language of art. As it touches on our collective humanity, art provides a structured yet malleable framework to express ideas, challenge conceptions, and explore new frontiers. But in many respects art is a living language like any other. Artists use it to communicate their experiences, influences, thoughts, loves, and frustrations. They showcase the aesthetically pleasing, echo the zeitgeist, and shoot poignant social commentary. These multiple layers enable ample space for expression that can be appreciated by all people, from young groupies to seasoned connoisseurs.

Like an animal left to fend for itself in the wild, art lives freely on the barren concrete walls of the city. It leads a mortal existence that is always in danger, dwelling unprotected from the elements and pedestrians who play with it, add to it, and destroy it.

by Yoav Litvin

...

If one pays careful attention to its colors, creases, markings, and bruises, one can hear echoes from its past and envision its life cycle, beginning with the creative spark that led to its birth, through its maturation, and on to its demise.

Yet documentation of this art solidifies its essence in time for many to share and enjoy, rendering it immortal. Thus, the documenter serves as an integral part of the creative process; an enabler and collaborator, a spirit that is physically missing from the picture, yet present in the shadow it leaves behind.

Often, artists use the language of art to communicate with each other. They do so to learn, share, and have fun. Such collaborations are intriguing and challenging; they test the artists' personal durability and originality of style on one hand while demanding flexibility and an openness to new approaches on the other. A fruitful exchange leads to debate, personal growth, and cooperation between artists with unique voices, ultimately producing a collaborative unit greater than the sum of its parts.

In the following pages you will gain insight into the process behind nine such collaborative artworks, from conception to ultimate presentation on the streets of New York City. Here, friends of different ages, locales, and backgrounds, brothers, business partners, and lovers come together 2Create.

You will learn the personalized vocabulary that affords these artists their original jargon and style—tools that are as fundamental to the creation of artwork as paint, a brush, a canvas, or a silk screen. You will witness a variety of relationships that successfully bridge two people, at times highlighting their independence and at times fusing two distinct entities into a unified duo.

In their work, all nine pairs demonstrate flexibility in their independence, empathy, and a belief in themselves, their collaborative partner, and the resulting work. These partnerships revolve around an exchange of ideas, a durable trust, ability to compromise, and mutual love and respect. They will make you marvel at, learn from, and experience what it means 2Create Art Collaborations in New York City.

COLLABORATING

CONTENT

JILLY BALLISTIC

ASVP

CEKIS

ICY

ZIMAD

DASIC FERNANDEZ

TRAP IF

DAIN

bunny M

MAP

JILLY BALLISTIC/AL DIAZ

ASVP

CEKIS/CERN

ICY/SOT

ZIMAD/JPO

DASIC FERNANDEZ/RUBIN415

TRAP IF/ALICE MIZRACHI

DAIN/STIKKI PEACHES

bunny M/SQUARE

#ANEMPIREINDECLINE

JILLY E
AL

Artists
JILLY BALLISTIC
AL DIAZ

BALLISTIC
DIAZ

Early Life and Work

JILLY BALLISTIC

"I was born and raised in southeast Brooklyn, New York. I grew up in a lower middle class neighborhood fed by 'mom and pop' shops and dotted with government housing that was home to Italian Americans, Puerto Ricans, African Americans, and Asian Americans. You'd hear hip-hop streaming from cars as they drove by—in English and any other language you can think of. Politically, I guess you can say my generation—second-generation Americans—were making the neighborhood ours in our own ways, including writing on the walls, or in my case, trash. Graffiti in NYC in the '80s was slowly beginning to change, but it still had a presence.

"My whole life I've been a consumer of art—film, painting, sculpture, and graffiti—though I didn't create graphic work until after college. I'm a short story writer at heart and I studied literature. After graduating, I wanted to publish three or four written collections and like most writers I was broke and couldn't afford the traditional ways a writer gets published (an agent, PR rep, etc.).

"I opted to spray-paint excerpts onto trash waiting to be collected on the curb. Sofas, stoves, fans, old televisions; I matched some of my writing with the objects I found to make a complete installation on the street, albeit a brief one. Of course, it was taken away on trash day, but the idea took off and the residents really loved it. That's how I got introduced to and quickly hooked on public art and communication. I continue to work with text and graphic images that together tell a story."

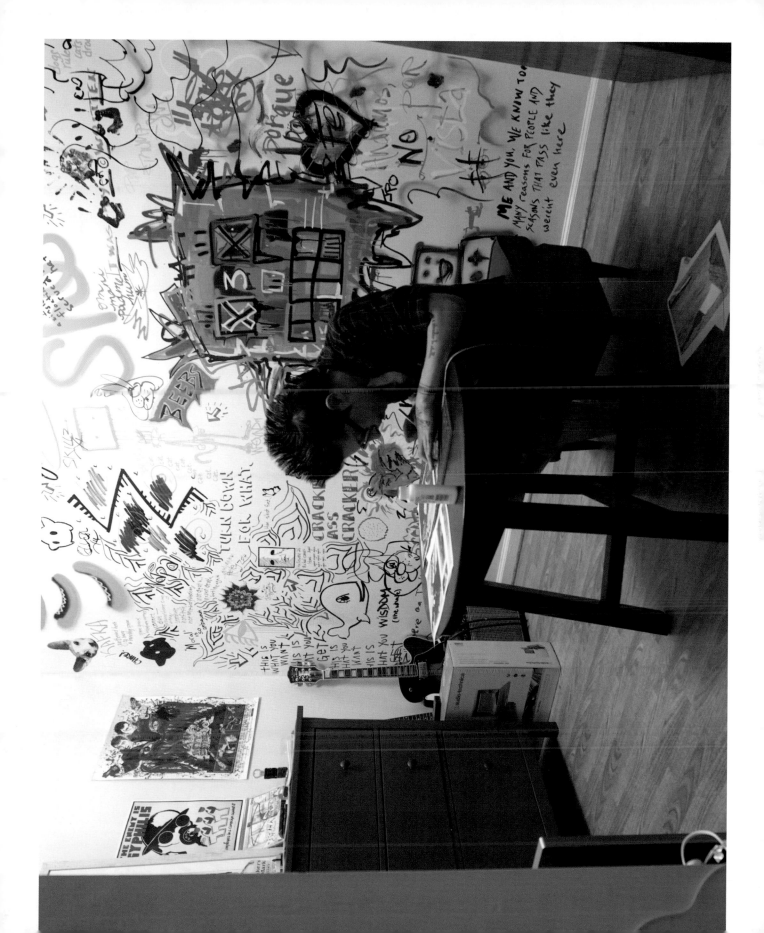

"POLITICALLY, I GUESS YOU CAN SAY MY GENERATION— SECOND-GENERATION AMERICANS—WERE MAKING THE NEIGHBORHOOD OURS IN OUR OWN WAYS, INCLUDING WRITING ON THE WALLS, OR IN MY CASE, TRASH."

"**The first step** in my creative process is to live. Seriously. I go about my day. I take the train but don't check out. I observe the architecture of the train, the ad space, mentally measuring the seats and poles, making notes in my head about certain subway stops that catch my attention for one reason or another. I'll then browse government files, libraries, and other photographic collections available online, looking for what matches well with what I've seen. When I hit something, I size it up and print. With texts I use, I write and rewrite until the message is short enough but on point.

"One of my ongoing projects includes placing historical images in locations around the NYC subway; I'm showing the evolution of war in a subtle way. Being site-specific, I want to work with a space and have an image blend in, but at the same time create an air of 'something's not quite right.'

"As such, I aim to disrupt onlookers' thoughts, making them interpret and grasp a meaning behind my art. Some people get confused when they encounter my work, even horrified - some laugh, are intrigued, indifferent, or love it or hate it. It seems to provoke a very mixed bag of opinions and emotions and I take that to mean that I'm on the right path."

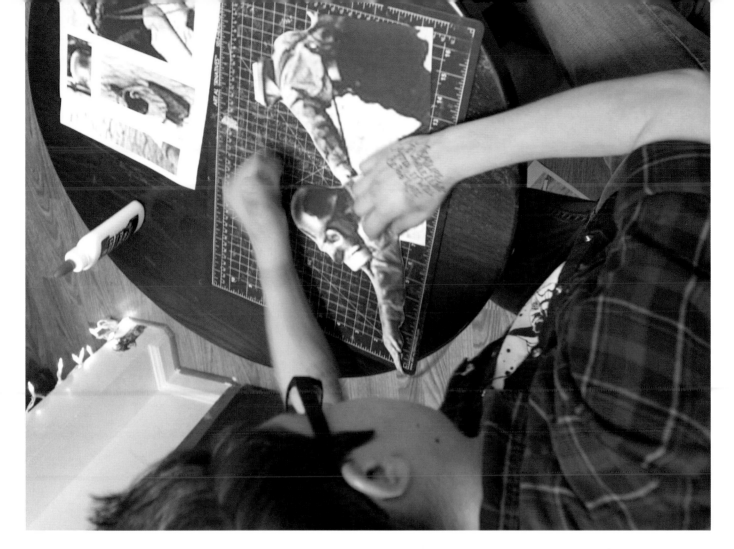

#02

AL
DIAZ

"I was born in the Lower East Side of Manhattan. I was a child during the '60s and a teenager in the '70s. During this period, lower Manhattan was a hub for an artistic explosion that would alter American culture. I inhaled it all in: visual art, music, dance, and street culture. As a child I exhibited an interest and ability for drawing. I would use my finger and draw on my imaginary sketchpad, decorate my crib with crayons and later, make my own 'comics.'

"In grade school, I was encouraged by my parents and teachers to enroll in painting and drawing classes. I went to classes in the East Village (Avenue A & 7th Street) and Spanish Harlem (124th Street). My most influential art teachers were Elizabeth Massano (6th grade) and Henry Fiol, a well-known Salsa musician and brilliant painter.

"The Lower East Side was home to many 'subversive' individuals. I grew up with a sense of suspicion towards authority. Even as a Boy Scout I was exposed to radical thought. In the Scouts we shared a space (St. Marks Church basement) with the Black Panthers and the Young Lords Party.

"By 1971 (at the age of twelve), my cousin Gil introduced me to graffiti. Gil grew up in Washington Heights, arguably the spawning ground for NYC graffiti culture. I was impressed by its clandestine nature and the stylistic elements. The pioneers of this art all seemed to have a certain edge to them and I wanted in. Aside from 'gang related' and the usual 'PAPO LOVES TINA,' the Lower East Side had little to no visible graffiti on the streets. Using the nickname 'Bomb,' I promptly went to work and

Early Life and Work

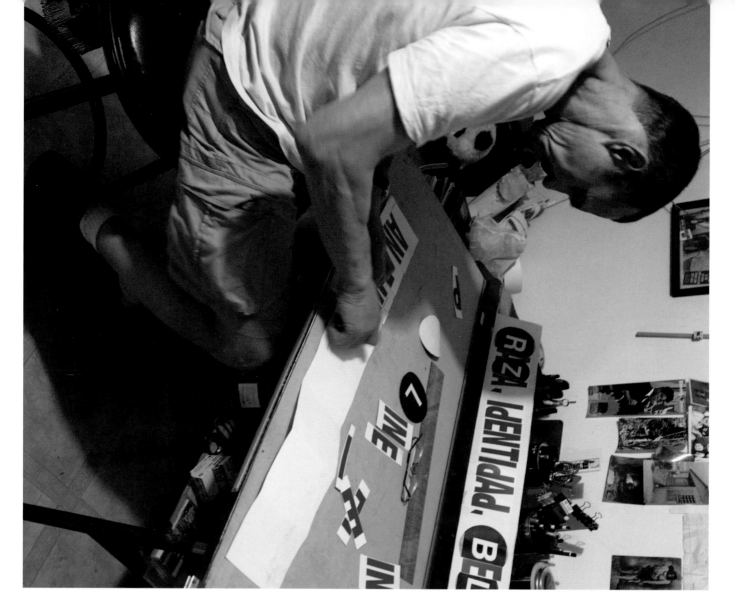

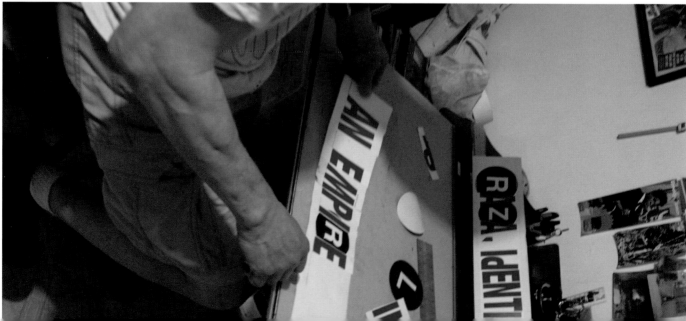

...

became one of the first prolific writers in the Lower East Side. Within a year or so I moved from the streets to buses, trains, and trucks. I traveled around the city's many neighborhoods to spread my name. By 1975, I had gained some respect as a writer; my 'hand-style' or 'tag' was well appreciated.

"I met Jean-Michel Basquiat in 1977 and dropped out of the 'Graff world' to pursue a new type of graffiti. We would write what we were thinking - what made us angry, disillusioned, faithless, and bored - and sign it with a common moniker- 'SAMO' (which stood for 'Same Old Shit'). We called it literate/text-based graffiti and it has remained my style ever since.

"I see art as the result of one's innate need to create. Unlike practical or 'necessary' things that are vital to our physical survival, it is a creation that sustains and feeds the soul."

"**I collect** WET PAINT signs used throughout the NYC subway system. Using multiple signs, I cut and scramble the letters to create new messages. I then 'repost' my de/reconstructed signs on subway station walls.

"I've always done this on my own, playing with the letters a lot and repurposing some letters to form others; for example, I formed two additional letters by turning the W upside down and forming an 'M' and 'P' into a lower case 'd'."

"I MET JEAN-MICHEL BASQUIAT IN 1977 AND DROPPED OUT OF THE 'GRAFF WORLD' TO PURSUE A NEW TYPE OF GRAFFITI. WE WOULD WRITE WHAT WE WERE THINKING - WHAT MADE US ANGRY, DISILLUSIONED, FAITHLESS, AND BORED - AND SIGN IT WITH A COMMON MONIKER- 'SAMO.' "

Creative Process

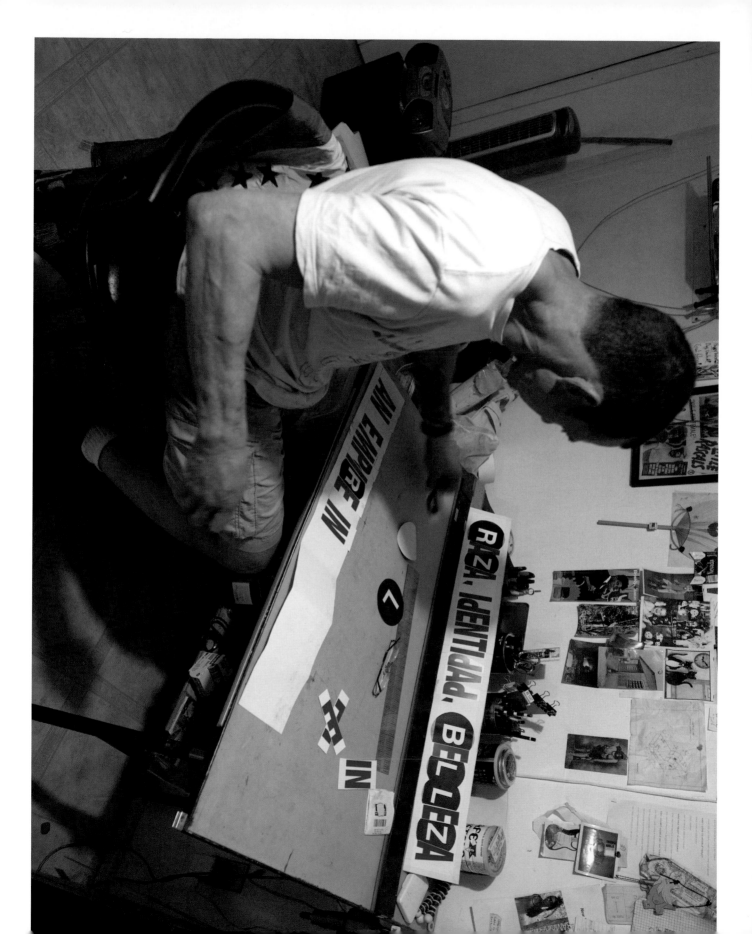

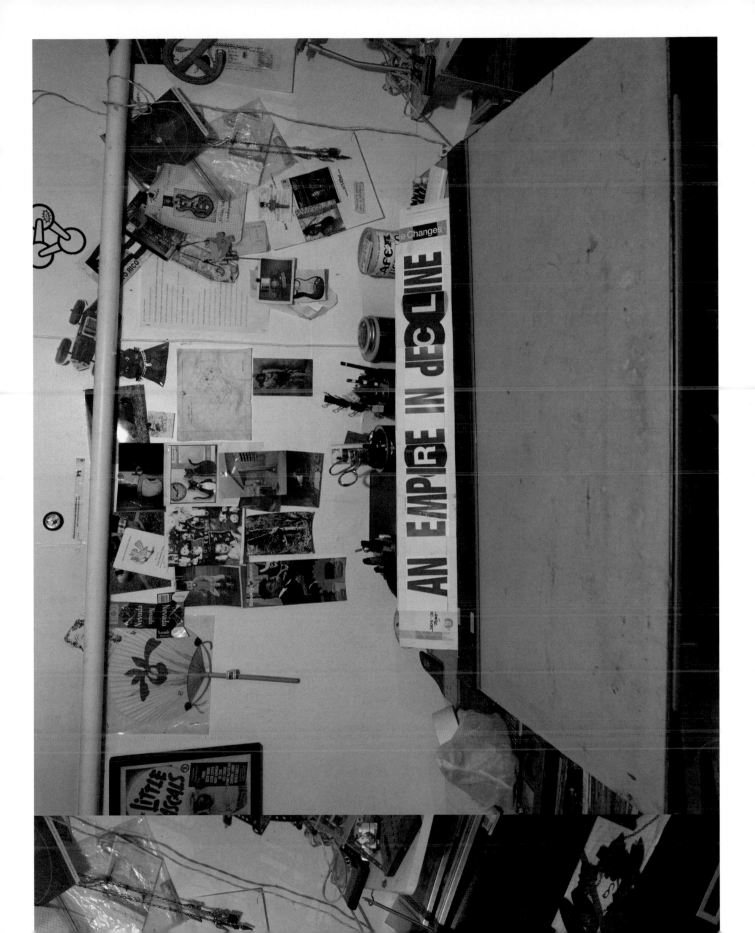

UNION
SQUARE

LOCATION

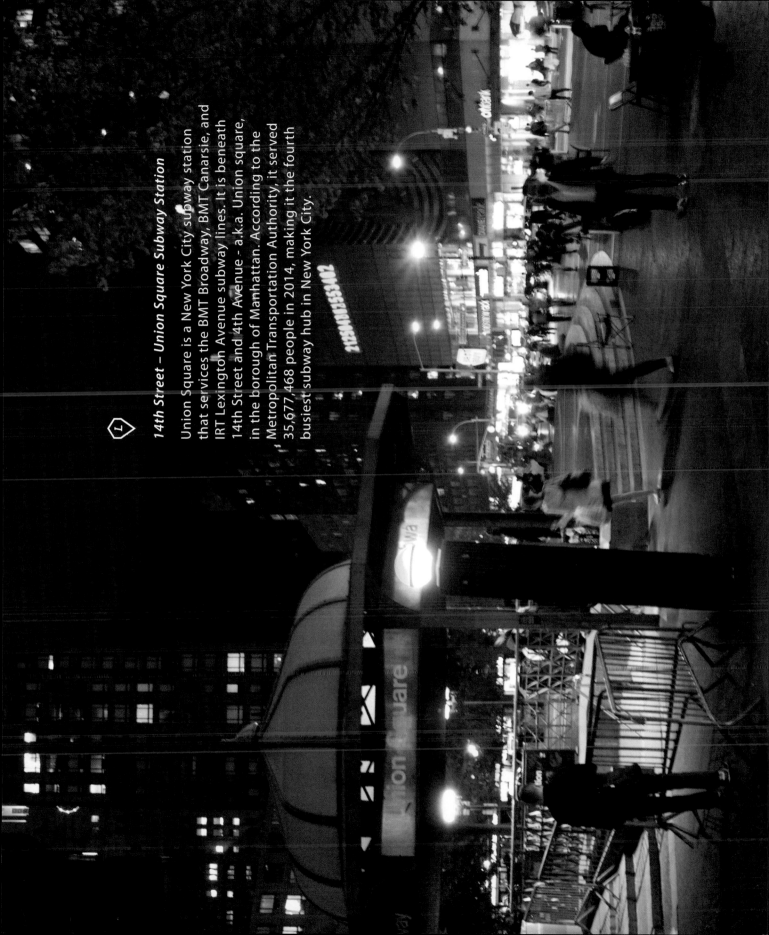

14th Street – Union Square Subway Station

Union Square is a New York City subway station that services the BMT Broadway, BMT Canarsie, and IRT Lexington Avenue subway lines. It is beneath 14th Street and 4th Avenue - a.k.a. Union square, in the borough of Manhattan. According to the Metropolitan Transportation Authority, it served 35,677,468 people in 2014, making it the fourth busiest subway hub in New York City.

Jilly Ballistic

"It's a process of taking away and narrowing down. I'm usually excited to collaborate with others. I find it challenges my style and pushes me to work with ideas, materials, and mediums I wouldn't otherwise think to use.

"I met Al Diaz through a mutual acquaintance, a neighbor of mine who introduced us. It's a small world, you know? We've been working together for several months now. Working with Al is fantastic. For me, it's just really exciting to cooperate with another artist who uses the subway. We understand the system and read it the same way. We know when to strike and put up a piece without having to say anything. I bring my point of view and experience and Al brings his. Our sense of humor, wit, and passion mix well and it shows through the work. It's important to keep in mind that just like any relationship between two people, you have to talk and communicate, with respect, of course. If you have an idea, shoot! If you have an opinion, say it. You hit a snag, say so. Be flexible and above all, make it fun. Street art and graffiti are experiences. Make them positive."

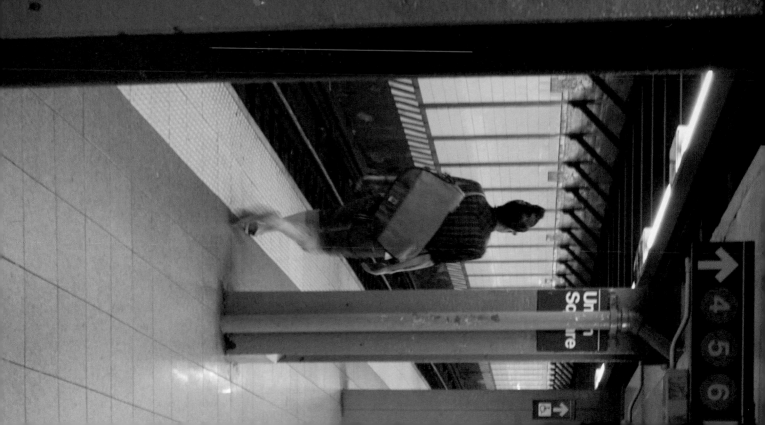

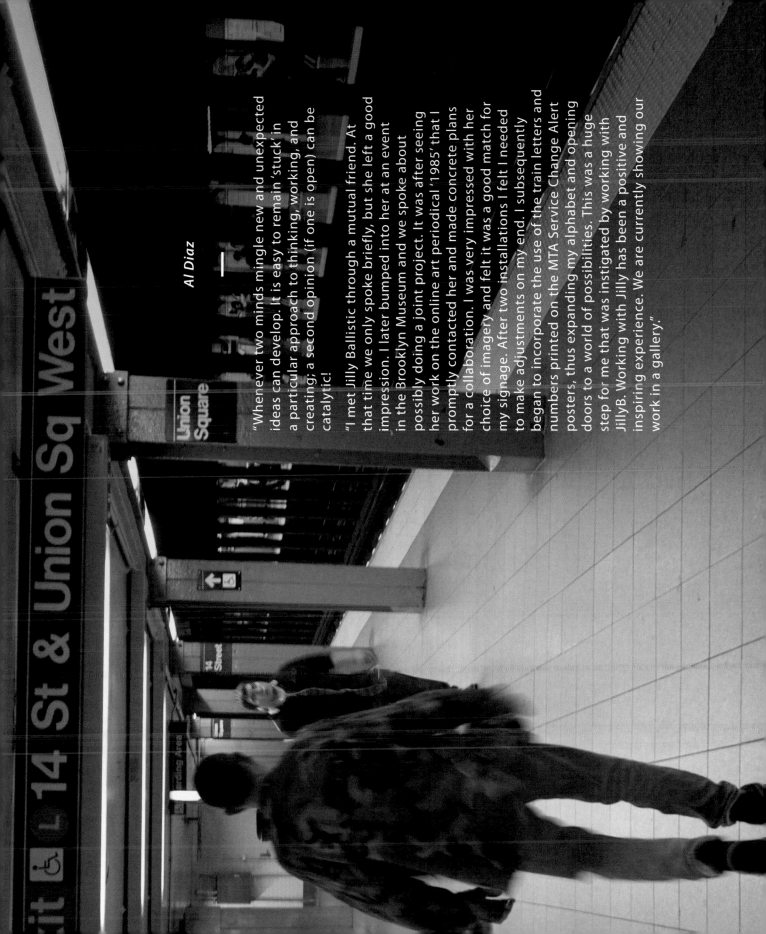

Al Diaz

———

"Whenever two minds mingle new and unexpected ideas can develop. It is easy to remain 'stuck' in a particular approach to thinking, working, and creating; a second opinion (if one is open) can be catalytic!

"I met Jilly Ballistic through a mutual friend. At that time we only spoke briefly, but she left a good impression. I later bumped into her at an event in the Brooklyn Museum and we spoke about possibly doing a joint project. It was after seeing her work on the online art periodical '1985' that I promptly contacted her and made concrete plans for a collaboration. I was very impressed with her choice of imagery and felt it was a good match for my signage. After two installations I felt I needed to make adjustments on my end. I subsequently began to incorporate the use of the train letters and numbers printed on the MTA Service Change Alert posters, thus expanding my alphabet and opening doors to a world of possibilities. This was a huge step for me that was instigated by working with JillyB. Working with Jilly has been a positive and inspiring experience. We are currently showing our work in a gallery."

"WORKING WITH OTHERS ON
SPECIFIC PROJECTS IS BOTH
BENEFICIAL AND CHALLENGING.
IT IS NECESSARY TO HAVE
ADMIRATION AND BELIEF IN WHAT
THE OTHER PERSON HAS TO
CONTRIBUTE. UNLEASHED EGOS
CAN BE VERY DESTRUCTIVE, SO
THERE MUST BE MUTUAL RESPECT
AND COMPROMISE IN THE MIX."

Al Diaz

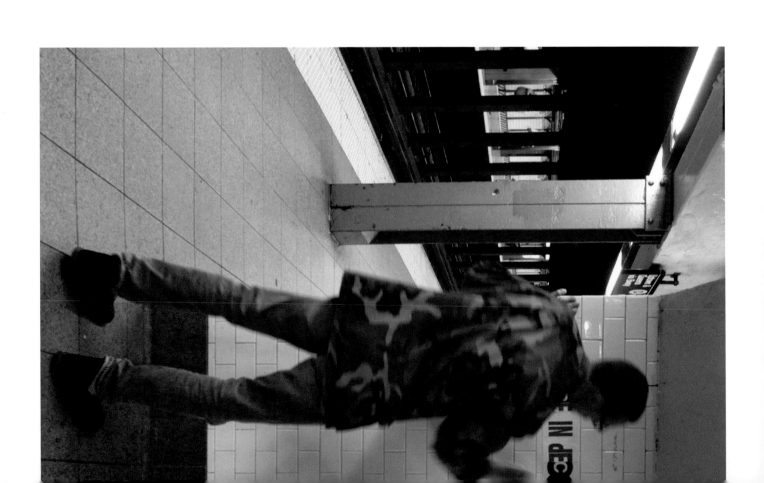

"WHEN I COLLABORATE, I GO ABOUT MY USUAL PROCESS BUT CHOOSE THREE OR FOUR ADDITIONAL IMAGES TO DISCUSS WITH WHOMEVER I'M WORKING WITH. I WANT TO HEAR THEIR OPINION AND MAKE SURE THE FINISHED PIECE SAYS WHAT WE WANT IT TO SAY/LOOK LIKE AS CLOSE AS POSSIBLE TO A SHARED VISION."

Jilly Ballistic

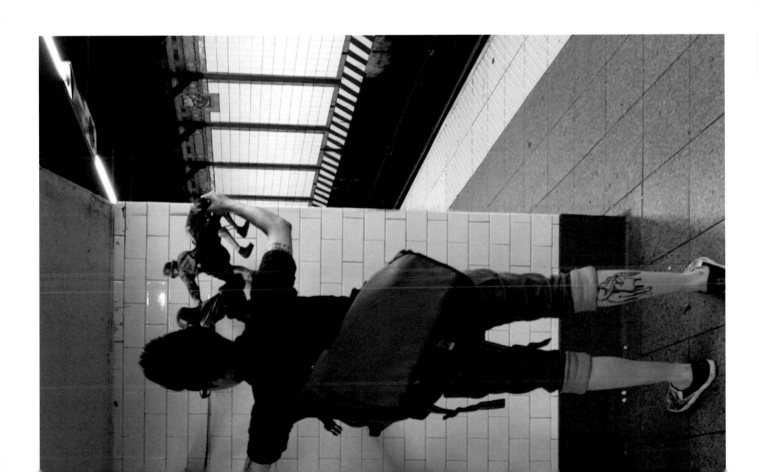

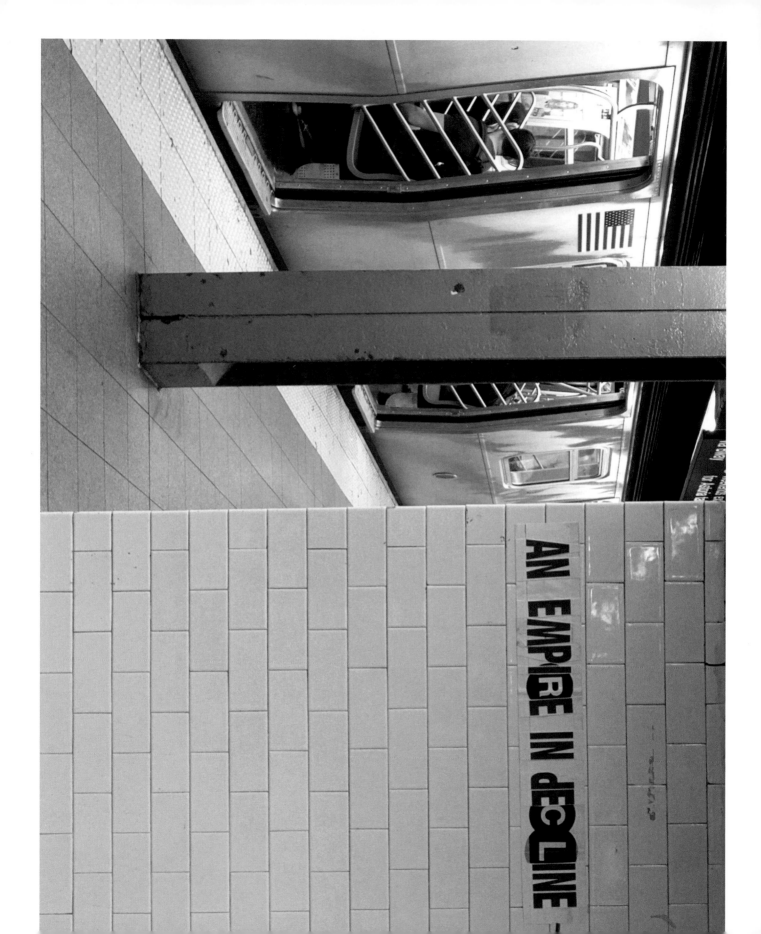

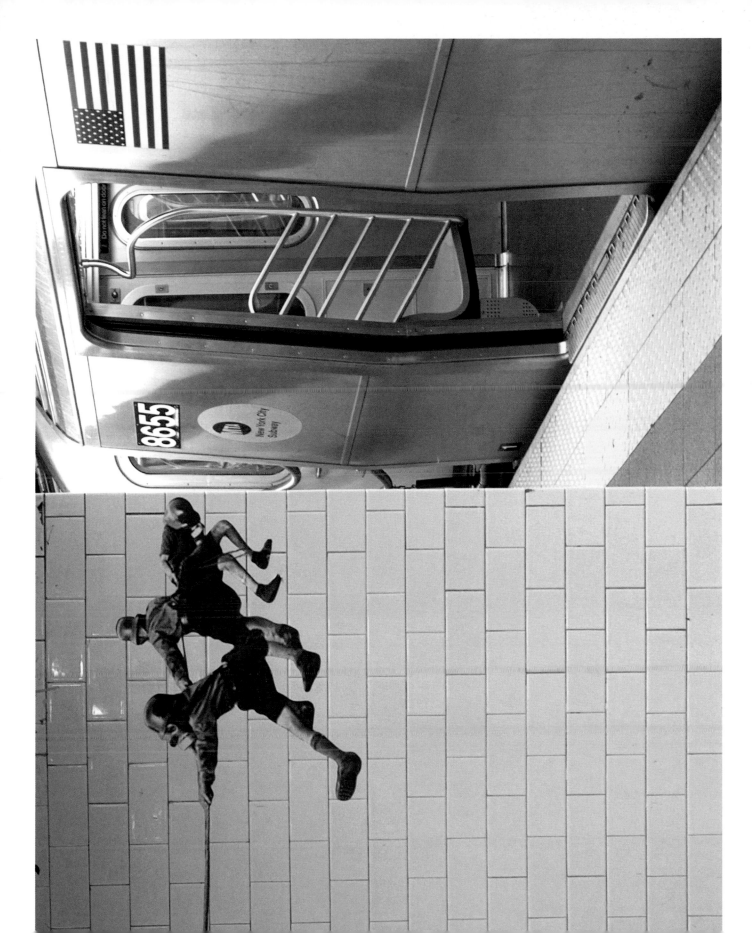

COLLABORATION
#01

#ANEMPIREINDECLINE

Artists
JILLY BALLISTIC
AL DIAZ

COLLABORATION
#02

Artists
ASVP

Early Life and Work

ASVP

/ Artist 1

"I grew up fifty miles east of New York City on the north shore of Long Island and visited the city regularly when I was young. From a very early age—maybe four or five—I spent a significant amount of my free time skateboarding, freestyle bicycle riding, and drawing, usually with pen and/or pencil in standard 8.5" × 11" or 18" × 24" bond paper sketch pads. This laid the foundation for what would become a lifelong interest in drawing and painting, and a general desire for creating things and sharing them with other people.

"During my childhood, I remember copying illustrations of Warner Brothers cartoon characters. I was also deeply inspired by the drawings and paintings of Norman Rockwell and the colors in Leroy Neiman's iconic sports images. As time went by, my interests gravitated heavily toward drawing comic book and fantasy characters, and this led to inspiration from artists like Jim Aparo and Frank Frazetta. As I matured my interests gravitated toward graphic illustrations by artists like Brian Schroeder (Pushead) and Vernon Courtland Johnson (VCJ), among others.

"I grew up in the mid-'80s through the early '90s in a somewhat insular, mostly white middle and upper class American suburb. In simple terms, I grew up in a place not unlike Shermer, Illinois, the fictitious hometown of the beloved 'Breakfast Club' and where many of John Hughes's stories took place. With that in mind, from nursery school through seventh grade I basically hung out with people like 'Brian.' In junior high, I hung out with people like ·

"HIP HOP OPENED THE EYES AND EARS OF MILLIONS OF KIDS AROUND THE WORLD, AND I WAS ONE OF THEM. IT TAUGHT ME THAT IN ADDITION TO THE TRIALS AND TRIBULATIONS OF '...A BRAIN, AN ATHLETE, A BASKET CASE, A PRINCESS, AND A CRIMINAL,' THERE WERE LOTS OF KIDS OUT THERE WHO WERE WORTH LISTENING TO AND LEARNING MORE ABOUT."

...

'Claire' and 'Andrew.' Three years later in high school, I was hanging out with people like 'Bender' and 'Allison.' The stereotypes were basically the same, but we were a little younger. My 'Allisons' were kids listening to bands like the Smiths, New Order, and the Cure. The 'Benders' were kids who listened to Metallica, Megadeath, and Slayer. The 'Claires' and 'Andrews' were still listening to the stuff of their older siblings, like the Eagles, Clapton, and the Steve Miller Band, and one of my still enduring personal favorite bands to hate, the Grateful Dead.

"Looking back, there was one stereotypical suburban white kid who was definitely absent among the detainees at Shermer because his proliferation was in its infancy, but not for long. That was the suburban kid who had discovered and embraced the culture of hip hop. My earliest exposure to hip hop was during jam circles at bicycle freestyle contests in the mid-1980s. There I was exposed to bands like RUN DMC, LL Cool J, The Fat Boys, and Eric B & Rakim. Then NWA, De La Soul, Public Enemy, and the Beastie Boys. Like many in America, my suburban town was monumentally changed by this - forever. Hip hop opened the eyes and ears of millions of kids around the world, and I was one of them. It taught me that in addition to the trials and tribulations of '...a brain, an athlete, a basket case, a princess, and a criminal,' there were lots of kids out there who were worth listening to and learning more about."

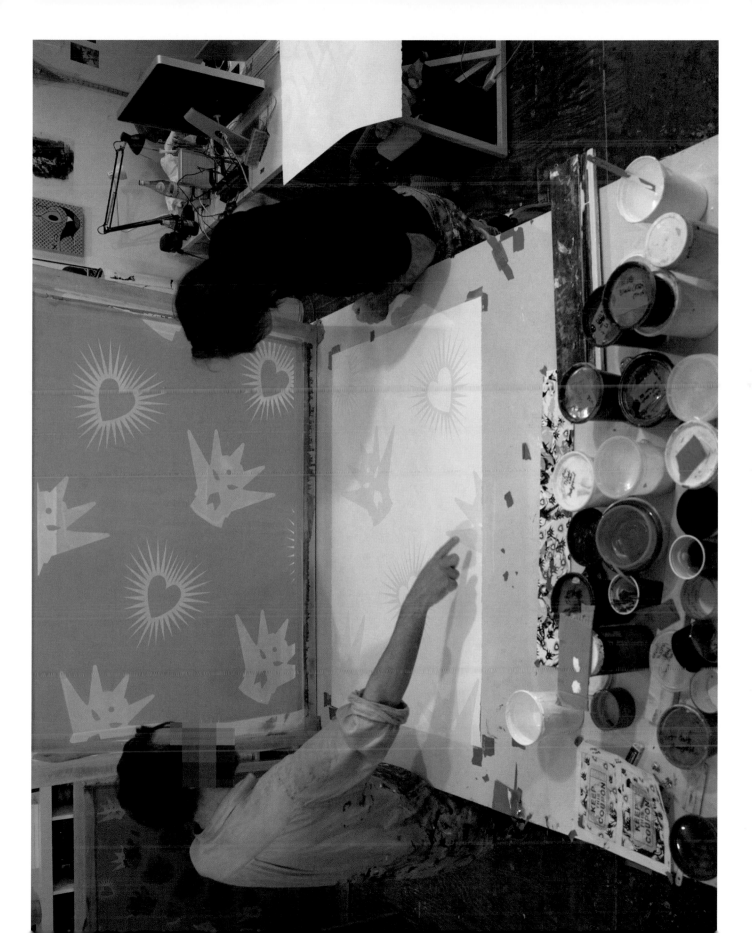

Creative Process

"THE INITIAL DRAWING IS THEN SCANNED AND THE PAINFULLY TEDIOUS PROCESS OF REDRAWING THE IMAGE DIGITALLY BEGINS. DEPENDING ON COMPLEXITY, THE REFINED DIGITAL DRAWING CAN TAKE HUNDREDS OF HOURS TO FULLY COMPLETE."

"When a concept comes to mind, I'll immediately write it down and/or roughly sketch it out. Then I periodically 'check in' with it, sometimes over long periods of time, and basically torture myself over whether it's something we should produce. After we choose something for production I create an initial drawing of the image. This process is usually done with pen and/or pencil on bond paper and ties closely to the kind of drawing I've been doing since childhood. The drawing is scanned and the tedious process of digitally redrawing it begins.

"Depending on complexity, the refined, digital drawing can take hundreds of hours to complete. Afterwards, we print a 1:1 film positive version of it and then expose the image onto a silkscreen. Depending on how many images are included in a given piece, this process can require exposing several images onto multiple screens that will be incorporated into the piece. We usually begin with the process of hand-painting the first layers of paint onto the canvas or paper and continue layering screen-printed and hand-painted elements until the piece is finished. Sometimes we will pass a single piece back and forth, individually contributing different layers to a single canvas. Other times we'll each produce an entire piece. Before production begins, we almost always make a full-color digital composite of what the completed work will look like. Though we have a very specific outcome in mind when we begin production, if something unexpected and interesting happens during the process we often embrace it."

#02

ASVP
/ Artist 2

Early Life and Work

"I am from Zürich, Switzerland. I grew up in a very creative and artistic environment; my father had his own advertising company and my mother worked as a fine artist. With their encouragement, I started drawing and painting at a very early age. They were a very important influence, together with several of my teachers along the way. As I grew creatively, so did my interest in various forms of art, including works by the old masters, modern or contemporary form, and the artists who mastered those techniques.

"As a child I had a strong interest in painting and drawing. I drew mostly animals I found in the backyard of our house in the countryside. Because of my fascination with nature I was drawn to realistic drawing techniques. Back then it was called *wissenschaftliches Zeichnen*, or technical drawing, which was considered an official career. Around the same time I also got into airbrush art: I painted helmets, hockey sticks, and t-shirts, and incorporated the technique into my drawings. The highlight was probably a 9' × 15' mural I painted at a youth institution using my tiny airbrush and a compressor. In my mid-teens I attended an art high school in Zürich called 'Liceo Artistico.' The school emphasized the visual arts from life drawings all the way to sculpture, aside from its normal curriculum.

"I was truly inspired by anything art related, and I would always visit art museums wherever I traveled. I also loved comic books and started a small collection at home. In my late teenage years I began to paint more freely, experimenting with a variety of different materials and backgrounds.

"I WAS FASCINATED BY TEXTURE AND HOW TIME CAN HAVE A TRANSFORMATIVE EFFECT ON OBJECT SURFACES, RENDERING THEM ABSTRACT. THAT'S WHEN I GOT MY FIRST CAMERA AND STARTED DOCUMENTING CORRODED WALLS OR SURFACES THAT I FOUND IN THE STREETS. IT WAS INSPIRING AND I CHANNELED IT BACK INTO MY PAINTINGS."

Early Life and Work

...

"I was fascinated by texture and how time can have a transformative effect on object surfaces, rendering them abstract. That's when I got my first camera and started documenting corroded walls or surfaces I found in the streets. It was inspiring and I channeled it back into my paintings.

"Politically themed work didn't appeal to me. It seemed less interesting and controversial, especially if you compared it to works coming from other countries where speaking up could change your life forever. However, Switzerland always had an active illegal graffiti culture that was more pronounced in Basel than in Zürich at the time. Graffiti certainly influenced me during the years I was painting with my airbrush. I remember artists that crossed the line between graffiti and street art. One of the pioneers was a Swiss artist named Harald Naegeli. He sprayed simple stick figures onto walls throughout Europe in the '70s.

"In my early 20s my mind was set on a fine art career. However, upon taking my dad's advice, I pursued a career in the graphic arts, studying graphic design/ communication arts at the Art Center College of Design in Pasadena. During those four years I was exposed to many great artists from all around the world. I am still very fond of artists such as Francis Bacon, Paul Klee, Robert Rauschenberg, and Antonio Tapies, but there were and are many more that have inspired me on my path.

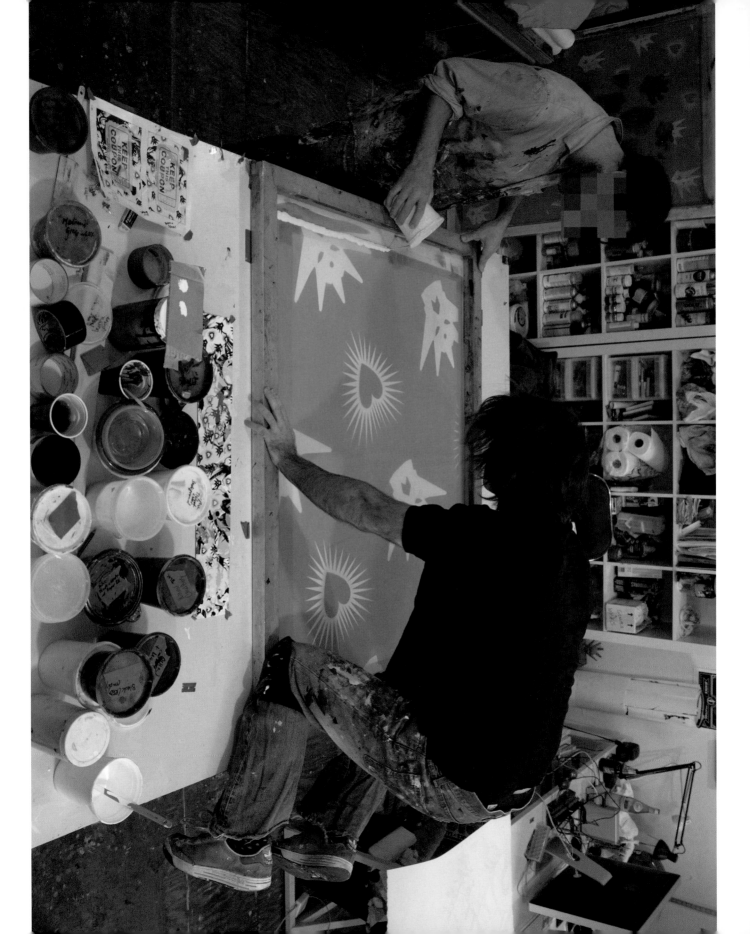

...

"After working in the field of design and advertising for years in New York, it became clear I wasn't creating the kind of things I wanted to. This led me back to pursuing a fine art career with ASVP. Aside from the mural I completed in my mid-teens, most of my work hadn't been exposed. With ASVP it's exactly the opposite: we began with the notion of taking our work into the streets and sharing it with the general public. This has been an exciting part of our work and something we will always continue to do."

"The actual process tends to be the same overall. It starts with an idea that is drawn out in pencil. We then refine the image further on the computer. Once it's ready, we can start going through the different production stages of making a screen print.

"We first print the films to prepare for exposure. Next we coat the screens with emulsion and expose them, taping off unwanted areas. Then we determine the inks, mix colors, and set up the printing table, as well as the paper or canvas. For canvas, we mount the material on a rigid surface to stabilize it. Finally, we plan out the printing process: which layer to print first, second, third, and so forth, always trying to anticipate where difficulties could arise. We begin with the most complex layers that will take the most time. If a piece contains hand-painted layers the process can take far longer."

"FINALLY, WE PLAN OUT THE PRINTING PROCESS: WHICH LAYER TO PRINT FIRST, SECOND, THIRD, AND SO FORTH, ALWAYS TRYING TO ANTICIPATE WHERE DIFFICULTIES COULD ARISE. WE BEGIN WITH THE MOST COMPLEX LAYERS THAT WILL TAKE THE MOST TIME."

Creative Process

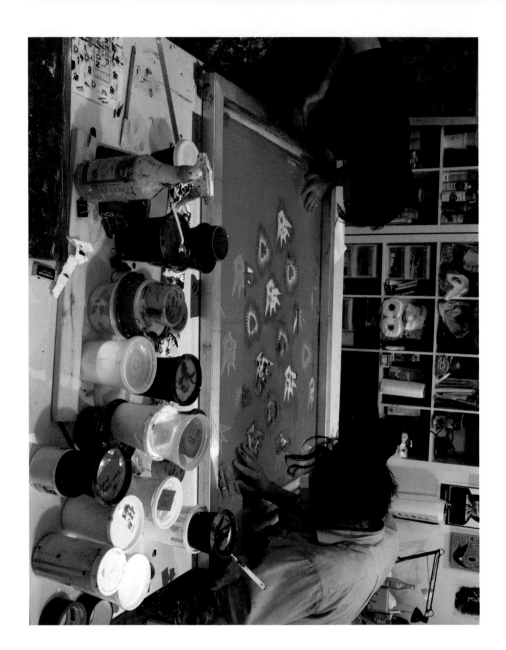

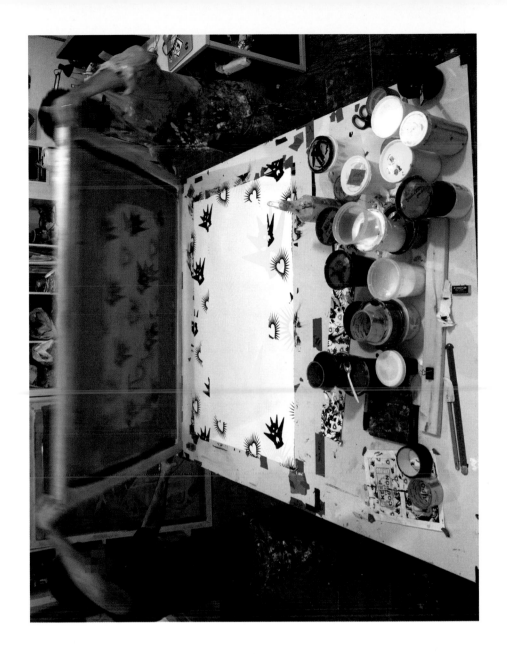

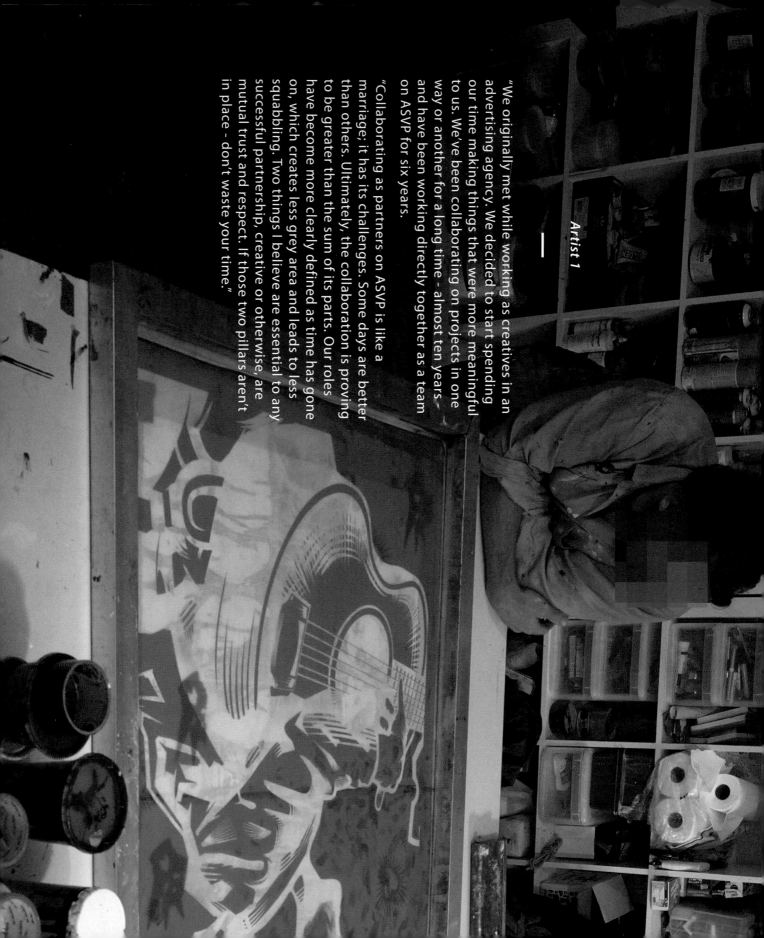

"We originally met while working as creatives in an advertising agency. We decided to start spending our time making things that were more meaningful to us. We've been collaborating on projects in one way or another for a long time - almost ten years - and have been working directly together as a team on ASVP for six years.

"Collaborating as partners on ASVP is like a marriage; it has its challenges. Some days are better than others. Ultimately, the collaboration is proving to be greater than the sum of its parts. Our roles have become more clearly defined as time has gone on, which creates less grey area and leads to less squabbling. Two things I believe are essential to any successful partnership, creative or otherwise, are mutual trust and respect. If those two pillars aren't in place - don't waste your time."

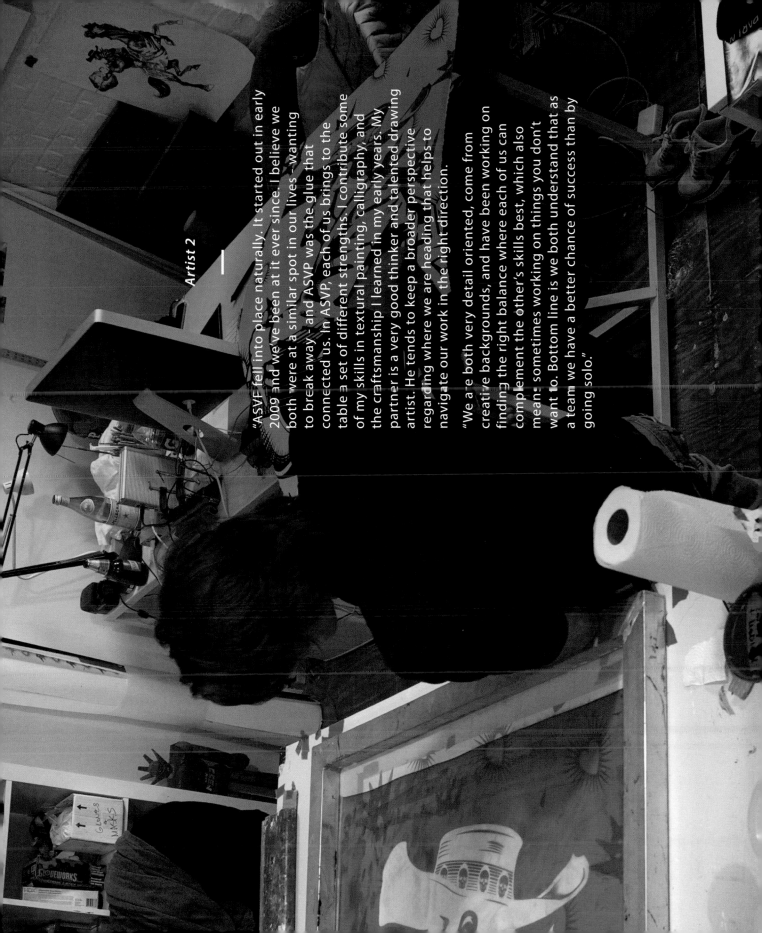

Artist 2

"ASVP fell into place naturally. It started out in early 2009 and we've been at it ever since. I believe we both were at a similar spot in our lives – wanting to break away, and ASVP was the glue that connected us. In ASVP, each of us brings to the table a set of different strengths. I contribute some of my skills in textural painting, calligraphy, and the craftsmanship I learned in my early years. My partner is a very good thinker and talented drawing artist. He tends to keep a broader perspective regarding where we are heading that helps to navigate our work in the right direction.

"We are both very detail oriented, come from creative backgrounds, and have been working on finding the right balance where each of us can complement the other's skills best, which also means sometimes working on things you don't want to. Bottom line is we both understand that as a team we have a better chance of success than by going solo."

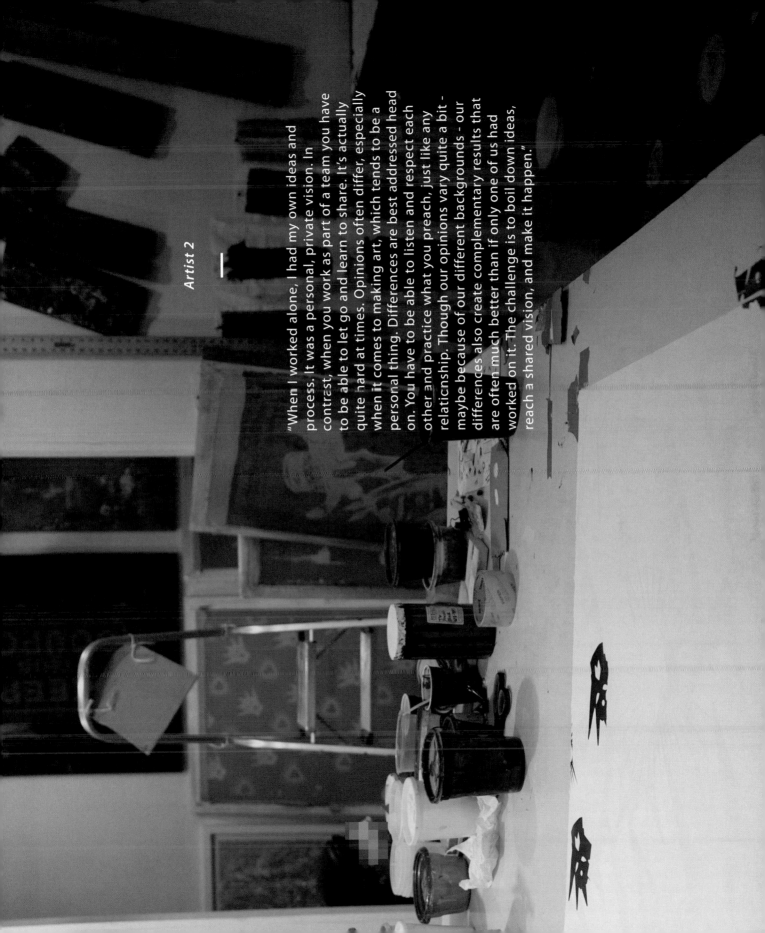

Artist 2

"When I worked alone, I had my own ideas and process. It was a personal, private vision. In contrast, when you work as part of a team you have to be able to let go and learn to share. It's actually quite hard at times. Opinions often differ, especially when it comes to making art, which tends to be a personal thing. Differences are best addressed head on. You have to be able to listen and respect each other and practice what you preach, just like any relationship. Though our opinions vary quite a bit - maybe because of our different backgrounds - our differences also create complementary results that are often much better than if only one of us had worked on it. The challenge is to boil down ideas, reach a shared vision, and make it happen."

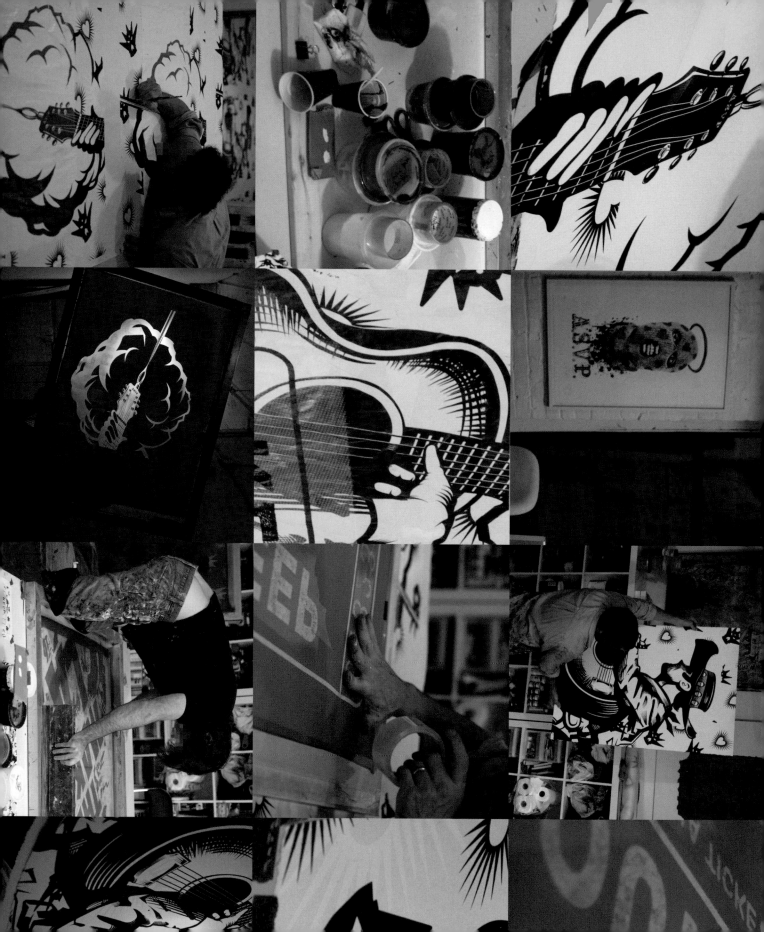

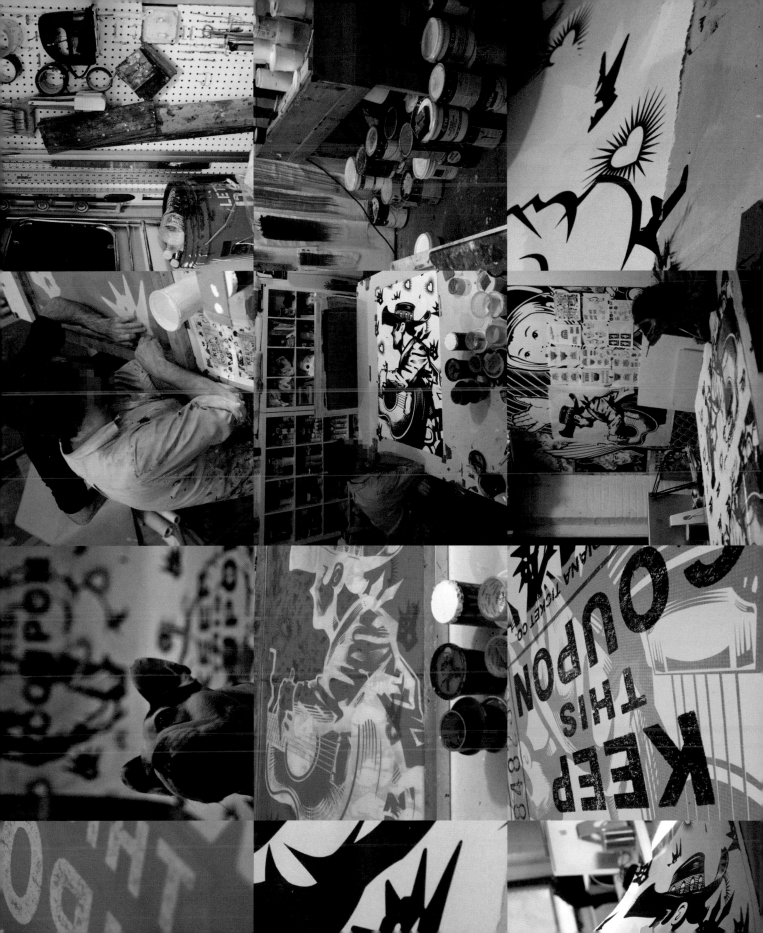

"TWO THINGS I BELIEVE ARE ESSENTIAL TO ANY SUCCESSFUL PARTNERSHIP, CREATIVE OR OTHERWISE, ARE MUTUAL TRUST AND RESPECT. IF THOSE TWO PILLARS AREN'T IN PLACE - DON'T WASTE YOUR TIME."

Artist 1

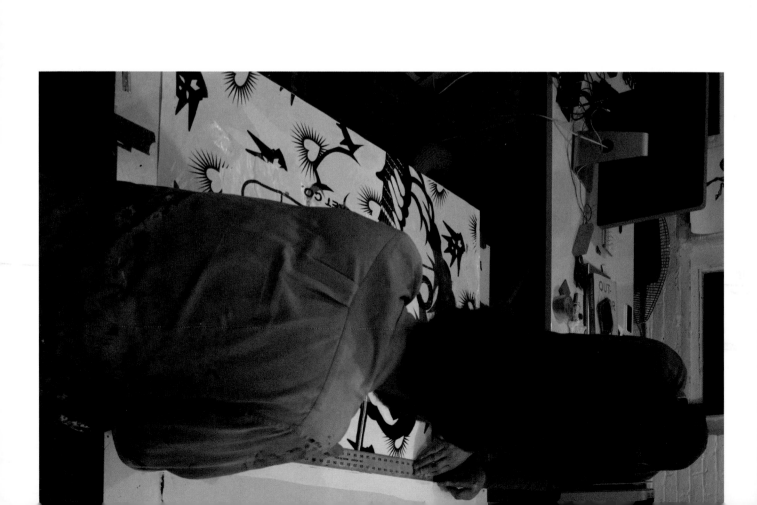

#KEEPTHISCOUPON

"OUR DIFFERENCES ALSO CREATE COMPLEMENTARY RESULTS THAT ARE OFTEN MUCH BETTER THAN IF ONLY ONE OF US HAD WORKED ON IT. THE CHALLENGE IS TO BOIL DOWN IDEAS, REACH A SHARED VISION, AND MAKE IT HAPPEN."

Artist 2

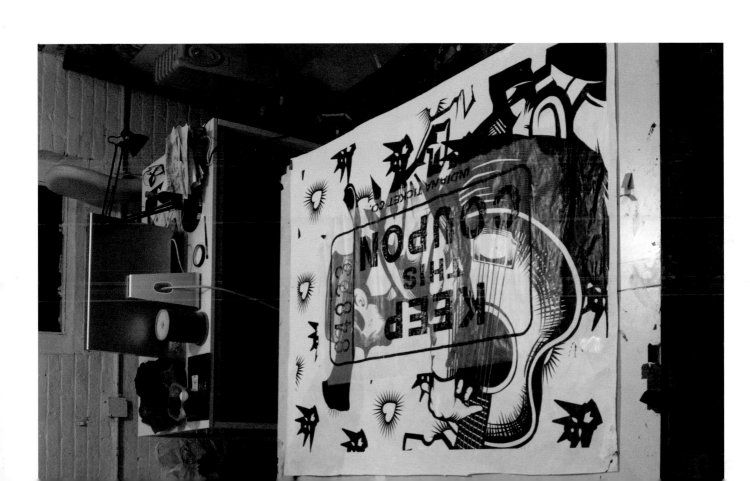

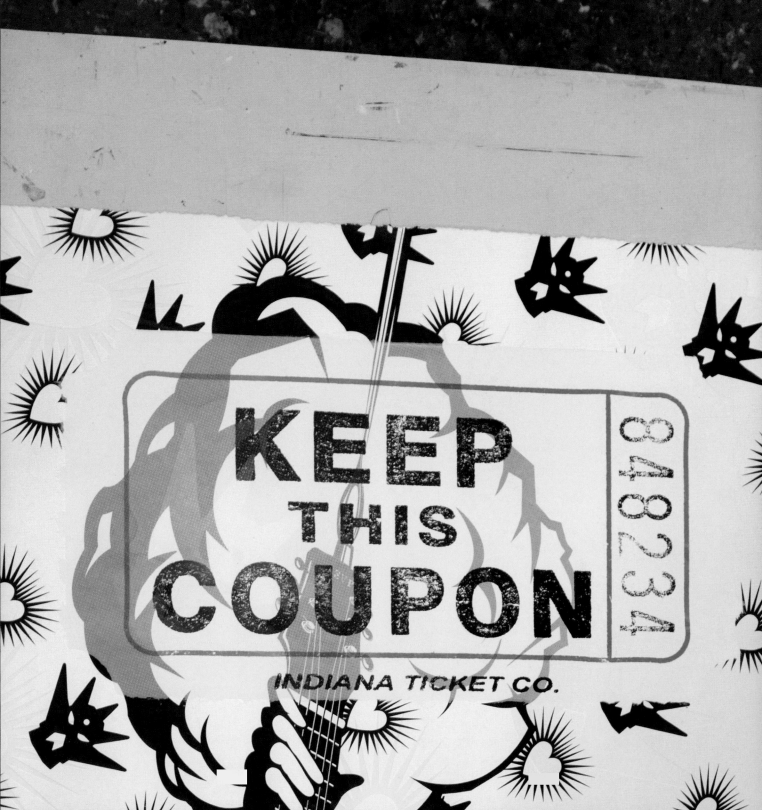

190
BOWERY

LOCATION

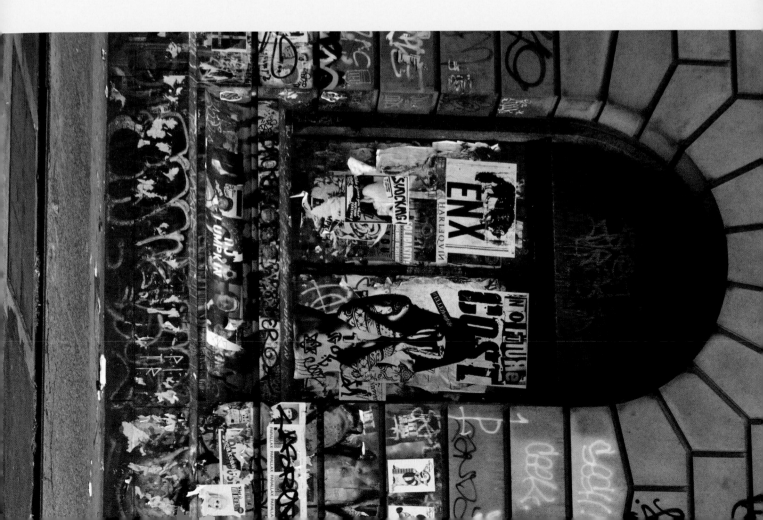

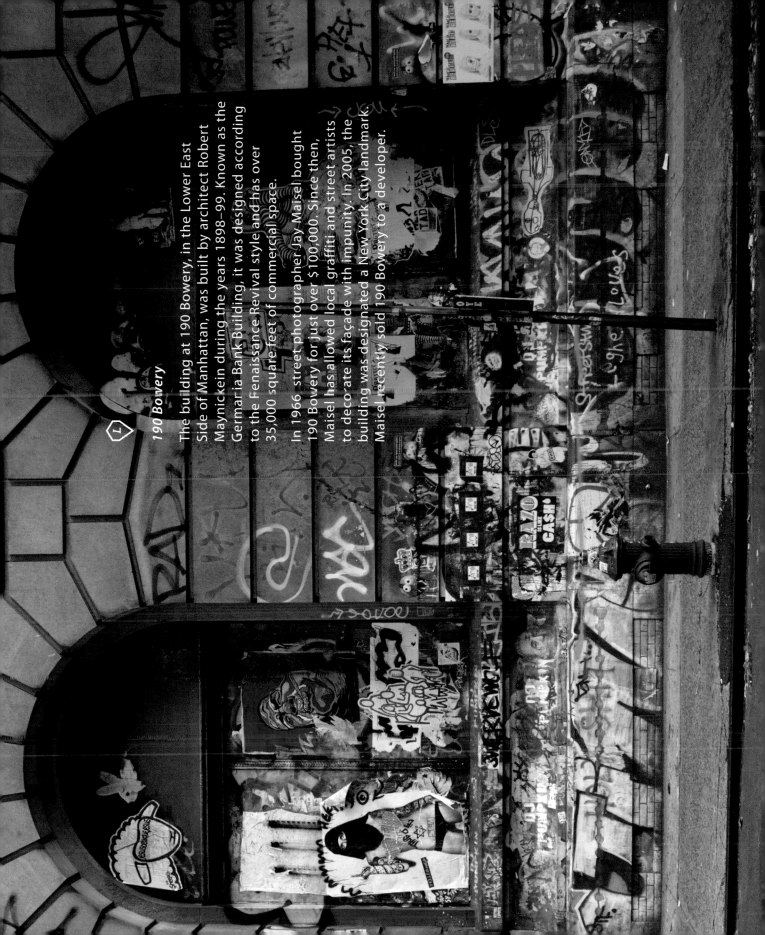

1 190 Bowery

The building at 190 Bowery, in the Lower East Side of Manhattan, was built by architect Robert Maynicke in during the years 1898–99. Known as the Germaria Bank Building, it was designed according to the Renaissance Revival style and has over 35,000 square feet of commercial space.

In 1966 street photographer Jay Maisel bought 190 Bowery for just over $100,000. Since then, Maisel has allowed local graffiti and street artists to decorate its façade with impunity. In 2005, the building was designated a New York City landmark. Maisel recently sold 190 Bowery to a developer.

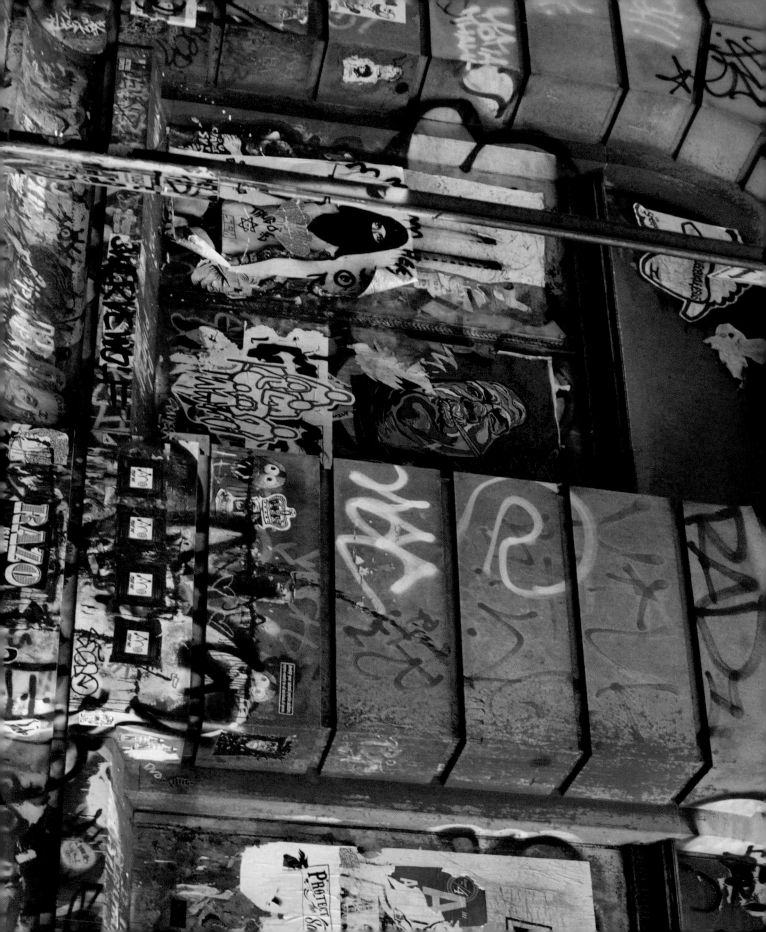

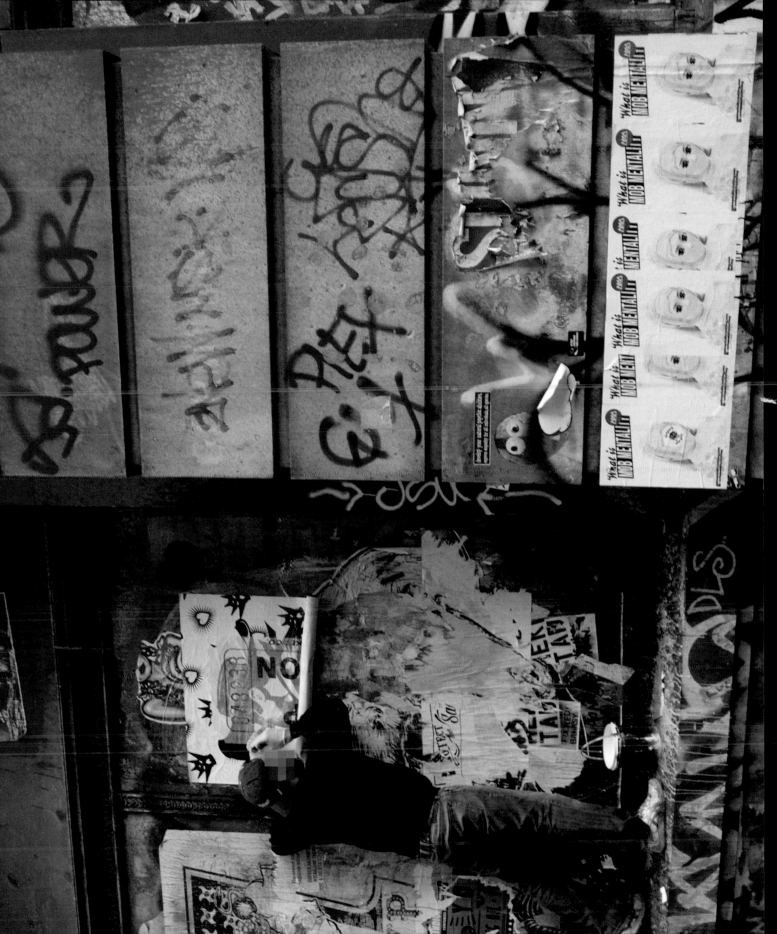

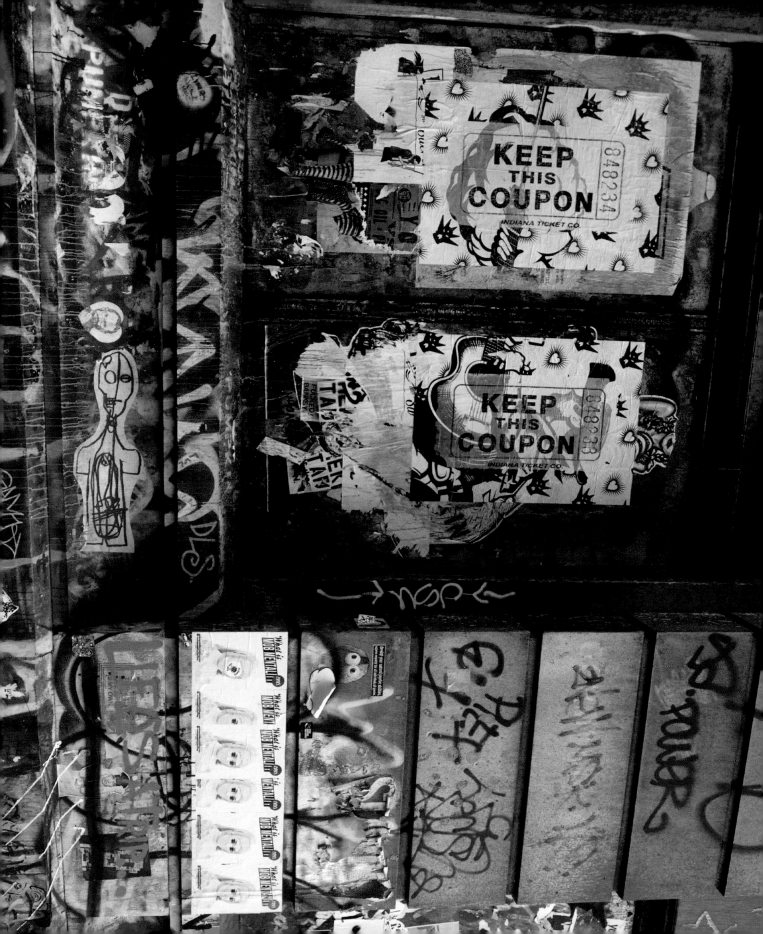

COLLABORATION
#02

#KEEPTHISCOUPON

Artists
ASVP

#GREENPOINTMURAL

CEKIS

Artists
CEKIS
CERN

CERN

LOCATION

GREENPOINT
BROOKLYN

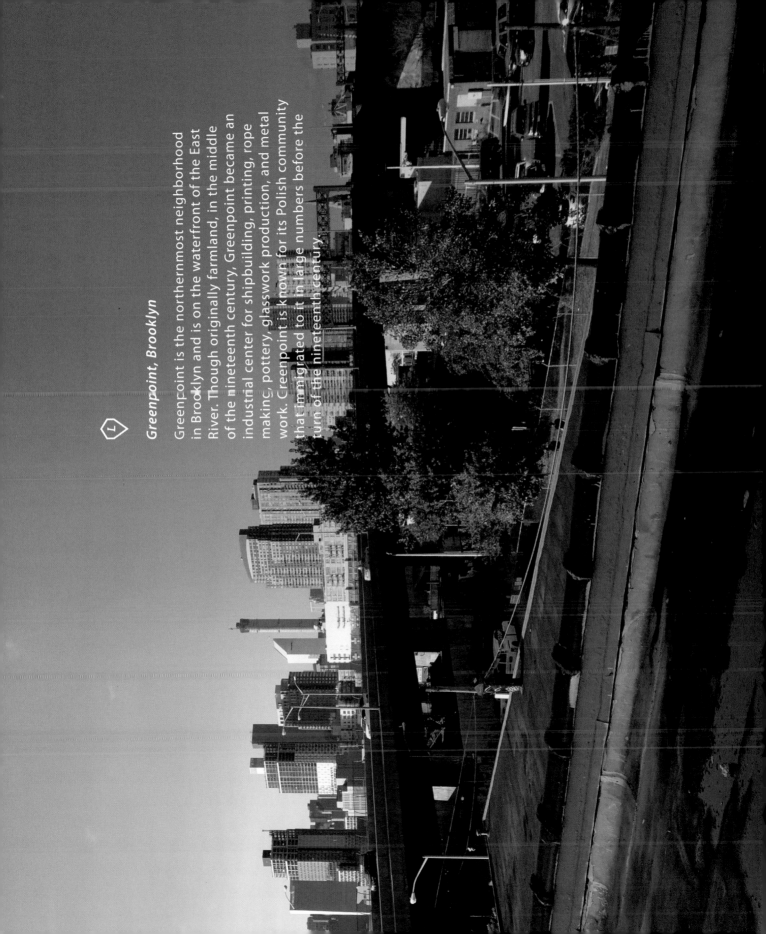

Greenpoint, Brooklyn

Greenpoint is the northernmost neighborhood in Brooklyn and is on the waterfront of the East River. Though originally farmland, in the middle of the nineteenth century, Greenpoint became an industrial center for shipbuilding, printing, rope making, pottery, glasswork production, and metal work. Greenpoint is known for its Polish community that immigrated to it in large numbers before the turn of the nineteenth century.

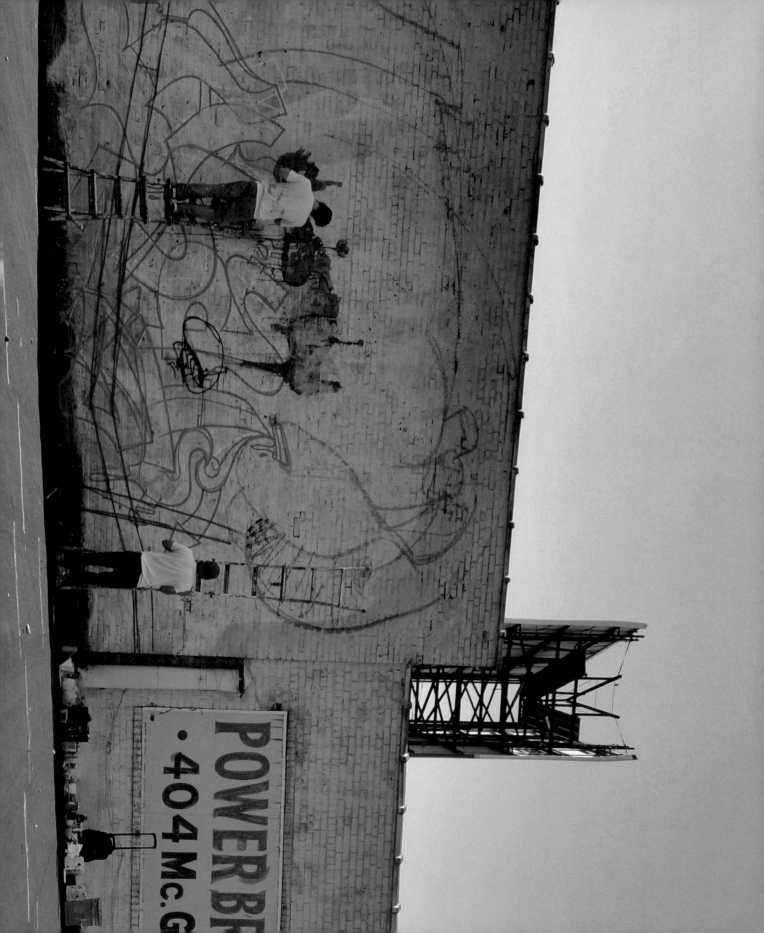

DAY 1

Early Life and Work

CERN

"I was born in Manhattan and was raised in Queens. I had a lot of freedom as a child, but also got into a lot of trouble. That said, my parents were more supportive than disciplinary; I wasn't given much direction, but was allowed to follow my interests. As a kid I was drawing cartoons, writing on desks, and playing guitar. Looking back, it's easy to see I was creative, but I didn't see myself as a natural artist. I slowly began a creative practice as a graffiti writer that years later would have me see the potential of becoming an artist in my own right.

"Queens had a lot of graffiti in the early '90s: it was all over the parks, highways, train lines, and schools. It was something that just went along with hanging out. Some people did such amazing stuff that as a beginner it kind of discouraged me – I felt I had no hope of being that good! I started writing graffiti around 1990. By 1995, I had long been developing style, but not consciously as an artist. Around that time I was also experimenting with psychedelics, which affected my ideas regarding my potential. My confidence was building and I became determined to develop my visions through practice.

"My family seemed happy that I liked what I was doing, even if they didn't understand it. They didn't really respect graffiti, but my path with art helped awaken me out of a lot of personal darkness, so they welcomed it. In school I took some art classes, but I didn't relate to the material at all. I was deeply inspired by the graffiti at that time, as well as the works I saw in the iconic books *Subway Art* and *Spraycan Art*. On a personal level the graffiti crews

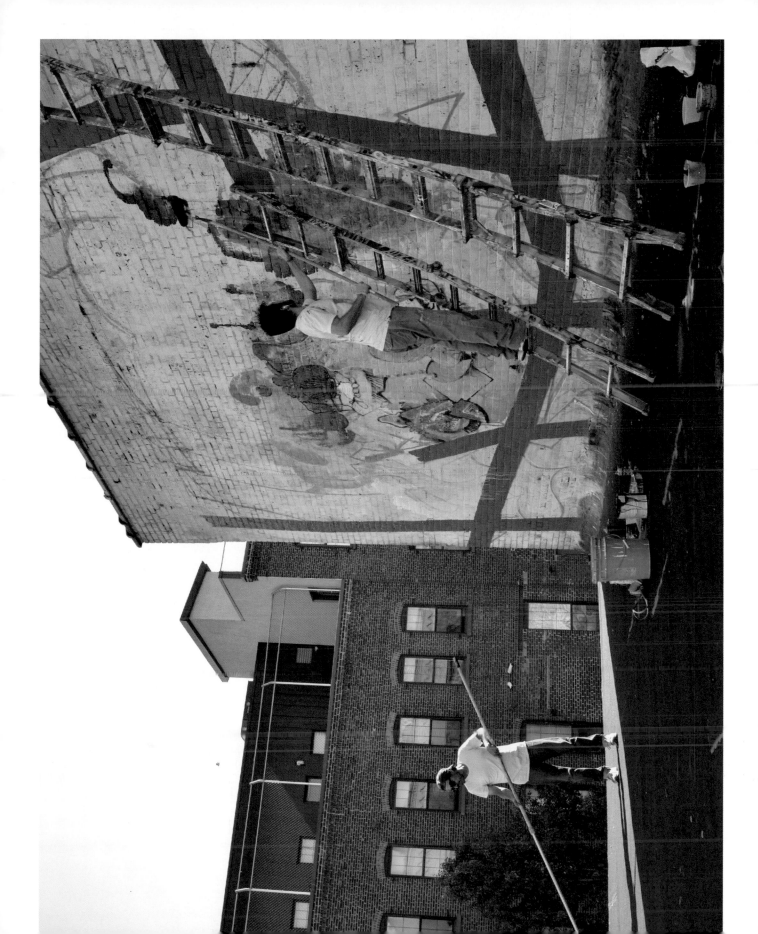

Early Life and Work

"IT WASN'T ABOUT VIOLENCE, BUT ABOUT 'BLOWING PEOPLE'S MINDS.' THIS WAS A GREAT PERSPECTIVE FOR ME AT A TIME WHEN VIOLENCE WAS QUITE PREVALENT IN MY AREA."

…

I was part of were all very supportive. We formed the YMI crew around 1995, and it was a huge force that encouraged me in a positive direction with my art and music. Everyone in the crew was pushing the limits of their work and we grew rapidly together. My artistic dreams seemed only possible in the world I lived in: a world of graffiti and hip hop that turned into second nature. I was dancing, rapping, and writing - would have been DJing if I could afford the equipment. I remember my cousin Coreen was aware of her talent at an earlier age than I was. It was intimidating to see someone like her with such talent and mastery. Quism advised me very early as a graffiti writer. He taught me it wasn't about violence, but 'blowing people's minds.' This was a great perspective for me at a time when violence was quite prevalent in my area.

"I grew up on the edge of the city, thirty minutes from midtown. The nature was polluted and it was a time when the Vandal Squad and the general anti-graffiti buff came down really hard on us. I saw a golden era end and nearly become erased. Rudy Giuliani was elected New York City's mayor when I was just finishing high school. It felt like a police state vibe took over the city on a lot of levels. I was involved with pirate radio and community activism and watched the Lower East Side become a new world as things got fancier and locals got pushed around and eventually out.

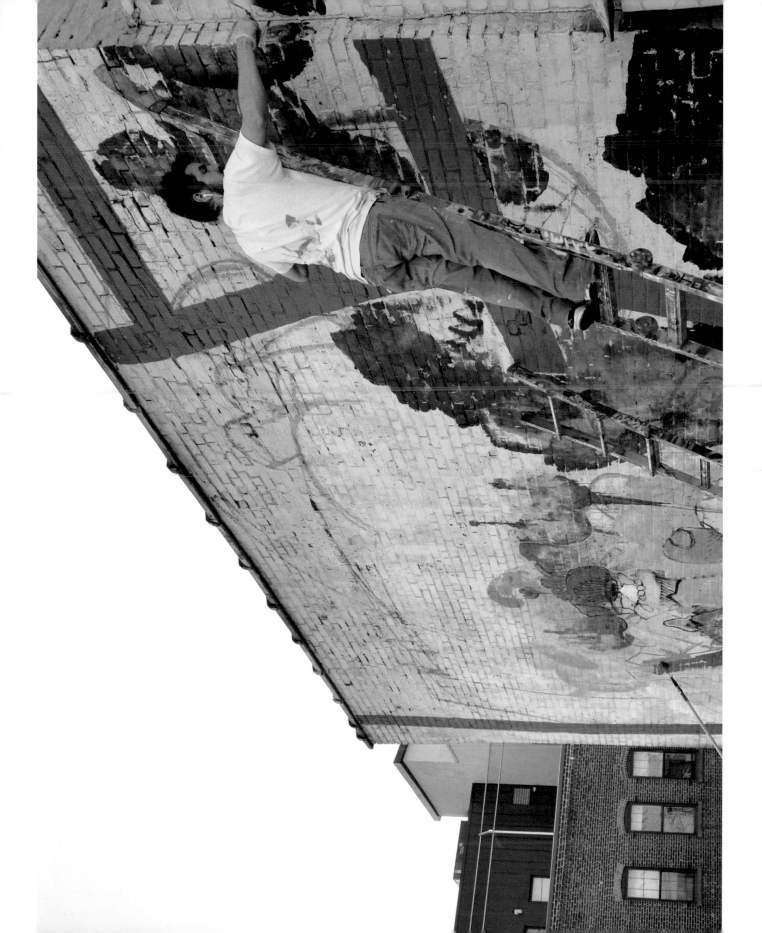

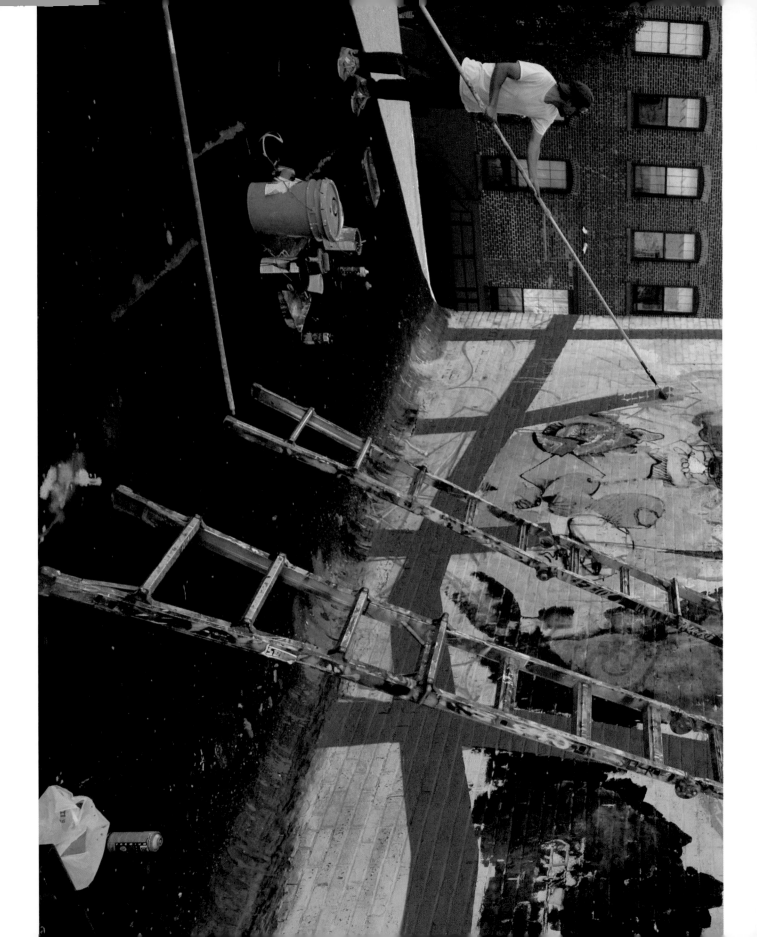

#02

CEKIS

Early Life and Work

"By the time I was really really creating art it had gotten a lot more creative, albeit weird. I experimented a lot with new techniques, ideas, etc., to keep it interesting, and the more I practiced the better I got. The same went for my whole crew. All of YMI was pushing themselves and each other; it was exciting to watch each other's artistic evolution."

"**I was born** in Santiago, Chile. During my childhood and until the age of fourteen, Chile was under the control of Pinochet's military dictatorship. I grew up in a neighborhood in downtown Santiago, on a nice block where everybody knew each other. My mom also grew up on that block and we had a very simple life. Those years instilled in me a very strong sense of political consciousness that profoundly affected my life, and later my art. I remember walking the streets of Santiago during that period and seeing anti-Pinochet political propaganda; works of art painted by very brave and idealistic youth. These political paintings were dispersed around my neighborhood and all over the city. They really shocked me and shaped the way my art has evolved.

"When I was thirteen, we moved to a radically different neighborhood that set me on my path as an artist. At that time the country was heading in a new democratic sociopolitical direction and this changed everything for me.

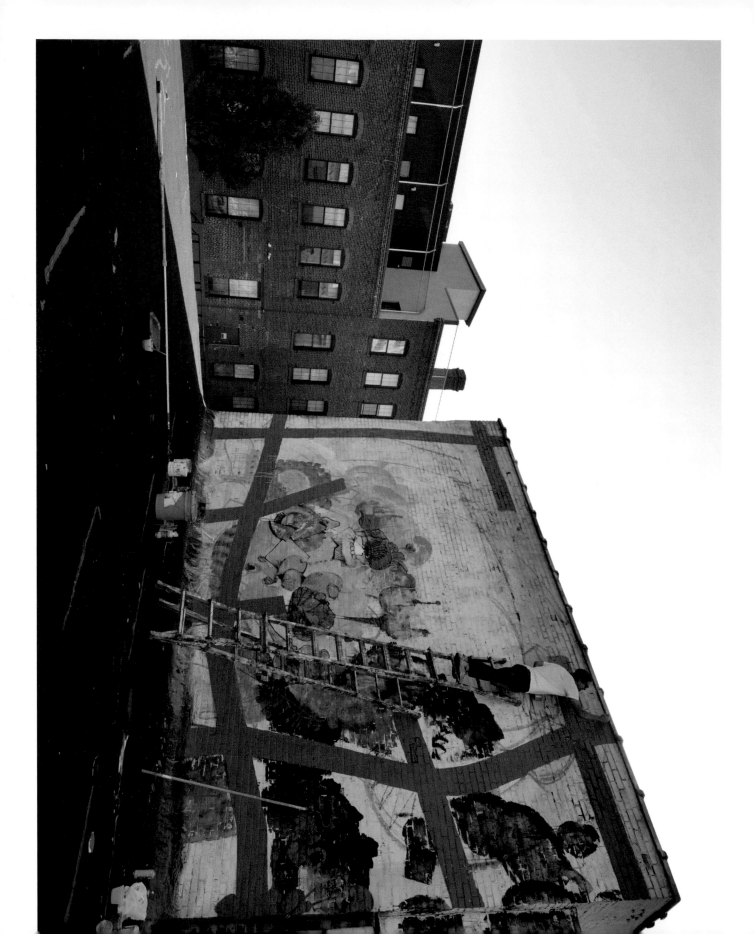

...

"As a youth, I looked up to muralist groups called *brigadas*. These crews have a long tradition painting in the streets of cities throughout Chile. By the end of the '80s the brigadas started using elements of 'New York style' graffiti to create their propaganda, like highlights or blendings, but they did it with thick brushes, not spray paint. In the early '90s I started to notice more and more people tagging with spray paint around my 'hood, and those were the beginnings of modern graffiti in Chile. These tags deeply inspired me.

"I always remember myself drawing, but I only became a real artist when I got into graffiti and met others like me on the streets of Santiago.

"Back then I was very inspired by artists and friends from Chile and beyond, including BSAI, SIC888, DERK, HORATE, and OSGEMEOS. My family wasn't really happy with my new passion for art. They were concerned for my safety, as being a graffiti artist meant working illegally at night. They wanted a different future for me. I guess art just didn't seem like a real job to them.

"In contrast, my friends were always supportive because they could relate to graffiti as a sign of the times."

"I REMEMBER WALKING THE STREETS OF SANTIAGO DURING THAT PERIOD AND SEEING ANTI-PINOCHET POLITICAL PROPAGANDA; WORKS OF ART PAINTED BY VERY BRAVE AND IDEALISTIC YOUTH."

Early Life and Work

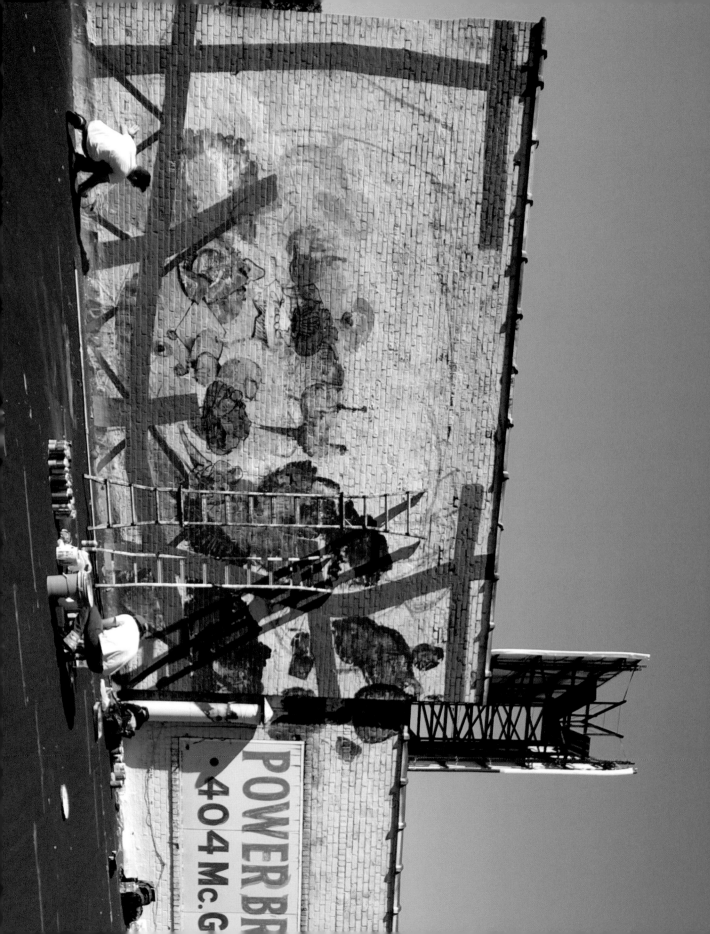

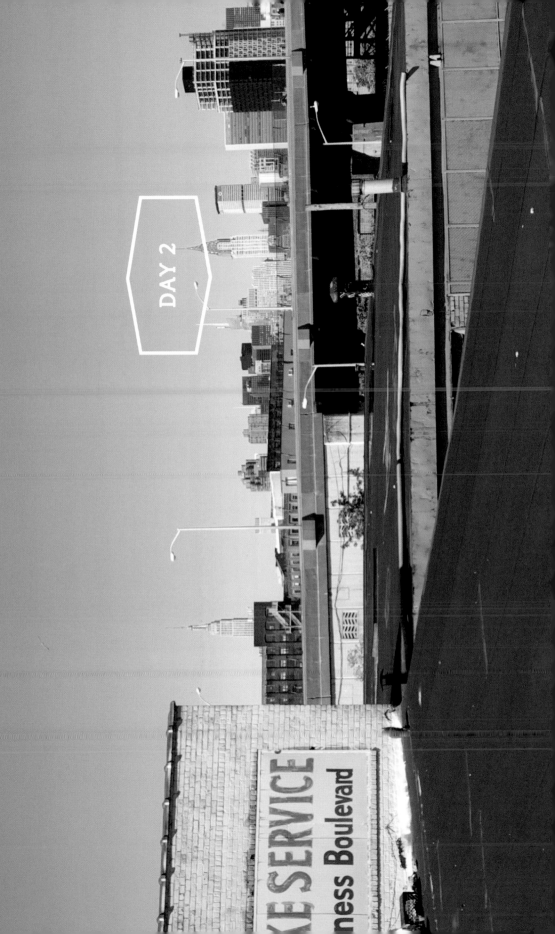

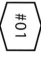

#01

CERN

"My personal process changes depending on the situation and perhaps over time. Sometimes the focus of the piece revolves around drawings I've been working on or visions I've been developing. Other times it's inspired by images I've seen, or the particular location in which that painting is being created. I try to go beyond myself and connect with the surroundings; the communities I work in have a big influence on what I'm painting. The dialogue between what I develop when painting in the outside world and what I develop in my studio or on sketches is an ongoing practice. Different things come out in both instances that I like bringing into either space.

"I've always experimented with my creative style as much as possible and, in a way, the act of experimentation has become its own style. I find that as time goes by I revisit certain languages and characters that I like to bring into different contexts, as well as develop new ones that become part of my artistic vocabulary. Throughout time I've found myself interested in working with most paints: spray was an early love and oils brought me to a place that really expanded my vision of painting. I started using watercolors just for fun when traveling but they have become a huge part of my practice. It's a gift to live a decent amount of time and to grow with many practices."

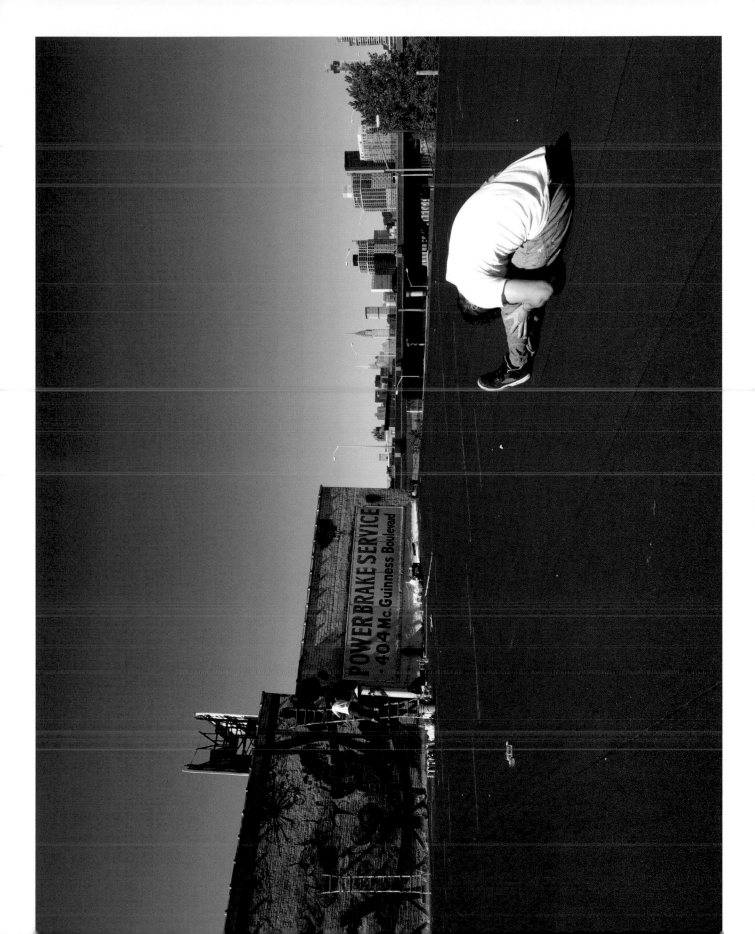

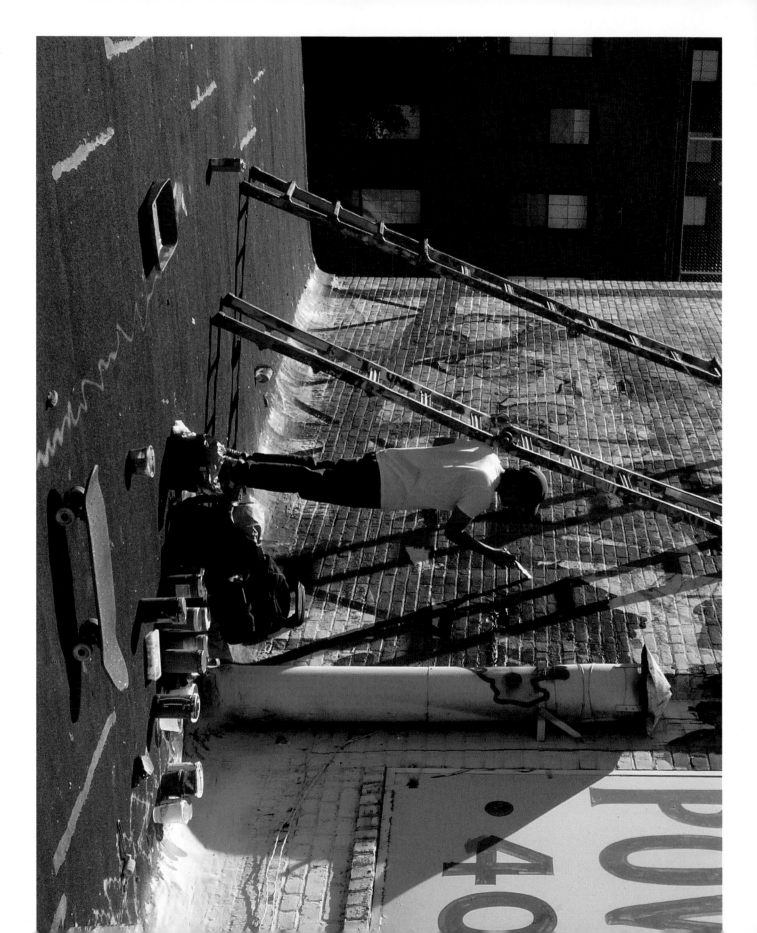

"**My process** depends on many factors. Sometimes I have an idea in mind so I start sketching it out, and other times I don't make an initial sketch and instead I work through it, trying to create something new or simply expand on an idea. This may work on the street or not. There are things I prefer creating for a canvas and others I like only for the street. I can get an idea for a piece from anything at any time, and if I can't immediately put it on paper I write it on my phone. Then, I either research for references and draw it out or simply draw from memory."

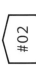

#02

CEKIS

Creative Process

"IN THE BEGINNING IT WAS MORE LIKE WE PAINTED TOGETHER BUT KEPT OUR OWN SPACE AND THEN FIGURED OUT A BACKGROUND TOGETHER; A MORE CLASSIC 'GRAFFITI STYLE' OF COLLABORATION. BUT WITH TIME, WE INDEPENDENTLY GREW AS ARTISTS BOTH VISUALLY AND TECHNICALLY AND ALSO MATURED AS A TEAM."

Cekis

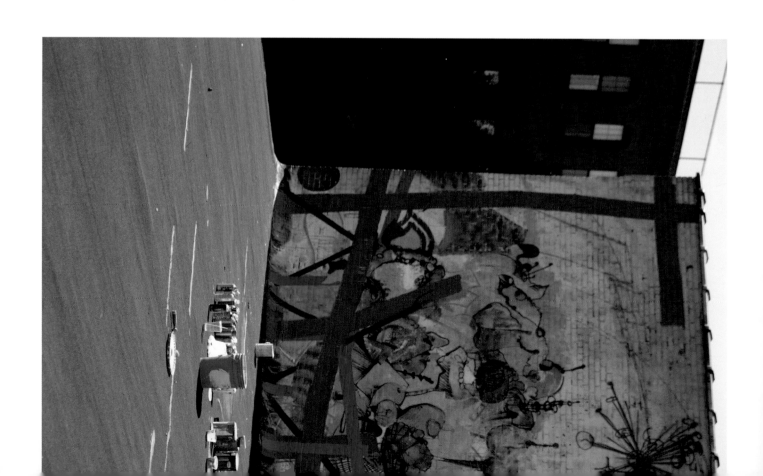

#GREENPOINTMURAL

"WHEN I COLLABORATE, I MAKE AN ATTEMPT TO COMMUNICATE AS MUCH AS POSSIBLE WITH THE OTHER PERSON, EITHER THROUGH IMAGES OR SIMPLY BY TALKING. I TRY TO MAKE SURE WE'RE ON THE SAME PAGE WITH RESPECT TO OUR CREATIVE VISION AND ANTICIPATED EFFORTS."

Cern

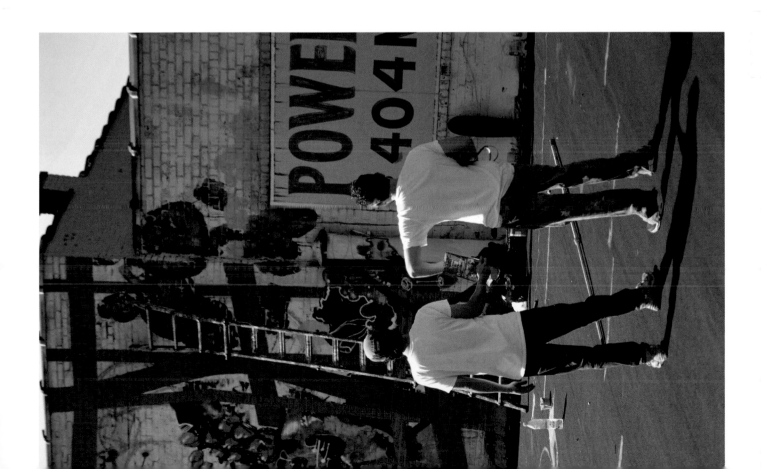

Cern

—

"When I collaborate, I make an attempt to communicate as much as possible with the other person, either through images or simply by talking. I try to make sure we're on the same page with respect to our creative vision and anticipated efforts. Over the years I have collaborated with many artists; sometimes it's just about having fun with different artists that are rocking together; other times it's with friends with whom certain ideas and styles had already been discussed. It can also just happen at random times - organized externally through various events. Some simple difficulties that I encounter when collaborating are because of spatial arrangements. It can be related to misconceptions about layering or misinterpretations of the other artist's work. Unfortunately, these can lead to work getting destroyed in the process.

"I met Cekis in Brooklyn in 2004. We started a large mural together in August 2004, and it's still running in Brooklyn. We began collaborating then and have done numerous projects together since. At this point I feel we know each other's work ethic and styles pretty well. Once we have a unified vision for a piece, the hardest part is having the time and physically executing it.

"Because we've worked together for years, we've already dealt with the initial difficulties that usually arise when you don't know the other artist. I find at this point it's mainly a pleasure and a relief to work with Cekis. We both trust each other's dedication and devotion to put in as much energy as needed so that our joint vision can come to life."

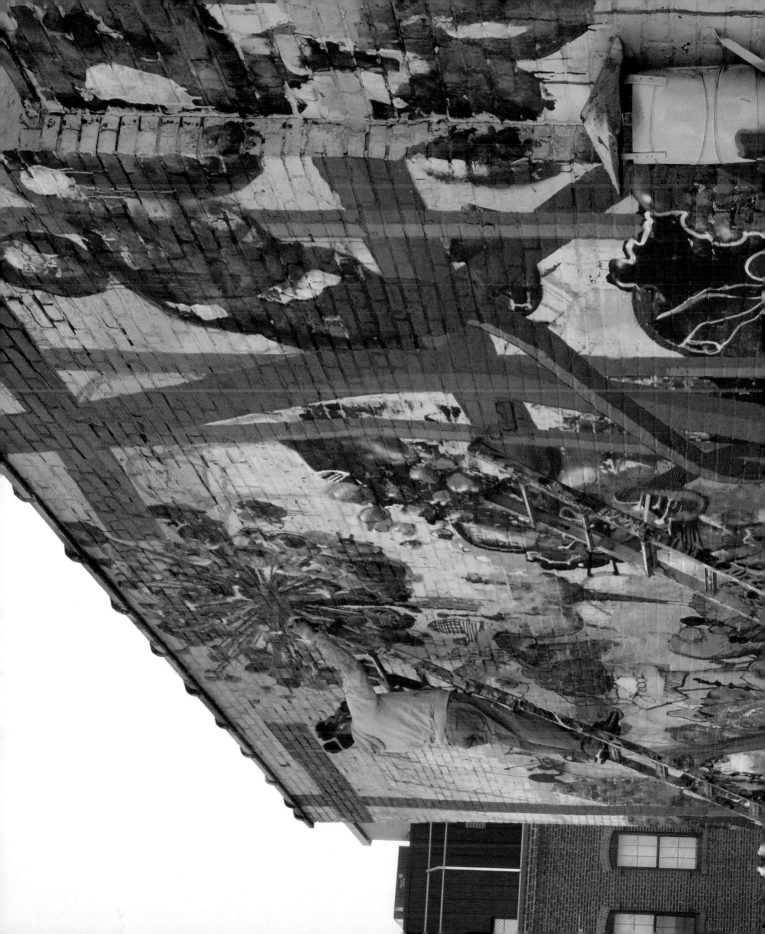

Cekis

"Compared to working alone, collaborating is a totally different process for me, but it feels natural too. I like to have my own area to paint, but I'm open to sharing my space and ideas with a friend who can inspire my work. It's the synergy around the artwork being painted that makes it a unique experience.

"Some difficulties in collaborating can be the basic idea of the piece. It's hard to come up with a new idea that both artists are excited about. I have more problems collaborating when I'm just getting to know an artist. Once the relationship develops and we're friends, it's super cool to collaborate and we go into the work knowing we'll finish the piece no matter what it takes. I have to admit I don't collaborate with many people. Back in Santiago I was used to working with my old crew DVE - I learned a lot about painting with them.

"Nowadays I collaborate only with close friends like Cernesto YM!! I met Cern right after I moved to NYC in 2004; I saw him painting live at this event and I approached him and we simply clicked. We've been collaborating since the very beginning. He was painting a lot around Williamsburg, Greenpoint, and Bushwick in Brooklyn.

"We did our first wall with other artists in Bushwick and from then on I painted a lot with him and his crew. It's pretty chill working with Cern; we always respect each other. In the beginning it was more like we painted together but kept our own space and then figured out a background together: a more classic 'graffiti style' of collaboration. But with time, we independently grew as artists both visually and technically and also matured as a team. Now we are able to connect our art more and truly create collaboratively. When we paint there are no rules! If I have an idea I'd like to try out, I share it with him, and if he has something to say about it I am happy to engage in a constructive conversation."

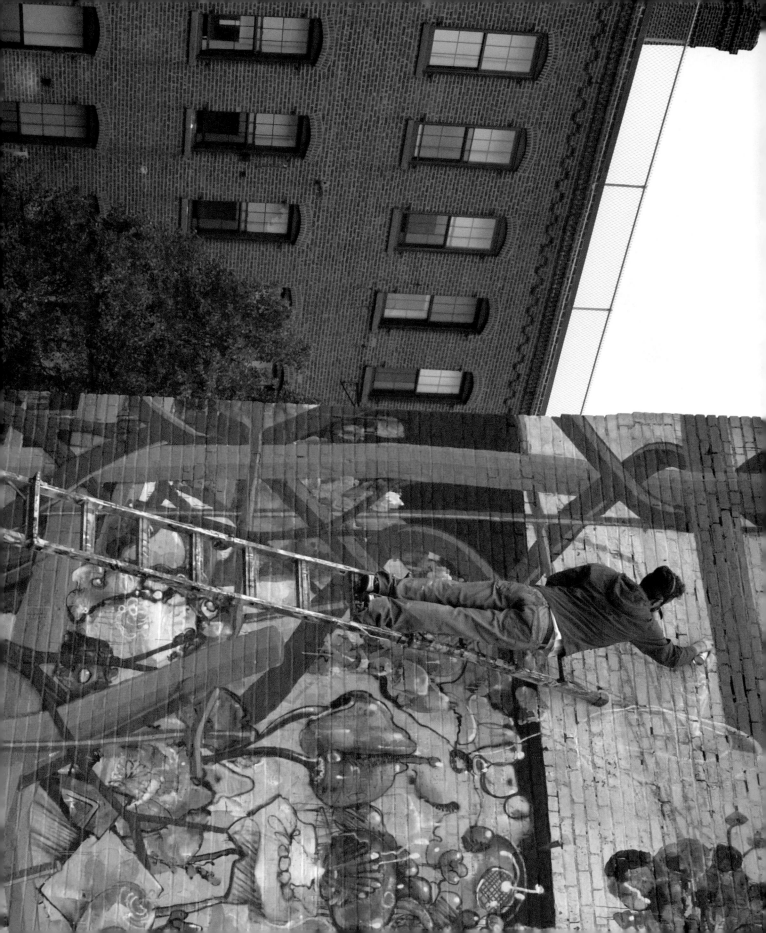

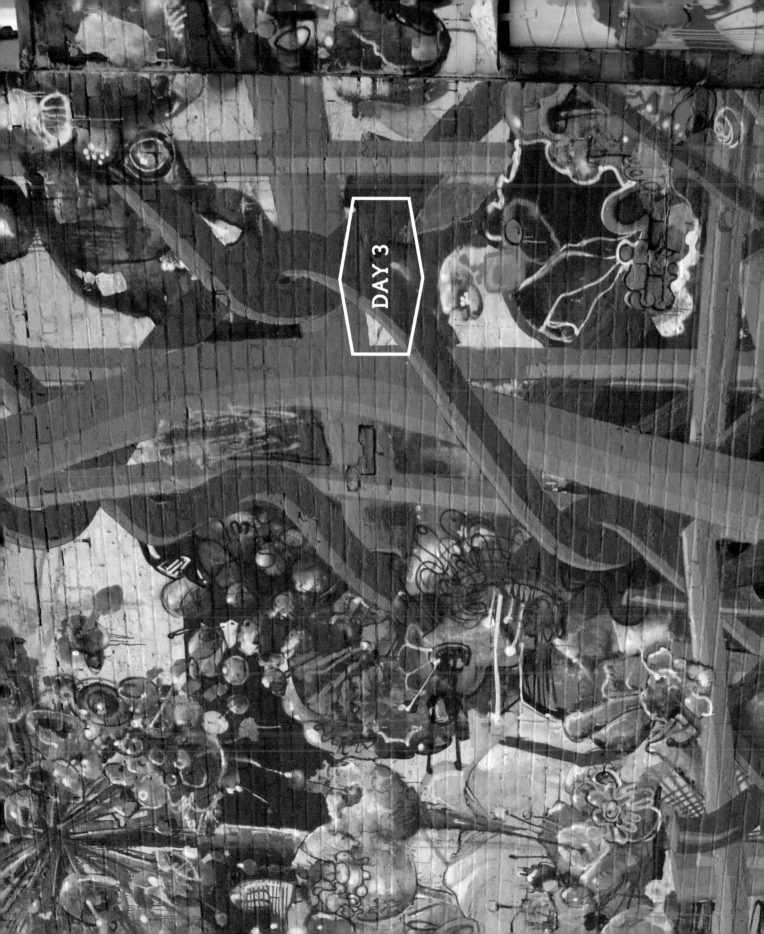

DAY 3

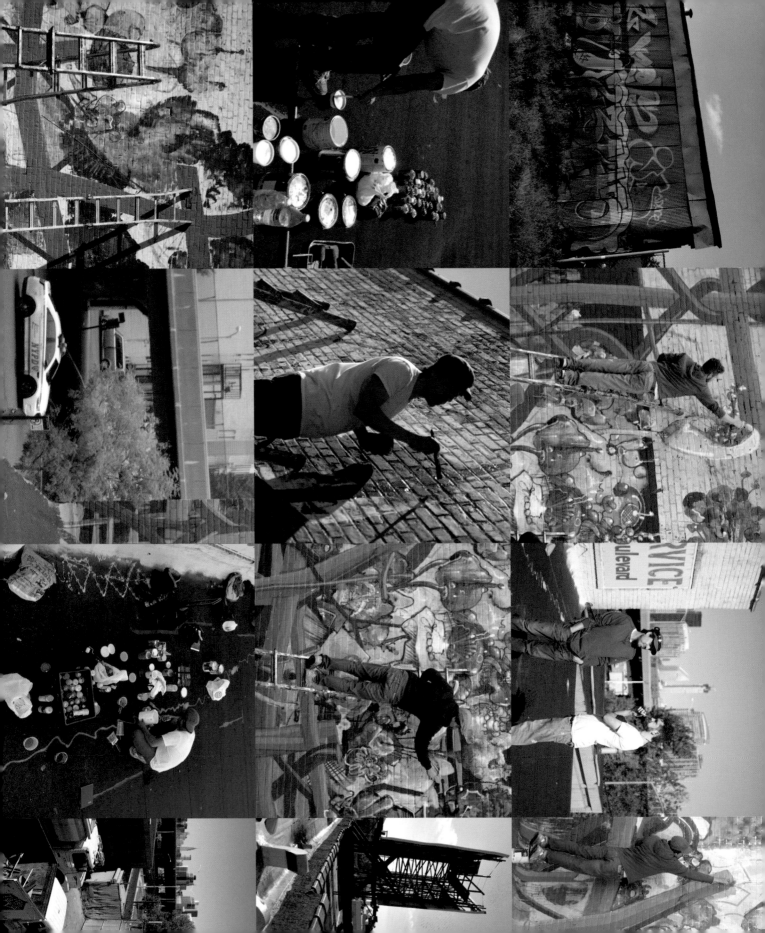

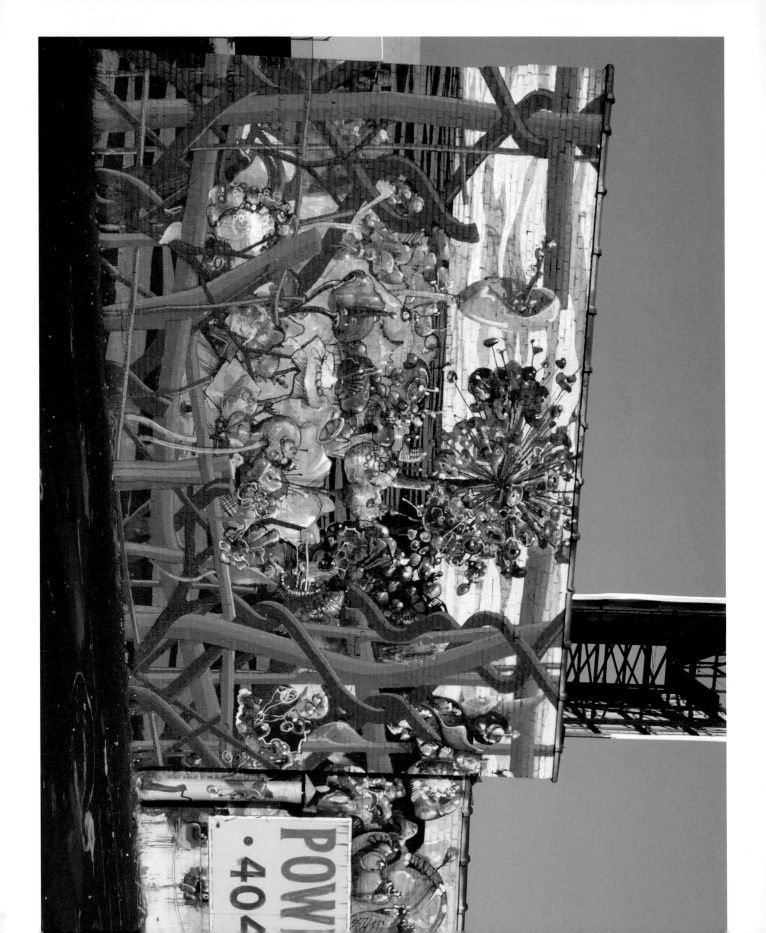

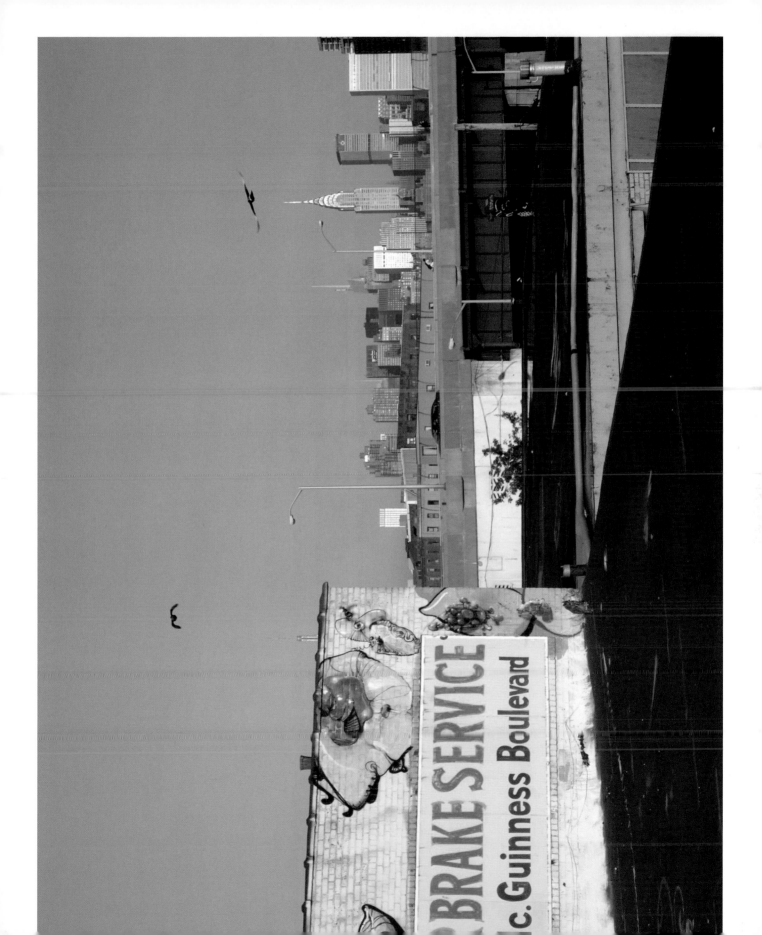

#GREENPOINTMURAL

Artists
CEKIS
CERN

#WELLINGCOURT

Artists
ICY
SOT

TO
O

| #01 |

ICY

"I was born in Tabriz, Iran. As teenagers, my brother (Sot) and I were always looking to have fun and we got into skateboarding and punk rock music. We started hanging out when he was twelve and I was eighteen. Very few people were into these things in Tabriz. Stickers were very popular in the skateboard culture and we wanted to make our own.

"At the time we didn't even hear about 'street art'; we just liked putting up stickers in different places. Through the Internet and social media we started getting exposed to street art and the work of other artists around the world; that's when we started making our own stencils. It was the easiest, safest, and fastest way to get our work on the streets. Street art was and still is illegal in Iran, so speed was always very important. We used to scope out a spot a few times before we'd put up a piece.

"There was no art on the streets of Tabriz other than political propaganda murals typically showing images of the revolution, fallen soldiers that were glorified as war heroes, and huge portraits of Iran's supreme leaders. These murals were the only paintings on public walls that people could see during their everyday lives until street art popped up in the public realm. Illegal street art changed this because of its unique and uncensored voice. Street art is made by the people, for the people."

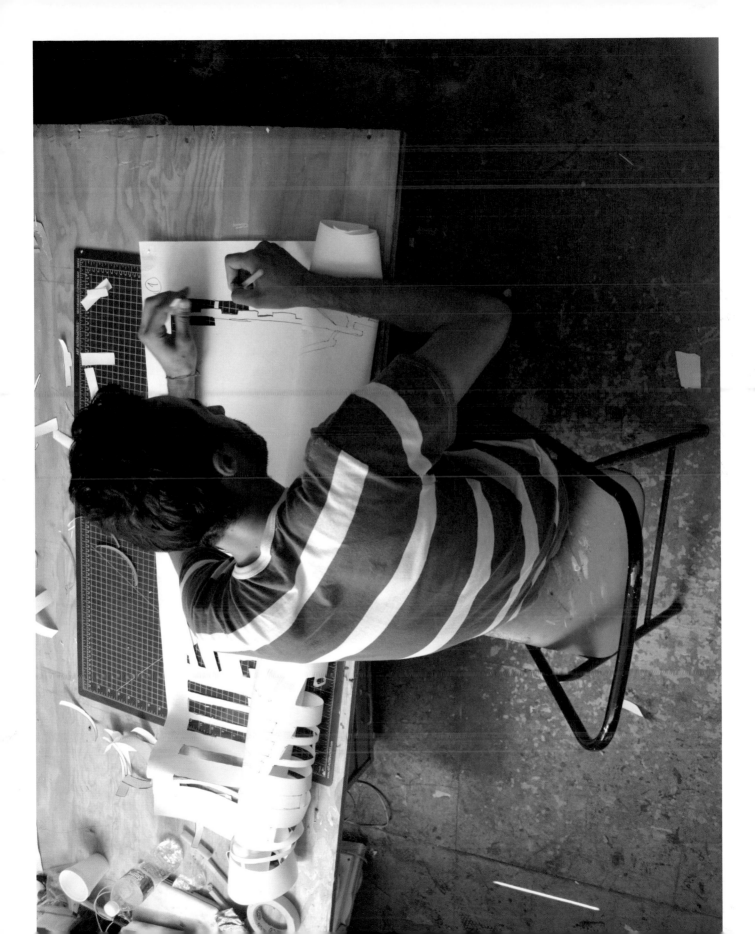

Creative Process

"I WAS BORN IN TABRIZ, IRAN. AS TEENAGERS MY BROTHER (SOT) AND I WERE ALWAYS LOOKING TO HAVE FUN AND WE GOT INTO SKATEBOARDING AND PUNK ROCK MUSIC. WE STARTED HANGING OUT WHEN HE WAS TWELVE AND I WAS EIGHTEEN."

"It all starts out with an idea. That's the most important thing for us, but it's just the beginning. We look for an image or images that best represents the idea simply by making a one-layered stencil.

"After that we follow a simple process of making a stencil, depending on the size. For a large mural on a wall, we divide the piece into several usually equal parts and use a projector connected to a laptop to project the images onto paper on which we mark the borders for cutting.

"Then we spend a while cutting and finally we use spray paint to create the image on the wall."

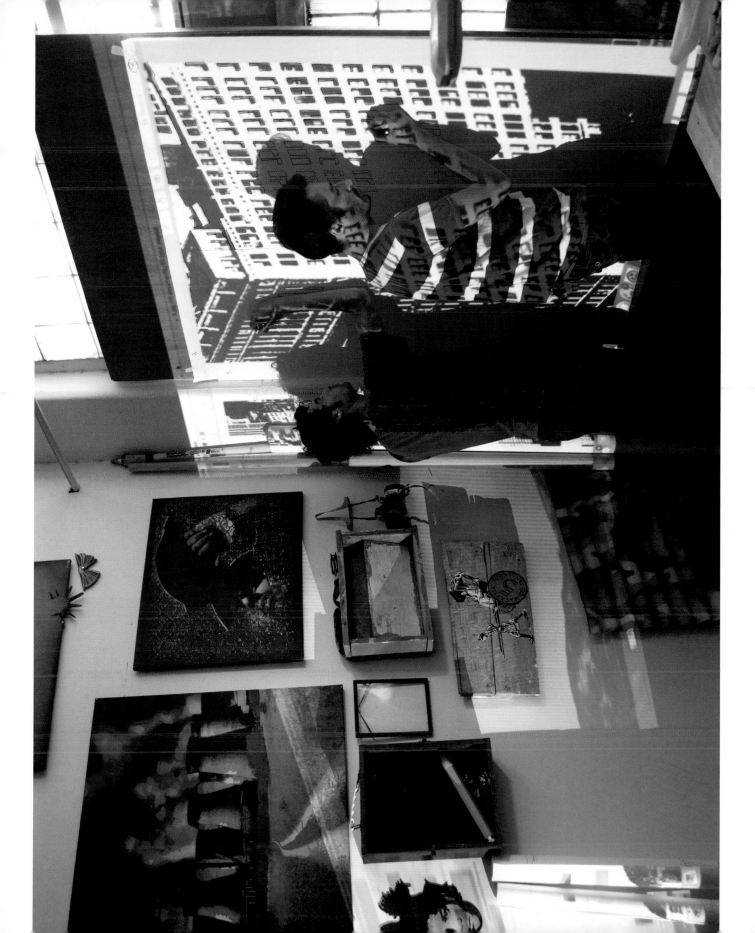

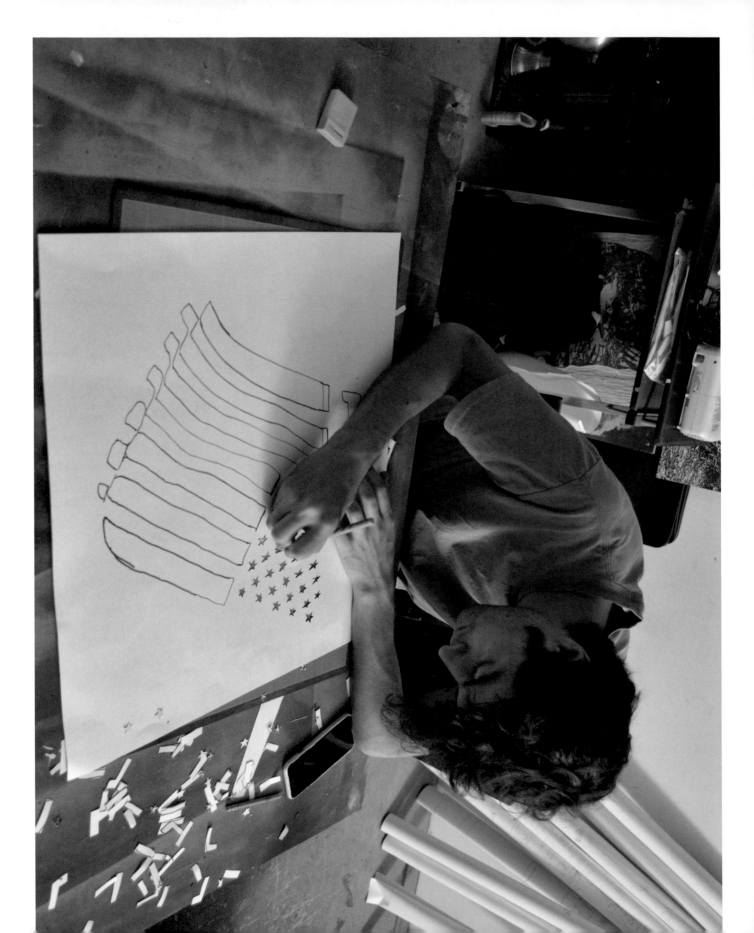

SOT

"**I started skateboarding** when I was a teenager. Back then I used to skate in the streets of my hometown (Tabriz, Iran) for seven or eight hours a day. I watched a lot of skate videos online and would play one of the early versions of Tony Hawk's skate game. In the game there was graffiti - stencils and stickers on the streets - which I really liked. At that time, I started making simple one-layered stencils and I used to put them on my board and skate spots in the city.

"My brother (Icy) and I were always together. Although he is older than me, I hung out with him and his friends all the time. Through the Internet - mostly Flickr - we found out about street art. We made a lot of friends from all over the world through the Internet and connected with other artists. This online community really helped us on our path. Then some international blogs posted our work and we developed a following. A friend from Amsterdam tried to send us street art books but the authorities prevented the books from reaching us. Finally a friend from Germany brought us books on Banksy and a copy of Hugo Kaagman's *Stencil King*. These books really inspired us.

"Life back home was very strict and limited, and we looked for an outlet to express ourselves - street art just seemed like the natural platform. With art we could express our feelings, our anger, and our passions on the streets. Iran is not a free society and we centered our works on the freedoms we were missing and wanted so badly. Having fun was basically illegal in Iran. We started by making

Early Life and Work

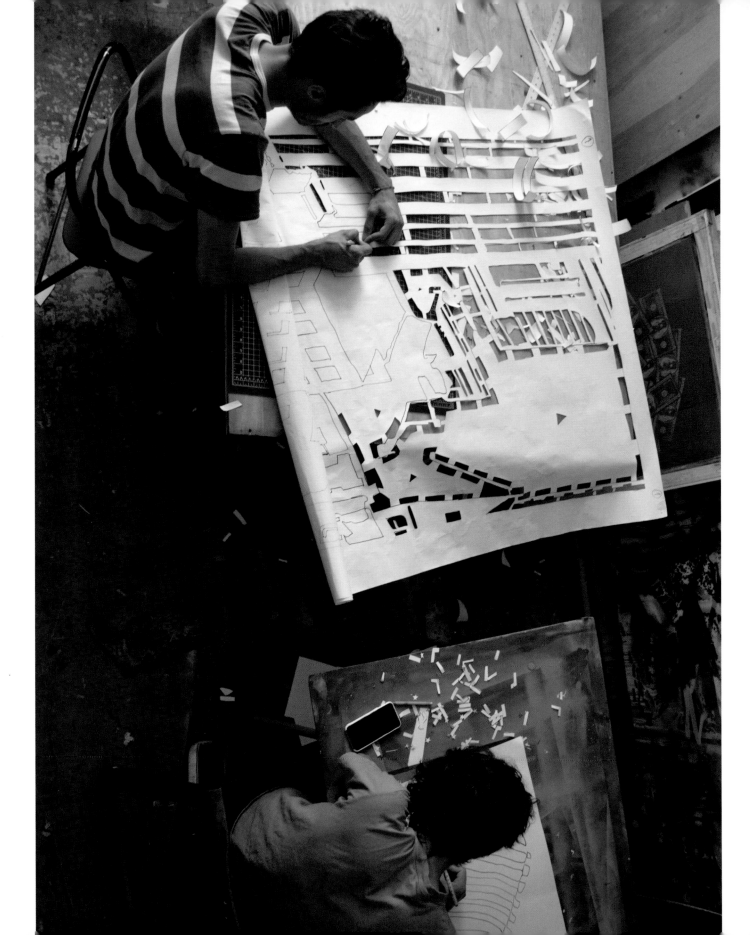

portraits of people around the city. One of our first pieces that got some international attention was a stencil of a guy with the words 'beer is not a crime.' A lot of people outside Iran were surprised to find out that drinking beer in Iran was illegal. We did another series of stencils with kids wearing different kinds of glasses and played around with the lenses as a way to portray the limitations in Iranian society; those that 'blind' free thinking and prevent young people from developing hopes and dreams for the future. Instead of clear lenses the glasses had forbidden symbols, jail bars, or were opaque.

"People were seeing Iran through our work and it motivated us to create an authentic representation. Street art is political per definition. It's a perfect way to share our thoughts with the population. We always try to inspire people to change or rethink their preconceptions about reality.

"It wasn't easy to make street art in Iran. For one thing, it was hard to find materials. Spray paint was difficult to come by. For example, when we painted multi-layered stencils, we needed to buy each color from a different brand, according to availability. Our work was usually painted over really quick, depending on the centrality of the location. If it were on the streets it would disappear very quickly, sometimes within twelve hours. The transient nature of the work actually motivated us to produce more. It's here and then it's gone, you know? We never consciously made a decision to become

"LIFE BACK HOME WAS VERY STRICT AND LIMITED, AND WE LOOKED FOR AN OUTLET TO EXPRESS OURSELVES - STREET ART JUST SEEMED LIKE THE NATURAL PLATFORM. WITH ART WE COULD EXPRESS OUR FEELINGS, OUR ANGER, AND OUR PASSIONS ON THE STREETS."

Early Life and Work

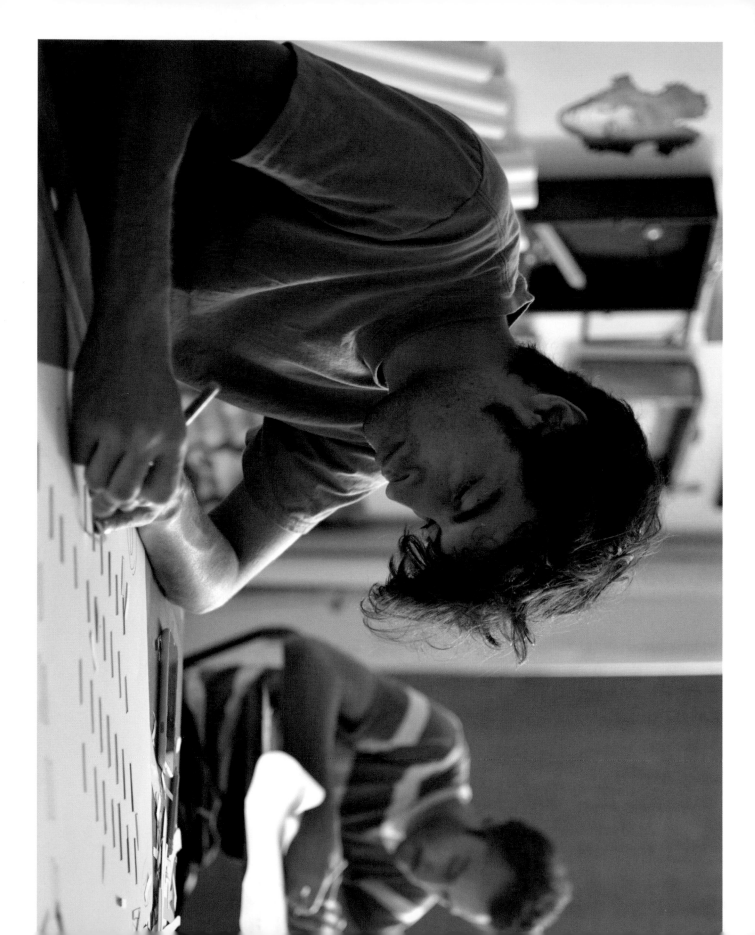

professional artists. Street art just happened for us that way."

"First we come up with an idea and we talk it through. We add and subtract until we both agree that it's ready. Our pieces always have several layers of ideas that enable the viewer to make their own interpretation.

"Our inspiration comes from our daily lives and from the news. Sometimes we use our own pictures and other times we use images off the Internet. We make collages of images to serve our ideas.

"Most of our stencils are black and white, one-layered stencils. We use an assortment of materials and methods, depending on the size of the wall, our budget, and if we want to reuse the stencil. No one taught us how to make stencils; we learned everything from first-hand experience."

"ONE OF OUR FIRST PIECES THAT GOT SOME INTERNATIONAL ATTENTION WAS A STENCIL OF A GUY WITH THE WORDS 'BEER IS NOT A CRIME.' A LOT OF PEOPLE OUTSIDE IRAN WERE SURPRISED TO FIND OUT THAT DRINKING BEER IN IRAN WAS ILLEGAL."

Creative Process

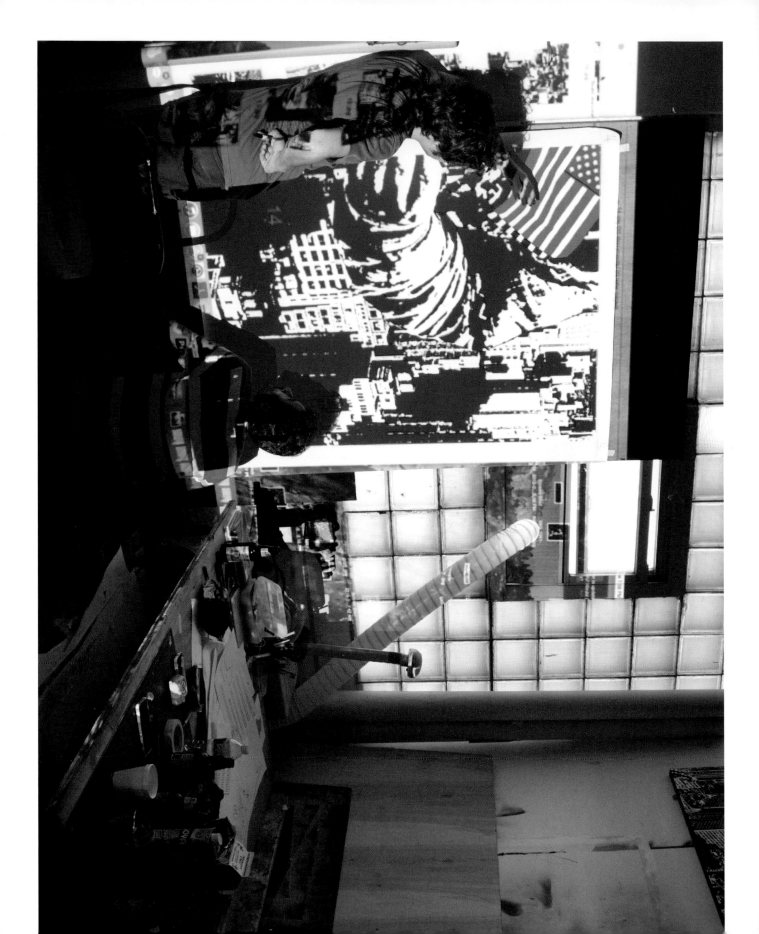

ASTORIA
QUEENS

LOCATION

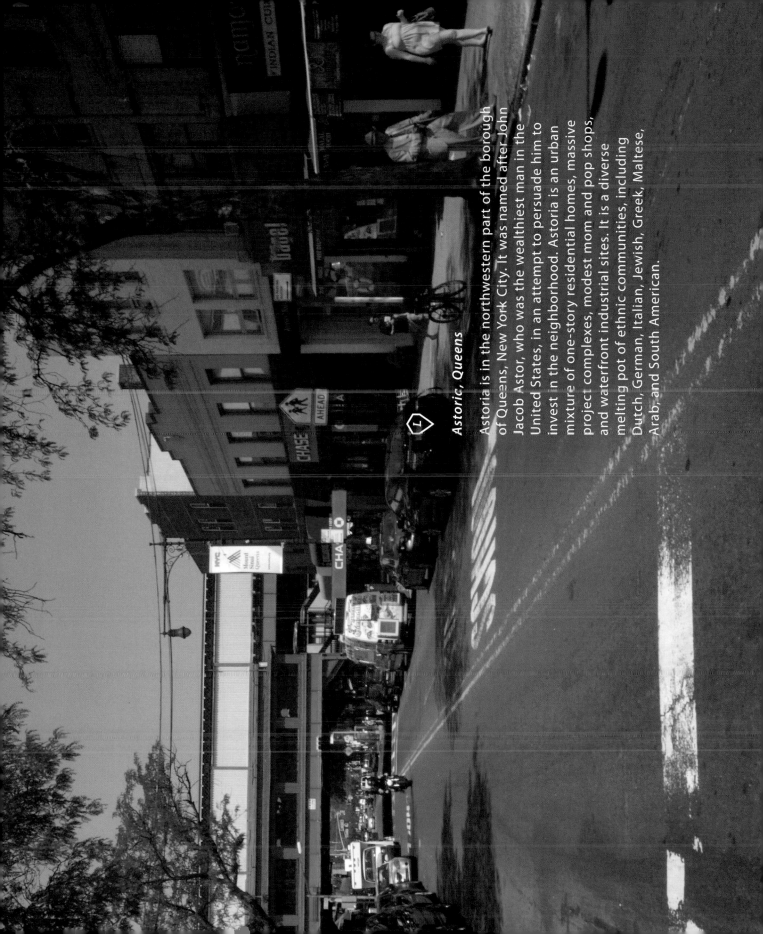

Astoria, Queens

Astoria is in the northwestern part of the borough of Queens, New York City. It was named after John Jacob Astor, who was the wealthiest man in the United States, in an attempt to persuade him to invest in the neighborhood. Astoria is an urban mixture of one-story residential homes, massive project complexes, modest mom and pop shops, and waterfront industrial sites. It is a diverse melting pot of ethnic communities, including Dutch, German, Italian, Jewish, Greek, Maltese, Arab, and South American.

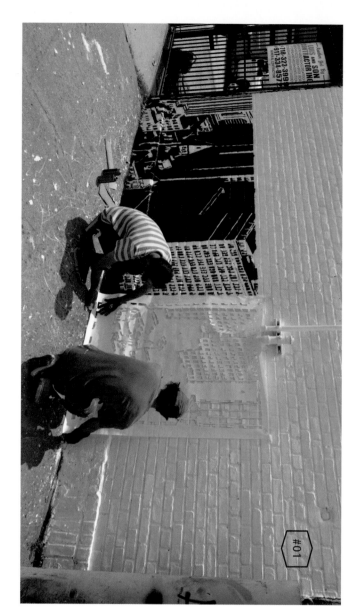

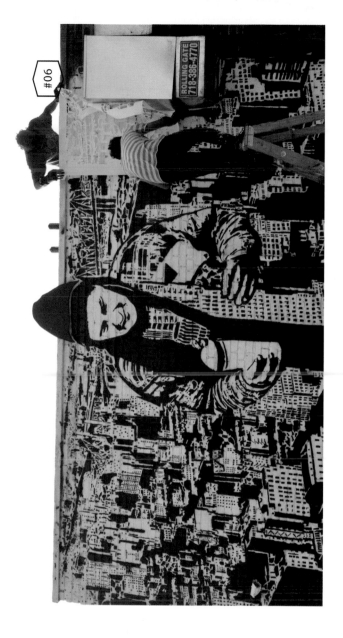

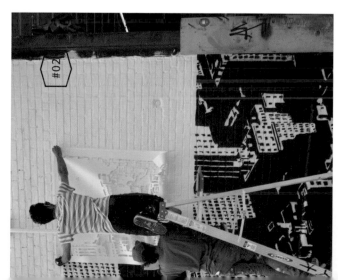

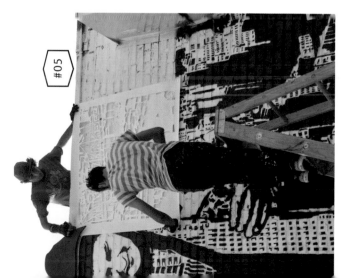

Icy

"My brother and I have been working closely together for eight years, which makes it hard to talk about a division of labor; we both do everything. Sometimes I come up with an idea and when I tell it to him he's not surprised because he just thought of the same idea. It's amazing like that. Our thoughts and ideas are one. It's a very powerful and positive experience. We inspire and challenge one another, and this leads to us constantly pushing our creative limits and increasing our productivity.

"Of course, sometimes we have different visions for a piece, but in that case we just discuss them until we reach a unified concept that is always stronger than our original ideas. The work on a wall is also very cooperative. We work faster together and always look out for each other."

"It's hard for me to imagine working alone. Honestly, I don't even see my brother and I as 'collaborating.' Being a duo is easier on many levels. The process is just different. We benefit from each other's different points of view and our initial concepts are always improved throughout the process. Plus technically we constantly help one another and working together relieves some pressures that come with creating. Throughout the years we've perfected the process of collaborating; we're totally open to critique from the other and this is extremely important. We mix and fuse our abilities to serve our artistic goals. I'll give you an example. One time we were just chilling at home. I was in the living room of our apartment and my brother was in the bedroom. I got this great idea and I quickly went over to the bedroom to share it with him. When I told him he couldn't believe it; he literally just had the exact same idea."

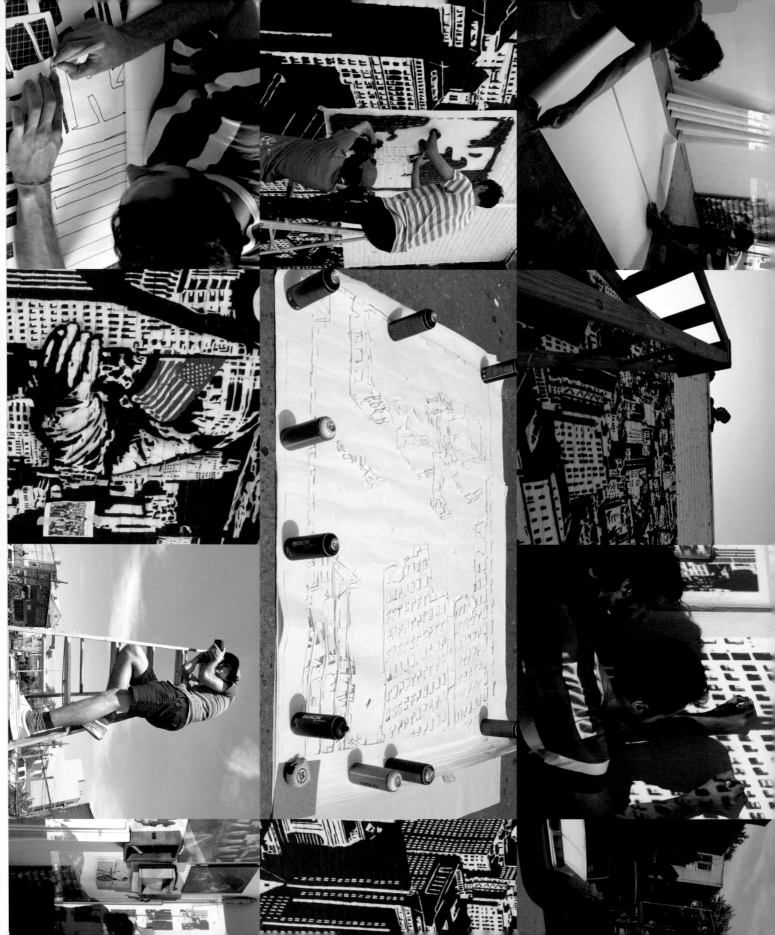

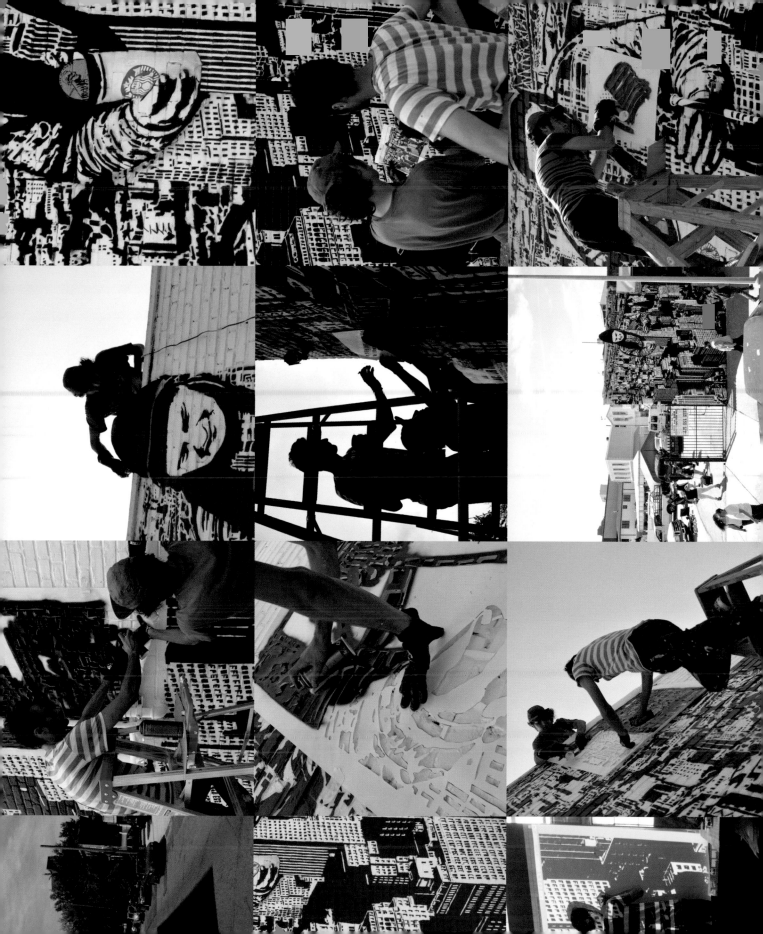

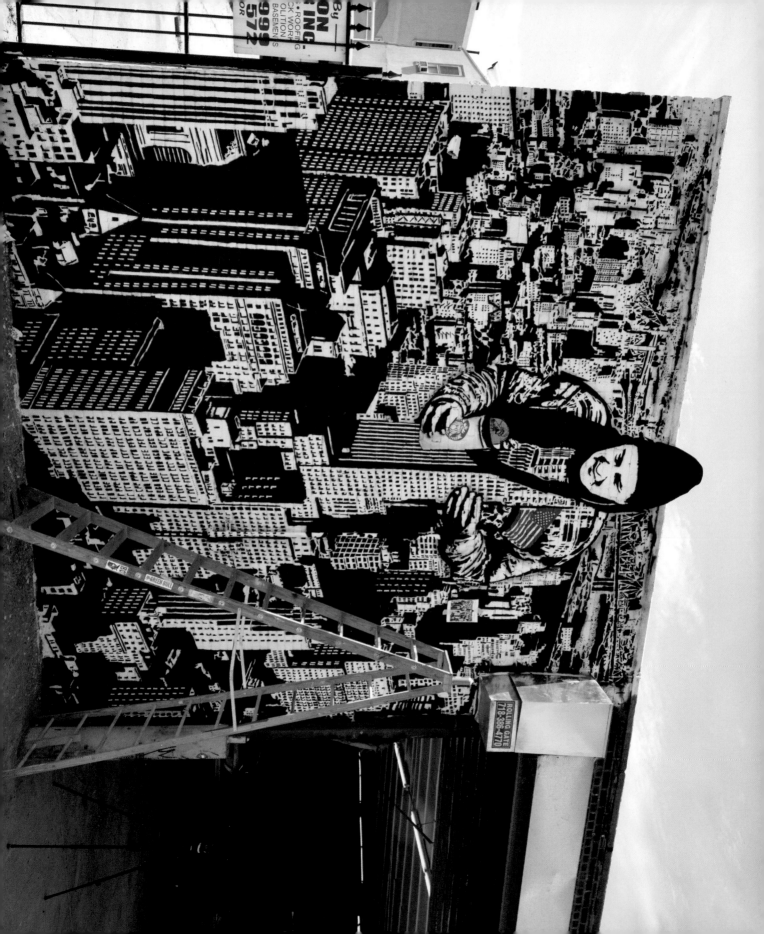

COLLABORATION
#04

#WELLINGCOURT

Artists
ICY
SOT

COLLABORATION
#05

UPON
ZIN

LOCATION

ALLERTON
BRONX

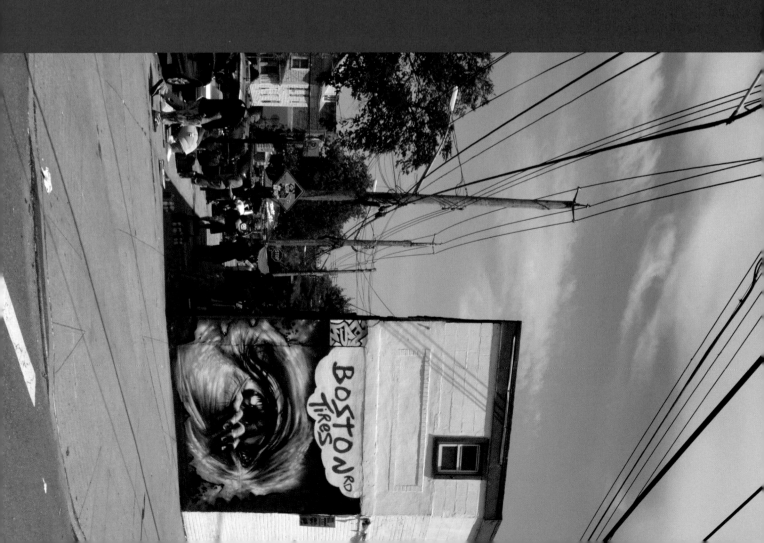

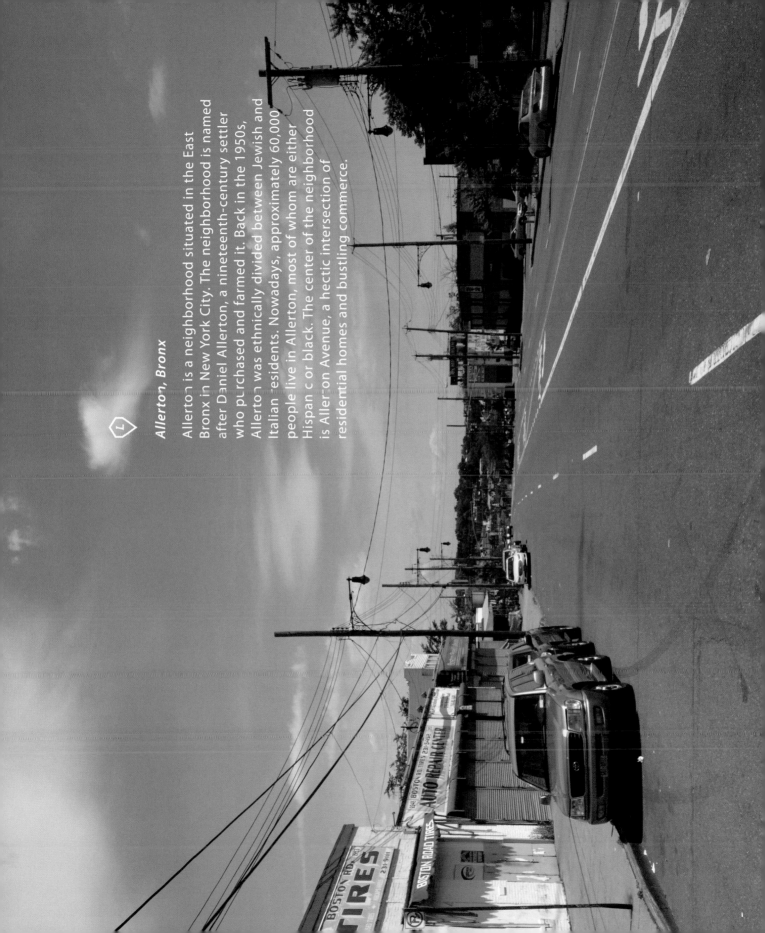

Allerton, Bronx

Allerton is a neighborhood situated in the East Bronx in New York City. The neighborhood is named after Daniel Allerton, a nineteenth-century settler who purchased and farmed it. Back in the 1950s, Allerton was ethnically divided between Jewish and Italian residents. Nowadays, approximately 60,000 people live in Allerton, most of whom are either Hispanic or black. The center of the neighborhood is Allerton Avenue, a hectic intersection of residential homes and bustling commerce.

Early Life and Work

ZIMAD

"I was born and raised in the South Bronx. My earliest memory of art was when I was six or seven years old. My mom would take my brother, my sister, and I to Canarsie, Brooklyn, by train from the South Bronx. I used to draw the characters I saw in the *Sunday Daily News* such as Beetle Bailey, Dick Tracy, and so on. Back then I didn't know anything about graffiti. When I was fourteen, I remember there were a couple of kids in the neighborhood who were tagging buildings and handball courts as well as doing large bubble-style lettering. That was my introduction to graffiti. These kids taught me how to draw bubble letters and how to make my own mop tip markers with Ban roll-on bottles and school erasers.

"That same year I got put down with 'Bronx Artist,' a crew started in 1977 by Dunk & Draze. I started by writing my real name, 'LUIS,' not really knowing any better. That didn't last long, though, as one of my friends at the time told me I needed a real tag – ZIMMATIC. After four days of writing it I felt like it needed to be shorter and that's when it became ZIMAD.

"Back in the South Bronx in the 1970s, there were tons of burnt down buildings, dealers selling loose joints for a dollar on the corner of the block, cars on cinder blocks with no tires, and the local bodega was the weed spot. Our playgrounds were the abandoned buildings. For fun we used to jump through hollowed-out windows onto mattresses. These were scary but also fun times. Hip-hop was born on the streets of the Bronx.

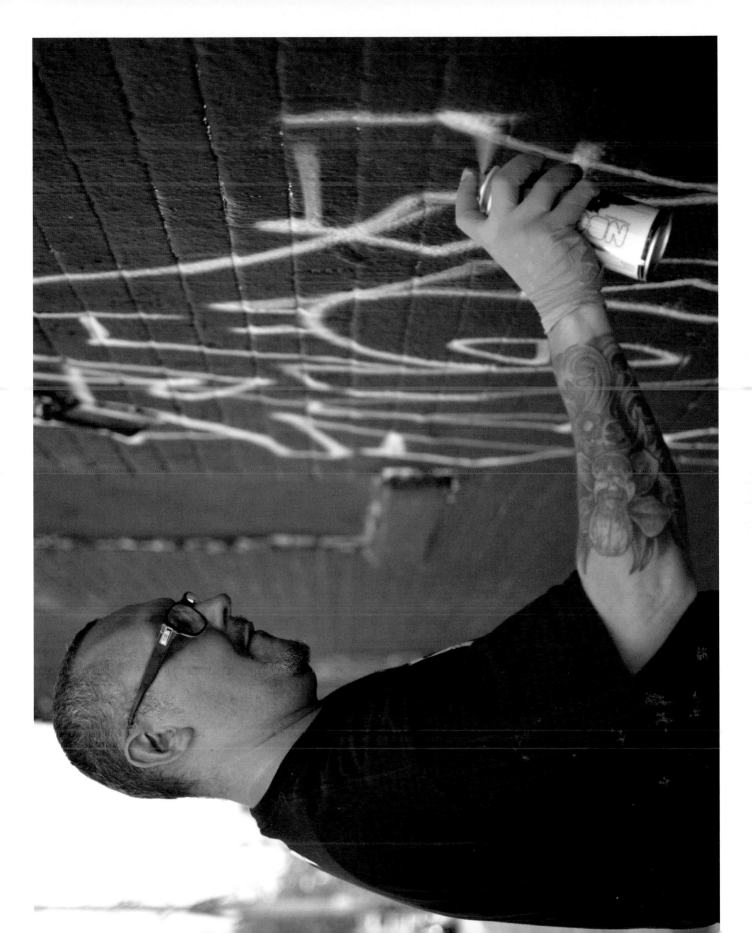

"WE DID WHAT WE DID FOR OURSELVES. WE DIDN'T CARE ABOUT THE OPINIONS OF THE GENERAL PUBLIC OR WHAT POLITICIANS AND HIGHER AUTHORITIES THOUGHT - WE DID IT FOR FAME."

...

"I remember DJ battles in the park after dark - powered by a mile of extension cords plugged into street lamp poles - blasting while breakdancers were spinning on cardboard boxes taken from the bodega. This was the best time to hear rap music, using mixed cassettes in oversized boom boxes that took twelve batteries to power - it was all from the streets! This was my childhood.

"During the early part of my career I was a writer; I loved the feeling of getting up. My inspiration came from what I saw on the walls and trains of New York City, writers like Dondi, Seen, Duster, Crash, Daze, Lee, Futura 2000, and Lady Pink to name a few. Their style and artistic abilities pushed me to work hard and improve.

"For a while the only people who knew I wrote graffiti were other graffiti writers. We did what we did for ourselves. We didn't care about the opinions of the general public, or what politicians and higher authorities thought - we did it for fame."

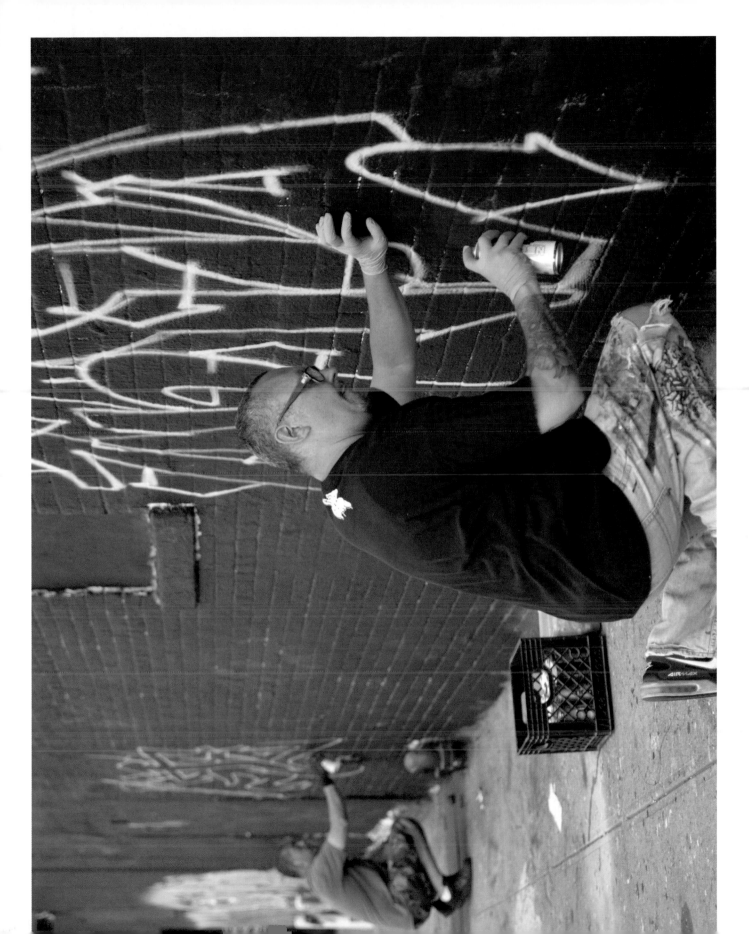

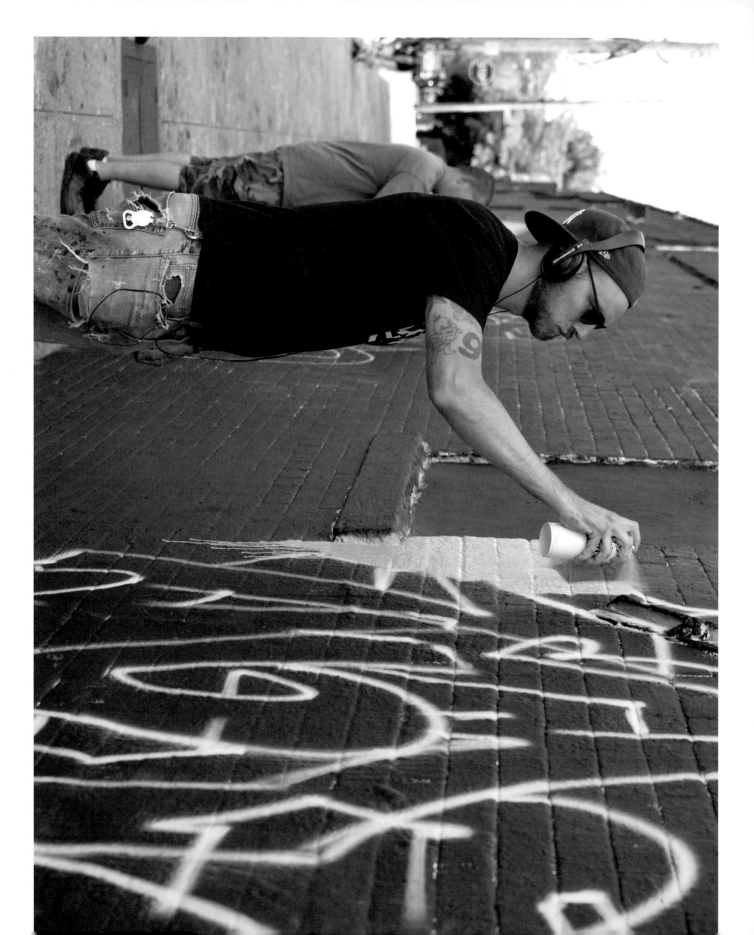

#02

JPO

Early Life and Work

"**I was born** in Bridgeport, Connecticut, and lived there until high school. I feel growing up in Bridgeport in the 1980s was a very pure time. Back then hip hop and graffiti culture in Bridgeport were one. It was everywhere. Then we moved to Ansonia, where I went to technical school. Ever since grade school I was drawing. In sixth grade a couple of my friends were doing tags in their notebooks and I started to get into that. The tag I wrote was 'SNAP.' We got into a little bit of trouble – running from the cops a few times – but nothing major. I really liked White Zombie and would draw ghoulish looking characters. I've always been into music and album covers inspired me. I come from a family of musicians; my dad's a drummer and my sister was really into punk rock. My sister introduced me to Andy Warhol and *Juxtapoz* magazine.

"When I was a kid my dad would take me to New York City: St. Mark's Place, Greenwich Village, and the Lower East Side back in the early '90s. I fell in love with it. My dad would hang at CBGB's with pop icons and tell me wild stories. My dream for many years was to work and live in NYC.

"As far as my career, the dam broke in 2013, and I let a reservoir of influence expose me to a wealth of cool things. I fractured my foot and was out of work for three weeks, so I picked up some paints, canvas, and brushes my dad had lying around in the basement and I went to town on eight pieces. Everyone around me has always been very supportive of my art. They have always said my art is like nothing they have ever seen before, but reminds

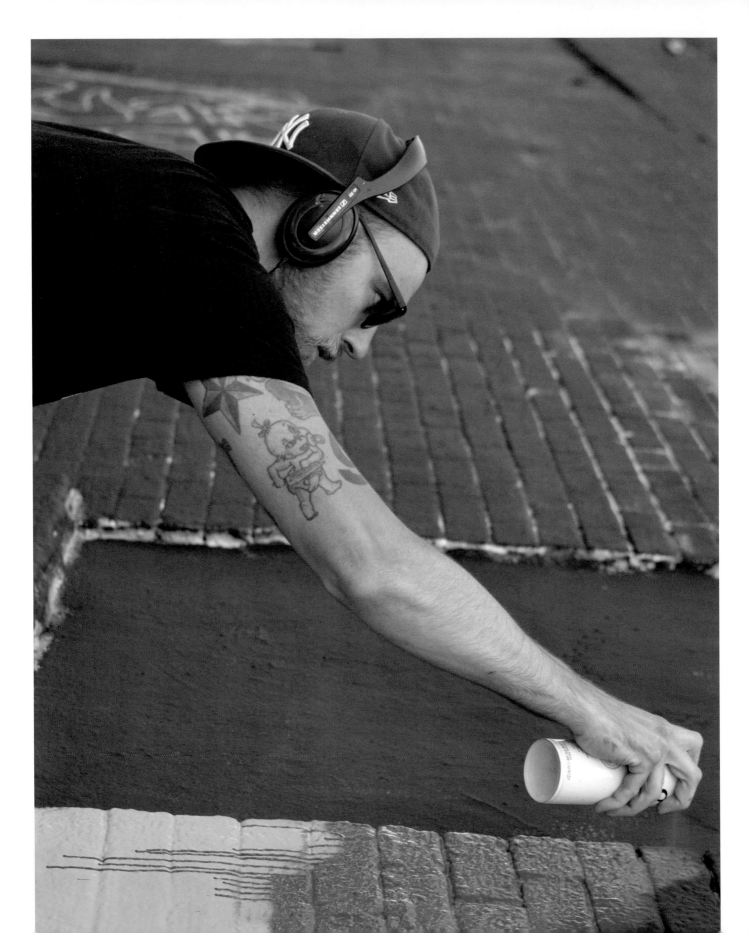

... them of certain things. I feel my work allows people to connect to it.

"I let my art speak for itself and usually steer clear of politics. I disagree with some stuff that goes on in America and sometimes I try to touch on that, but honestly, I try to separate myself from all the bad news – it just makes me anxious. My art is my own reality and I like to keep it that way."

"THE DAM BROKE IN 2013, AND I LET A RESERVOIR OF INFLUENCE EXPOSE ME TO A WEALTH OF COOL THINGS. I BROKE MY FOOT AND WAS OUT OF WORK FOR THREE WEEKS, SO I PICKED UP SOME PAINTS, CANVAS, AND BRUSHES MY DAD HAD LYING AROUND IN THE BASEMENT AND I WENT TO TOWN ON EIGHT PIECES."

Early Life and Work

Creative Process

ZIMAD

"I begin with an idea, which I draw out so as not to forget it when another idea pops into my head. I let concepts and ideas come to me naturally and then build on them.

"Many times I start a piece on a canvas or a wall with nothing in mind and as I start to paint ideas come to me, as if the wall or canvas is telling me what it wants to be. I feel the color pallet I pick also guides me in this process. When an idea comes to me while I'm painting I look on my phone for a reference to guide me in its production."

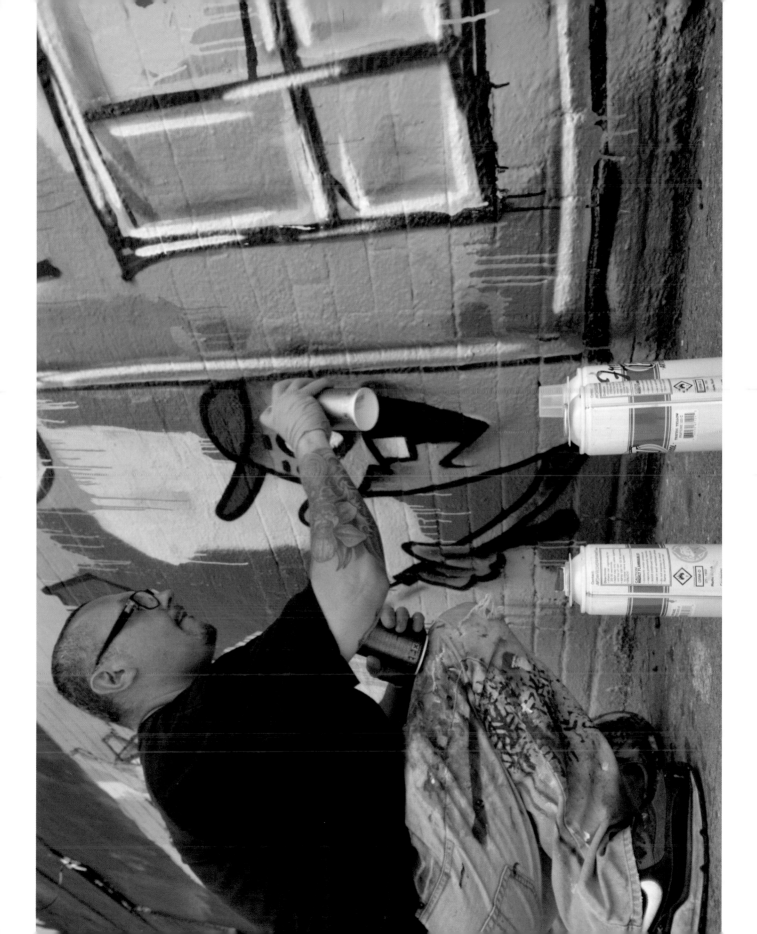

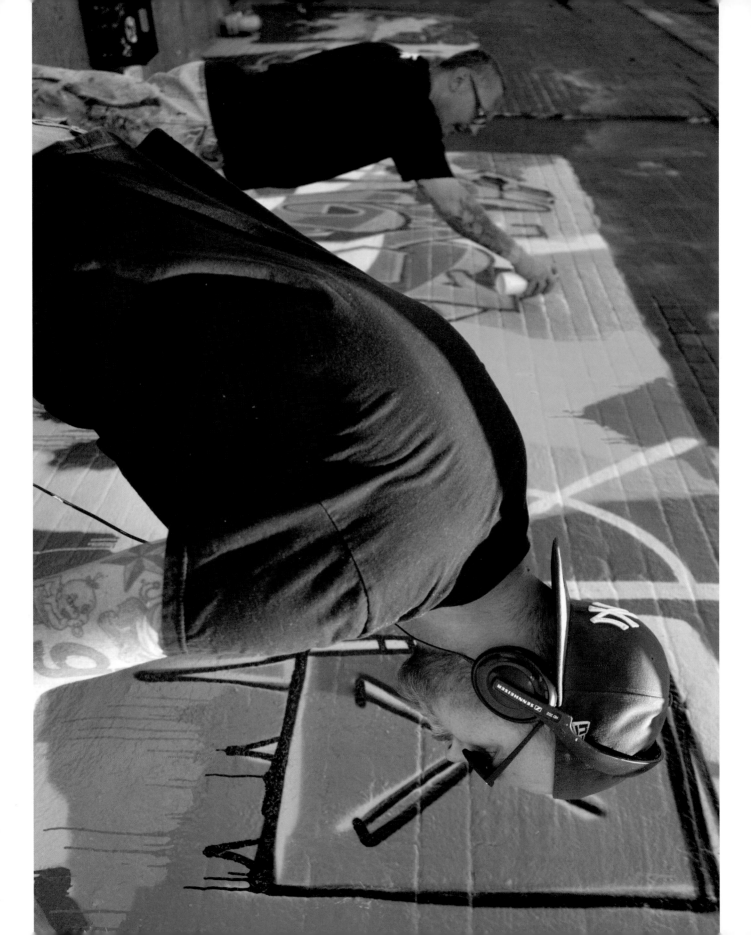

#02

JPO

Creative Process

"I don't pre-think a wall; for me, that just takes the fun away. I like to let things inspire me as it goes - I feel like my pieces paint themselves. I go into a subconscious place in my brain and just let it take over. I do not have formal art training; I just let other artists and their work inspire me. I'm always learning from the people I work with. My process is all about layering. If I preplan a wall it creates too much stress for perfection. I think mistakes are perfection because that's the way life is. I feel best when making art is natural and very easy to do."

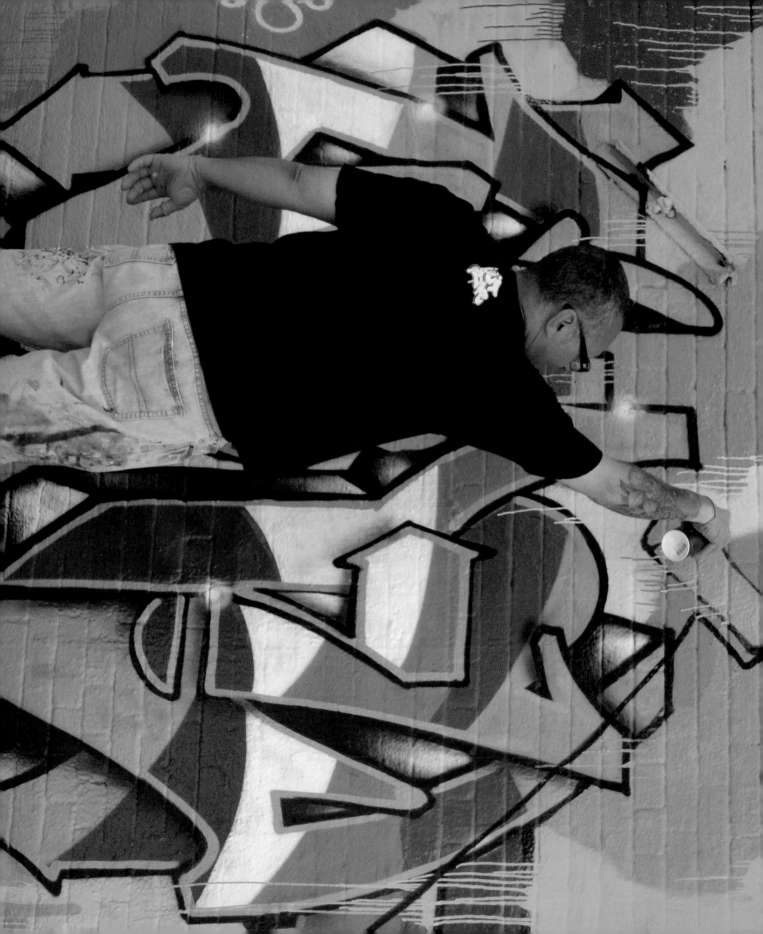

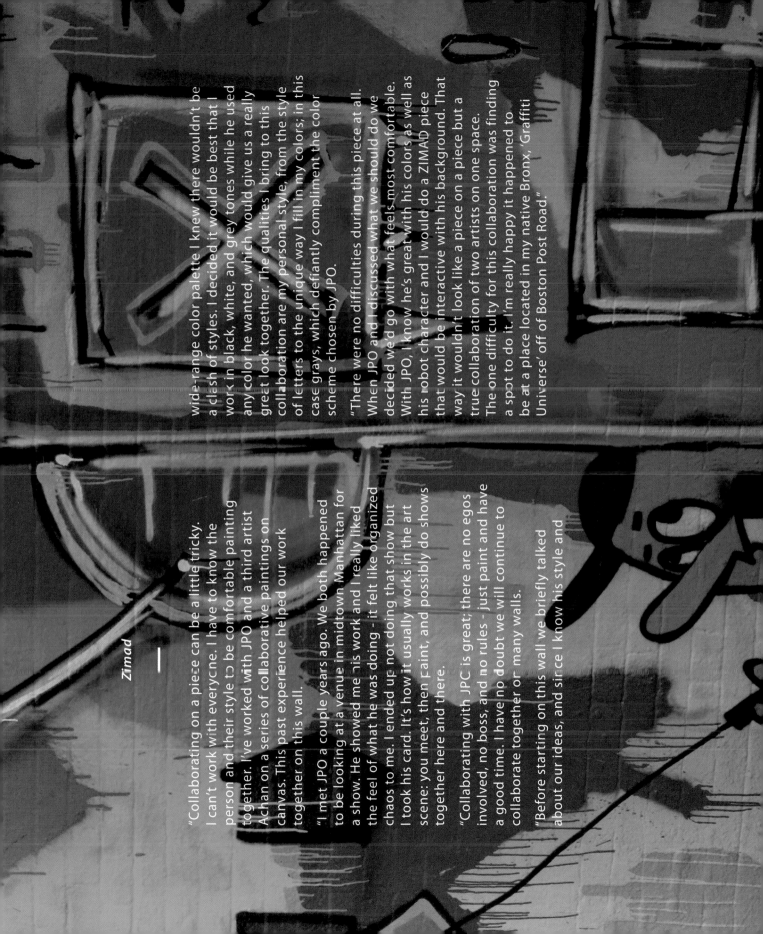

Zimad
—

"Collaborating on a piece can be a little tricky. I can't work with everyone. I have to know the person and their style to be comfortable painting together. I've worked with JPO and a third artist Achan on a series of collaborative paintings on canvas. This past experience helped our work together on this wall.

"I met JPO a couple years ago. We both happened to be looking at a venue in midtown Manhattan for a show. He showed me his work and I really liked the feel of what he was doing – it felt like organized chaos to me. I ended up not doing that show but I took his card. It's how it usually works in the art scene: you meet, then paint, and possibly do shows together here and there.

"Collaborating with JPC is great; there are no egos involved, no boss, and no rules – just paint and have a good time. I have no doubt we will continue to collaborate together or many walls.

"Before starting on this wall we briefly talked about our ideas, and since I know his style and wide-range color palette I knew there wouldn't be a clash of styles. I decided it would be best that I work in black, white, and grey tones while he used any color he wanted, which would give us a really great look together. The qualities I bring to this collaboration are my personal style, from the style of letters to the unique way I fill in my colors; in this case grays, which defiantly compliment the color scheme chosen by JPO.

"There were no difficulties during this piece at all. When JPO and I discussed what we should do we decided we'd go with what feels most comfortable. With JPO, I know he's great with his colors as well as his robot character and I would do a ZIMAD piece that would be interactive with his background. That way it wouldn't look like a piece on a piece but a true collaboration of two artists on one space. The one difficulty for this collaboration was finding a spot to do it. I'm really happy it happened to be at a place located in my native Bronx, 'Graffiti Universe' off of Boston Post Road."

JPO

"The most important thing to do before collaborating is pick the right person to collab with. This can be either friends or people whose work I respect. It's simple. Collaborating starts by meeting other artists at parties over drinks and simply saying, 'Hey, I like your work, we should work together!'

"The first collaboration I did was with Jilly Ballistic. It just clicked with her. Collaborations should be easy and fun.

"I met Zimad at the planning of my first show. He liked it straight off. Back then I didn't know my asshole from my elbow as far as art, but he loved my work straight out. He was curating a summer show at 5Pointz in Queens and invited me to show at their gallery. It gave me a big break; as a result I got a show in Long Island and some press.

"Zimad has been a really big impact on my art career. His work inspires me constantly and I'm humbled that he likes my art.

"For this piece we discussed the general theme before we went in. We decided I'd do the background and he'd do a Zimad graff piece on top. But that was all. Then we just started out on the wall and discussed placement: my Weightless the Robot character, his character, and my 'Not Kansas' tag. The wall with Zimad was one of the easiest collaborations I've done. He is very seasoned and super talented at what he does and that makes it easier for me to do my art."

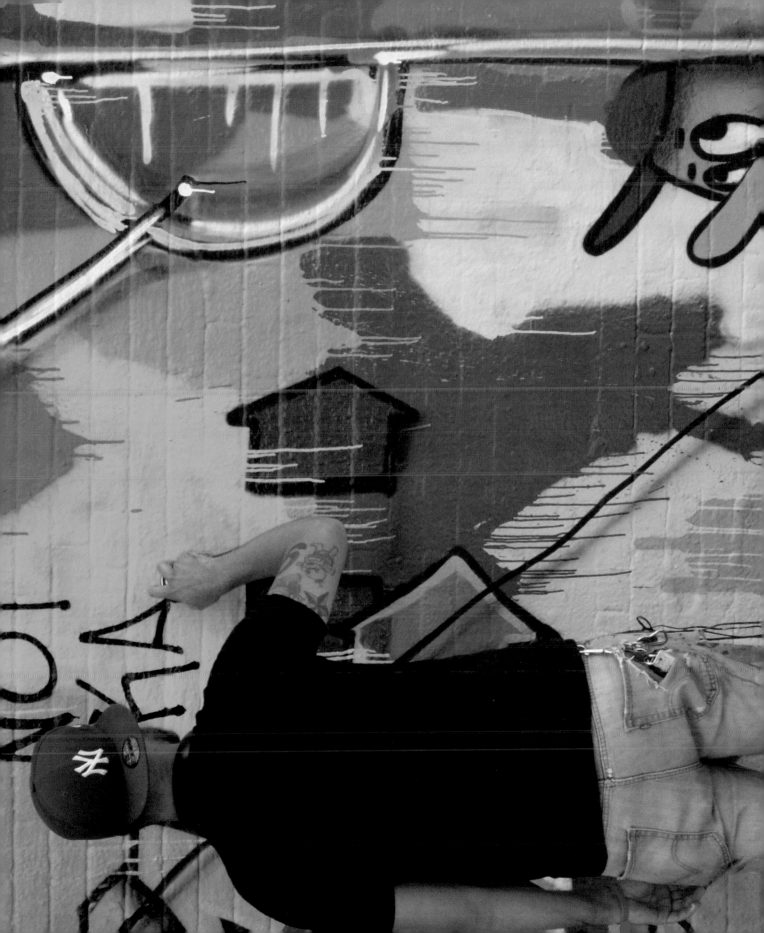

"BEFORE STARTING ON THIS WALL WE BRIEFLY TALKED ABOUT OUR IDEAS, AND SINCE I KNOW HIS STYLE AND WIDE-RANGE COLOR PALETTE I KNEW THERE WOULDN'T BE A CLASH OF STYLES."

Zimad

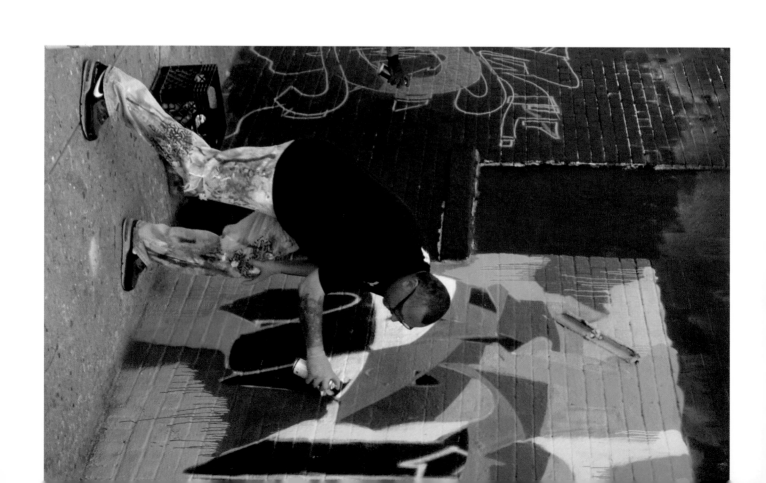

"IT'S SIMPLE. COLLABORATING STARTS BY MEETING OTHER ARTISTS AT PARTIES OVER DRINKS AND SIMPLY SAYING, 'HEY, I LIKE YOUR WORK, WE SHOULD WORK TOGETHER!'"

JPO

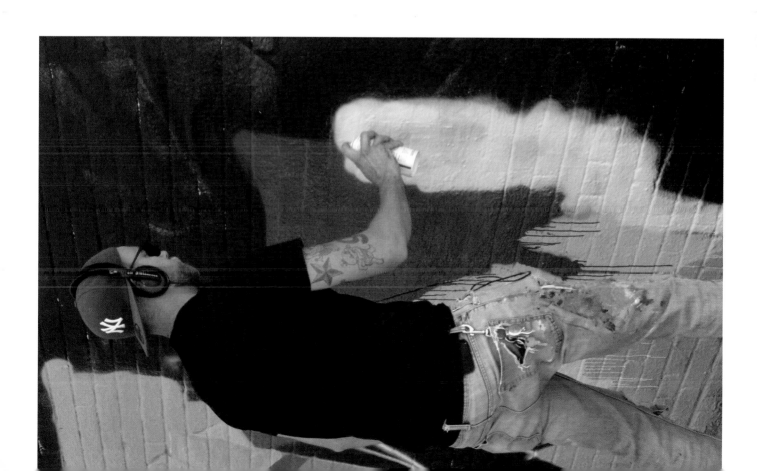

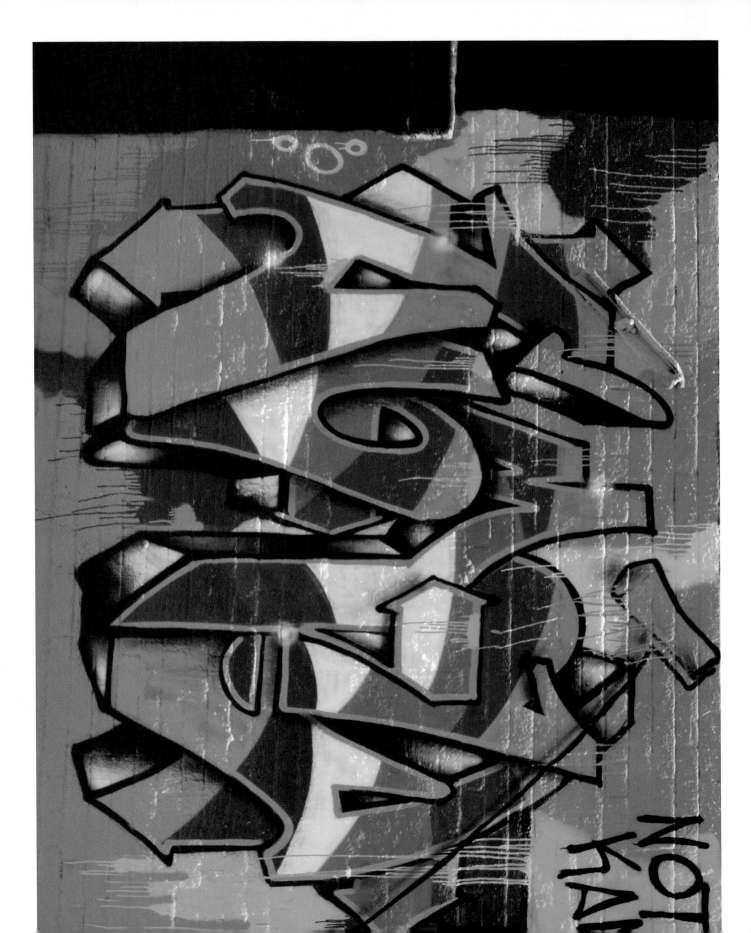

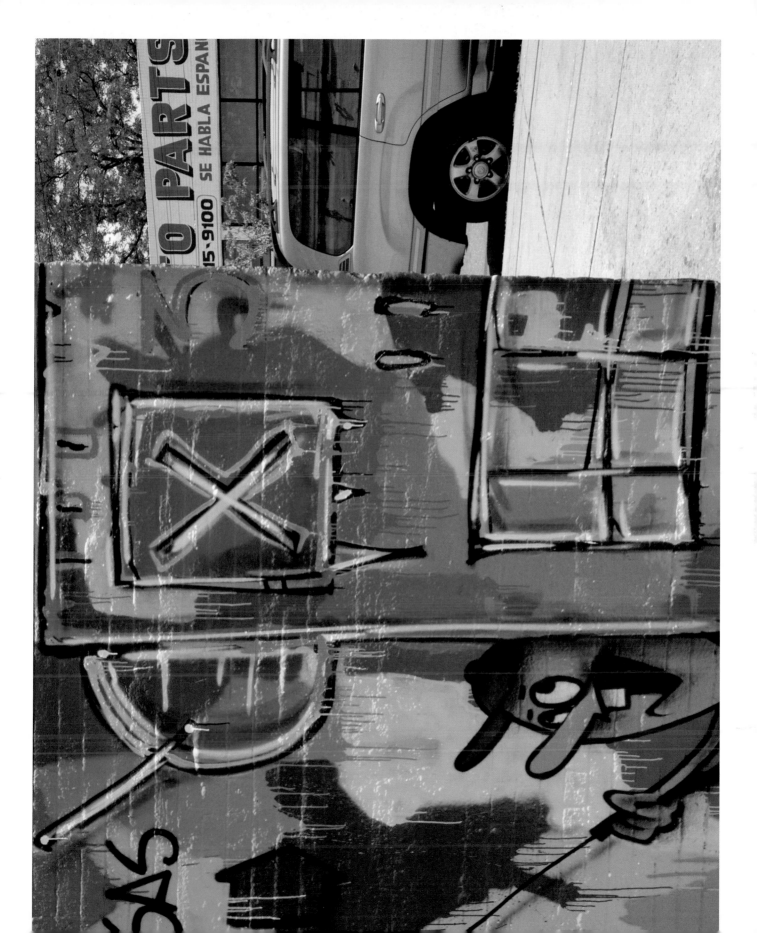

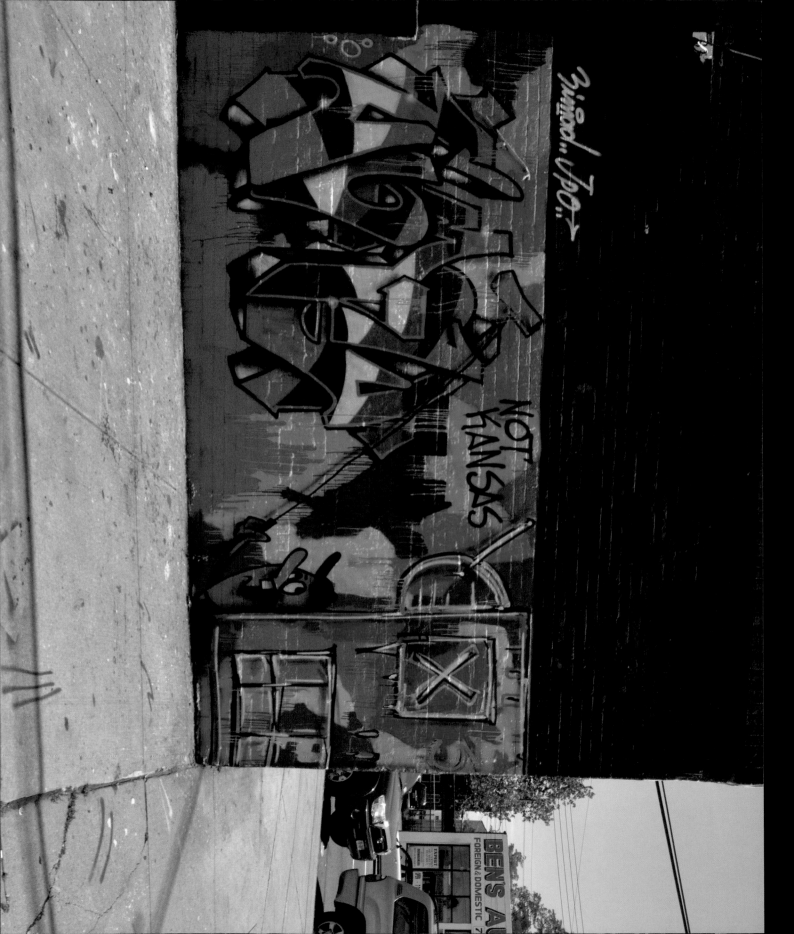

COLLABORATION
#05

#GRAFFITIUNIVERSE

Artists
ZIMAD
JPO

#PULASKIBRIDGEMURAL

DASIC FE
RUBIN

Artists
DASIC FERNANDEZ
RUBIN 415

RNANDEZ
415

PULASKI BRIDGE

LOCATION

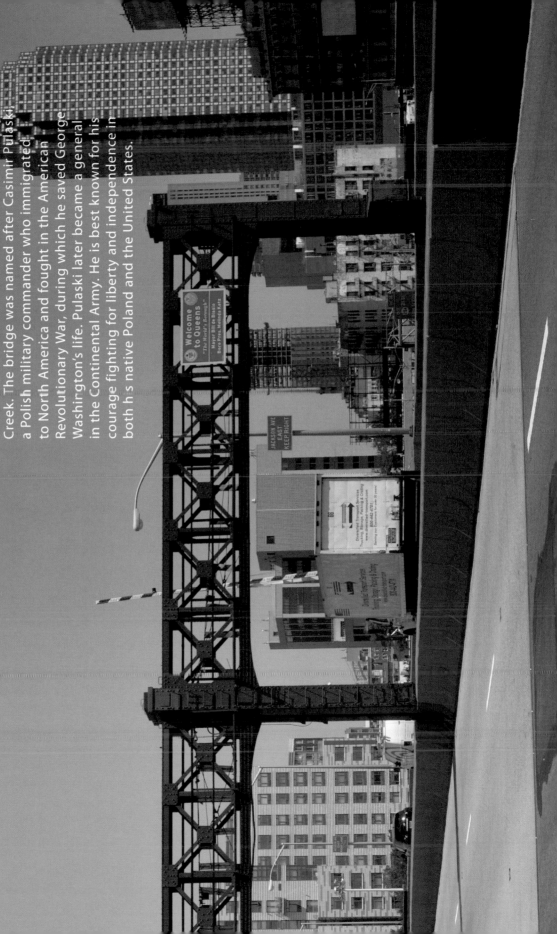

Pulaski Bridge

The Pulaski Bridge connects Greenpoint, Brooklyn, with Long Island City in Queens over Newtown Creek. The bridge was named after Casimir Pulaski, a Polish military commander who immigrated to North America and fought in the American Revolutionary War, during which he saved George Washington's life. Pulaski later became a general in the Continental Army. He is best known for his courage fighting for liberty and independence in both his native Poland and the United States.

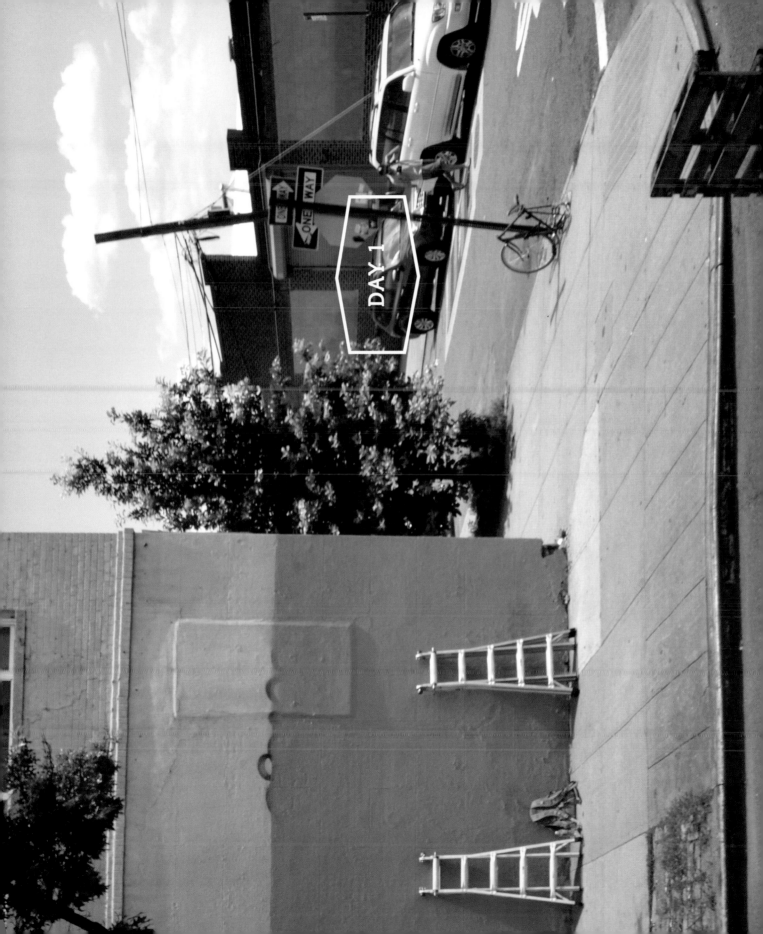

DAY 1

Early Life and Work

#01

DASIC FERNANDEZ

"I was born in Santiago, Chile, and moved at age three to Rancagua, a city a bit to the south of Santiago. Then I moved to a farm nearby where I spent most of my childhood. I was always very passionate about my hobbies and loved art since I can remember. At eleven, I got acquainted with hip-hop culture and fell in love with it. I was attracted to the purity of graffiti, where the artist can be anyone and the work belongs to everyone. I was lucky: back then there were several great graffiti writers. Graffiti is a response to what's going on around us. People like to separate art on the streets as either 'graffiti' or 'street art.' The graffiti and street art communities are totally different and there are lots of differences. But if you ask me, it's all graffiti because that's what I've always been doing with my friends back in my neighborhood.

"On weekends I used to visit my grandmother in Santiago and would see the awesome graffiti pieces there. She lived in Villa Francia, a neighborhood whose residents were notorious for their political activism and resistance to the military dictatorship in Chile. My family was always political; my grandmother was a member of the communist party and resisted Pinochet's regime. In 1986, one of the members of the resistance group that tried to assassinate Pinochet (and failed) hid in my grandmother's house for a while. Together with my newfound passion for graffiti, my family's political activism inspired me in my art.

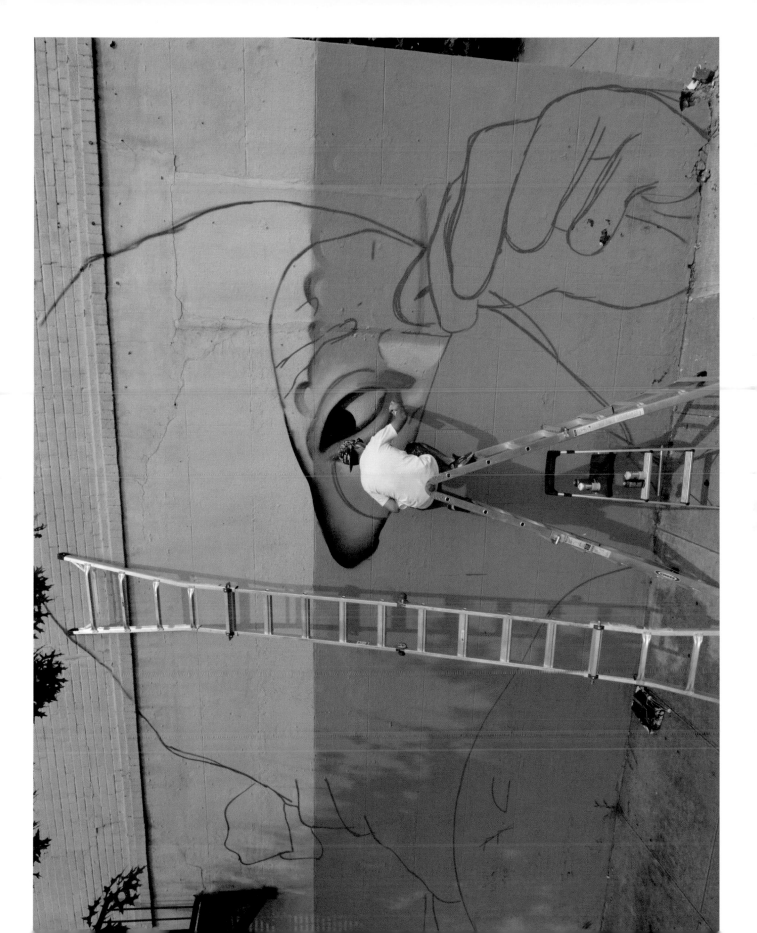

"AT ELEVEN, I GOT ACQUAINTED WITH HIP-HOP CULTURE AND AT FOURTEEN I WAS EXPOSED TO GRAFFITI IN RANCAGUA AND FELL IN LOVE WITH IT. I WAS ATTRACTED TO THE PURITY OF GRAFFITI, WHERE THE ARTIST CAN BE ANYONE AND THE WORK BELONGS TO EVERYONE."

...

"When I finished high school I moved to Santiago to study architecture. Then, at age twenty-one and after five years in the architecture program, I went on a trip to Brazil that changed my life. The time I spent traveling and painting there clarified what I knew to be my true path in life. When I returned, I quit the program in Santiago and began my full-time career as an artist. Everyone thought I was crazy, of course.

"Connecting with people through my art is the most inspiring thing for me. It's the essence of my work. I love talking to the people who come to my walls. Painting in the streets is the reason I get up in the morning. For me, style comes before message. When an artist develops an original style, then s/he can start delivering messages. A developed style has the power to captivate audiences for messages an artist wants to deliver, whether political or otherwise. If an artist is all messages without a mature, developed style, their work is just not credible."

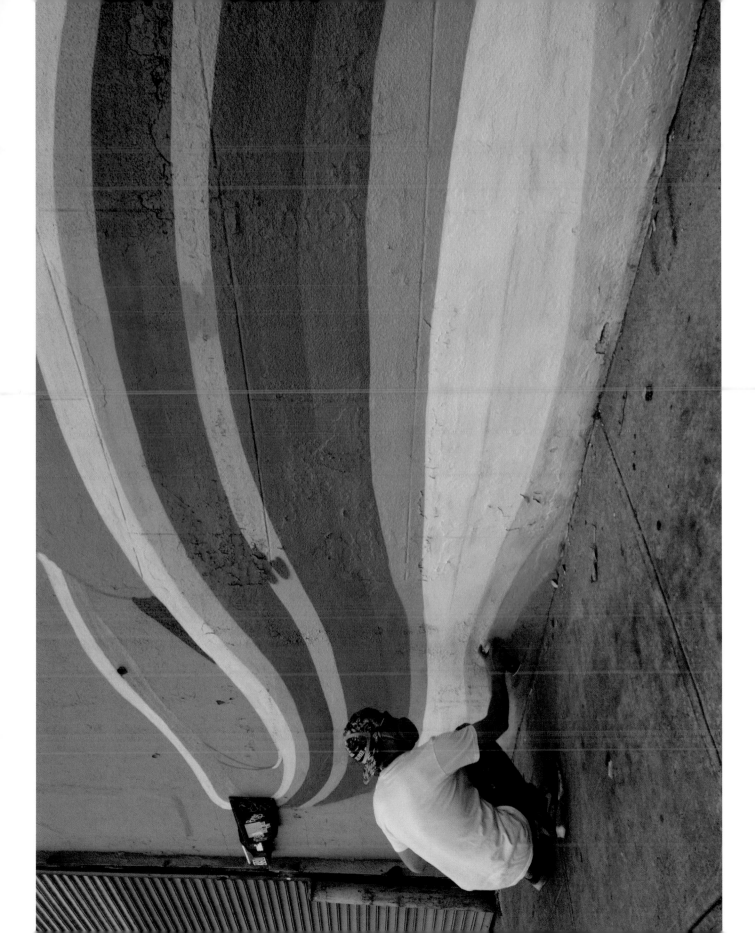

#02

RUBIN 415

"**I was born and raised** in Sweden, but I'm Finnish by heritage. I spent my childhood in a working class housing project in Gothenburg surrounded by grey concrete.

"As a kid, I remember riding the tram through the tunnels and thinking I wanted to add color to the concrete, and that's what I ended up doing! I've been drawing and painting for as long as I can remember, but when I was nine years old I saw the movie *Beat Street* and that changed my life; that's when I started tagging the streets. Growing up in a low-income housing project was not always easy, and just like for the kids in the Bronx or any other project, graffiti was a way to be seen. Unfortunately, my hometown had a strict zero tolerance policy towards graffiti. It wasn't fun spending a long night working hard on a burner, only to see it buffed the next day.

"During those years I led parallel lives. My closest childhood friends weren't into graffiti. They listened to heavy metal and drank beer and that's what I did with them. They knew I did graffiti, but they weren't very interested, nor did they care about it, which was fine by me. Then I had my graffiti friends who were spread out across the city. When I was with them it was all about graffiti. Being a young graffiti writer was tough. My mom knew of course and was supportive, but also very worried. Most people thought it was a bad thing, but several have supported me since I was a kid and that has always meant a lot."

Early Life and Work

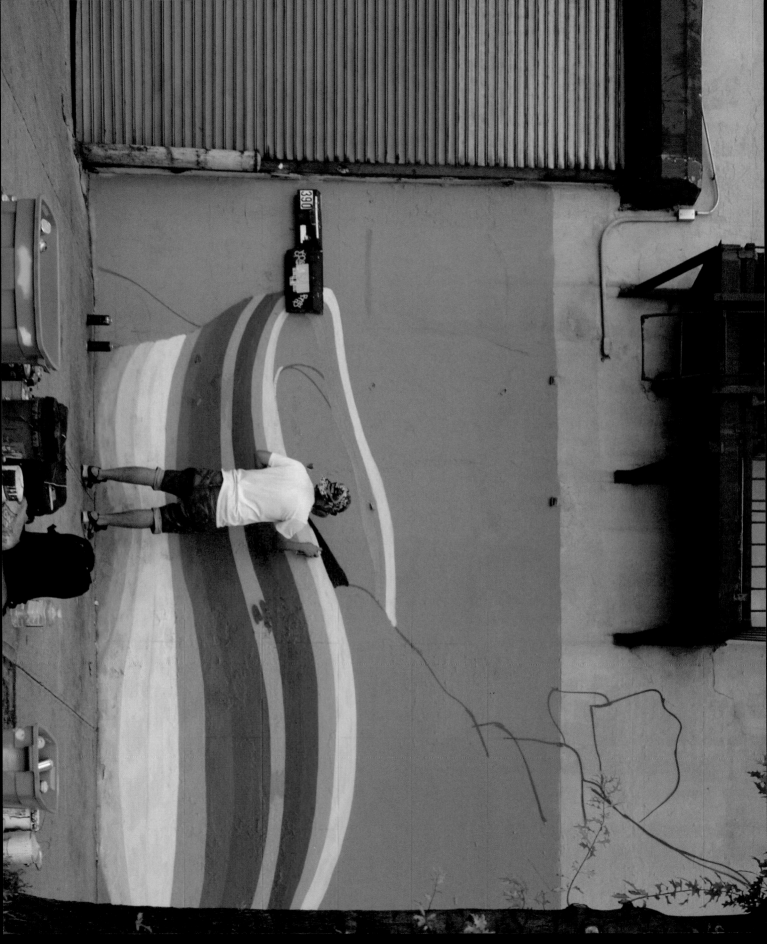

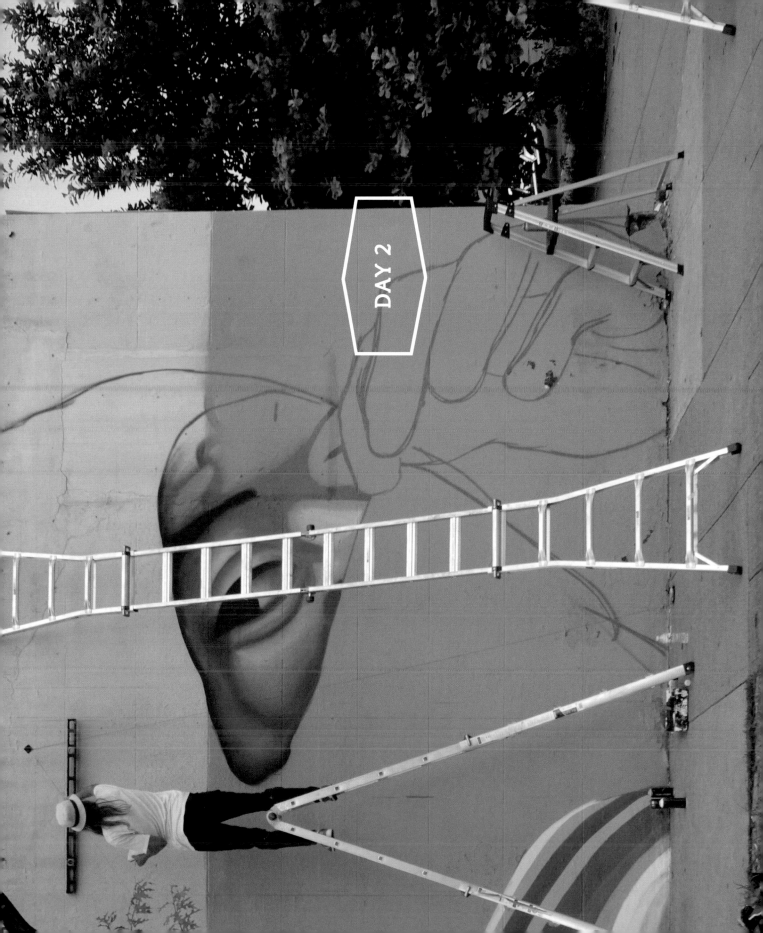

DAY 2

Creative Process

#01

DASIC
FERNANDEZ

"I like to pick a good spot that interacts with the wall and later with my art, so the first thing I do is take a step back and look around the wall. I like to paint in spots where the art can potentially dominate a space and consequently change its identity. If there's a lot of space in front of the wall, I make the work large enough so it can be appreciated from a distance.

"On the other hand, if there is not much space to appreciate the wall from afar, I make it very detailed so viewers who are close can enjoy. With regards to the actual piece, I think about an idea that would work in the context and then I sketch it out. Then I get a photo of the actual wall at the location to see how the sketch can work there.

"After that I work freestyle and usually stick to my original ideas."

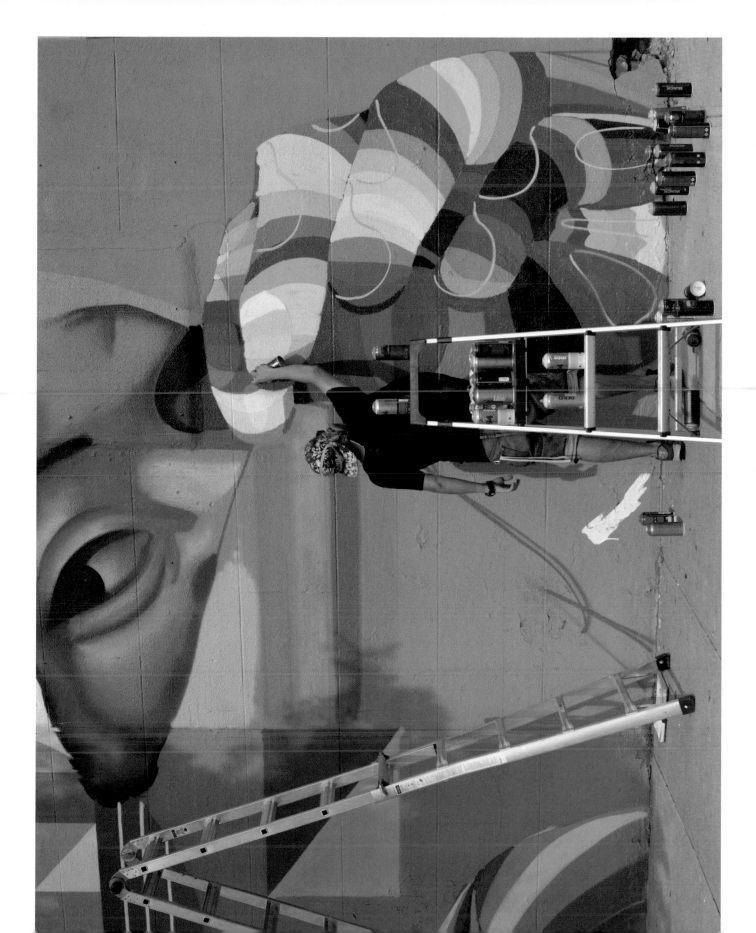

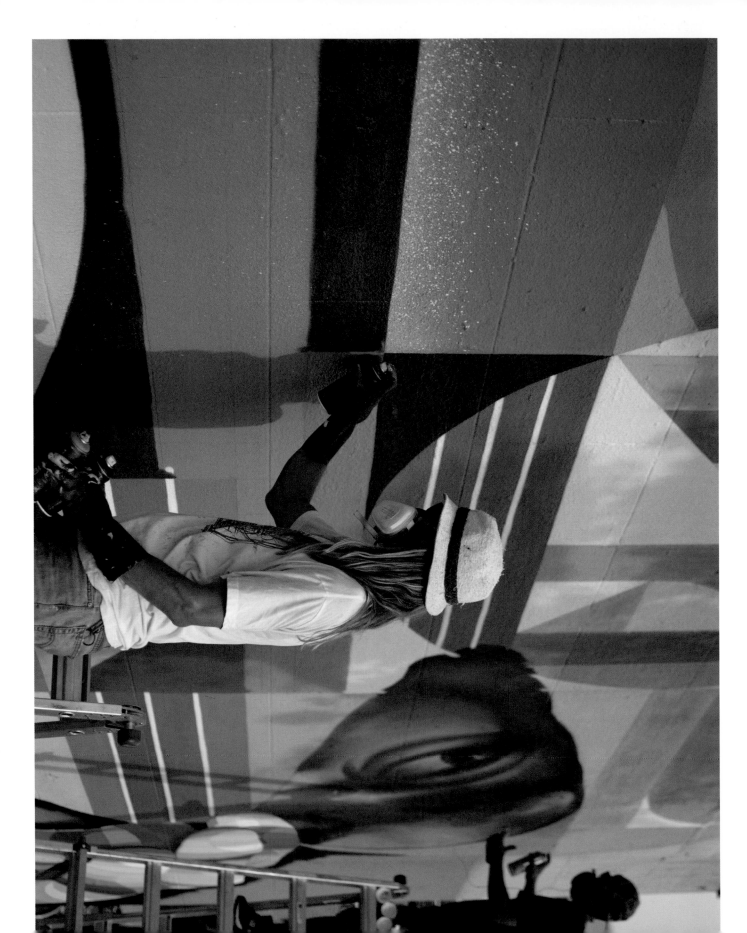

#02

**RUBIN
415**

"There's a lot of mental work and processing until I get the right idea and direction. Then I usually do a series of really quick rough sketches. I like to work fast and loose with my sketches and I try to think as little as possible. Colors usually come in late in the process and I like to improvise and map them out fast. I always paint everything freehand. I don't use tape or stencils.

"While having preset work routines is important, I also constantly challenge myself by changing my methods. For example, I sometimes start at the end or middle of a piece. Other times I do not make a sketch before beginning on a piece, rather creating a composition from bits and pieces of several sketches. Lately I've been using a chalk liner as my main composition tool on murals."

Creative Process

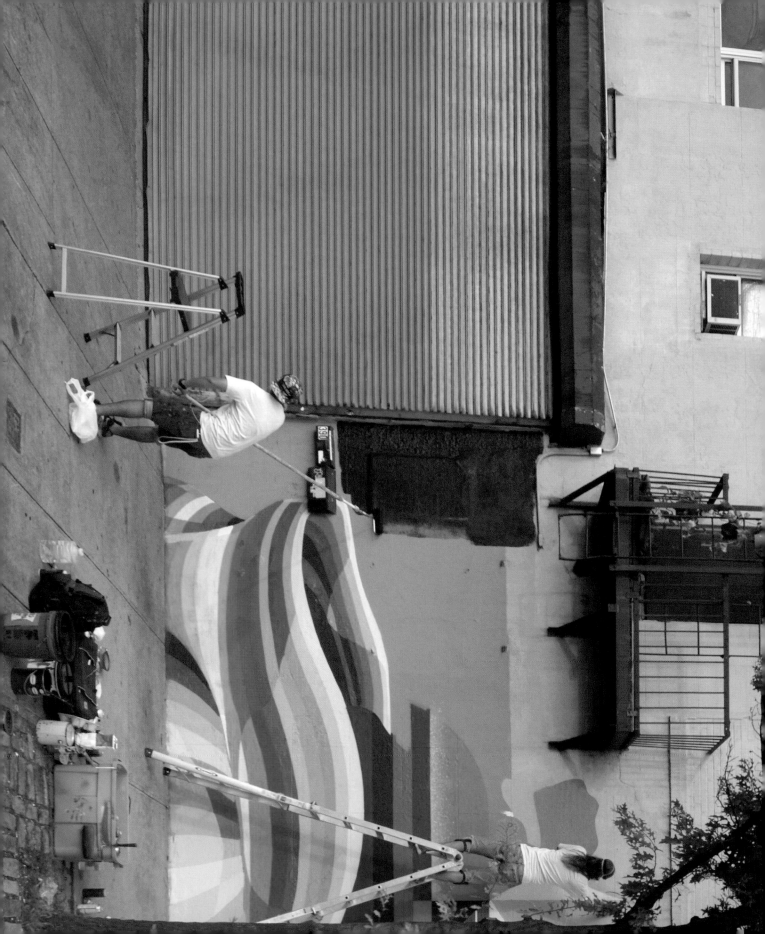

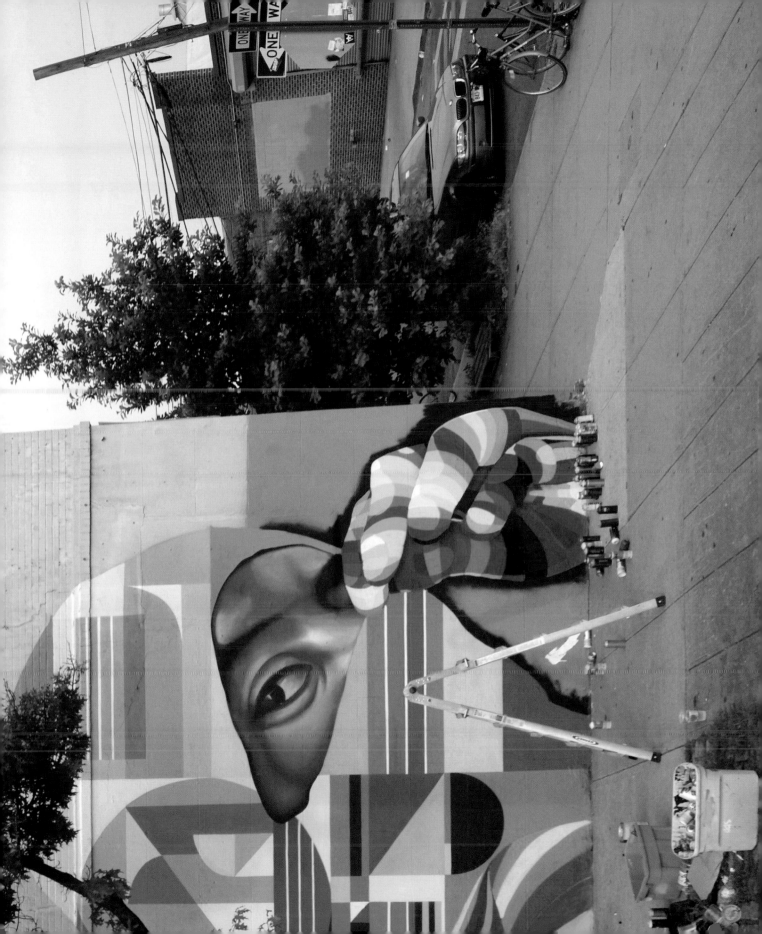

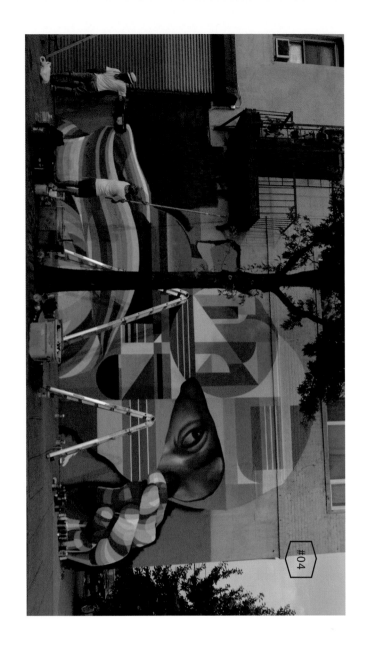

#04

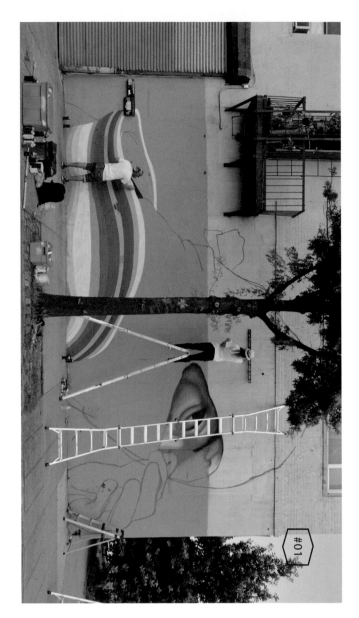

#01

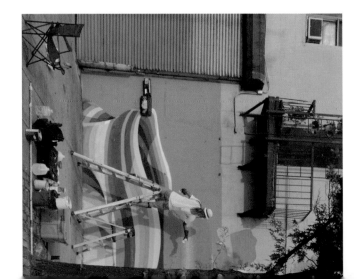

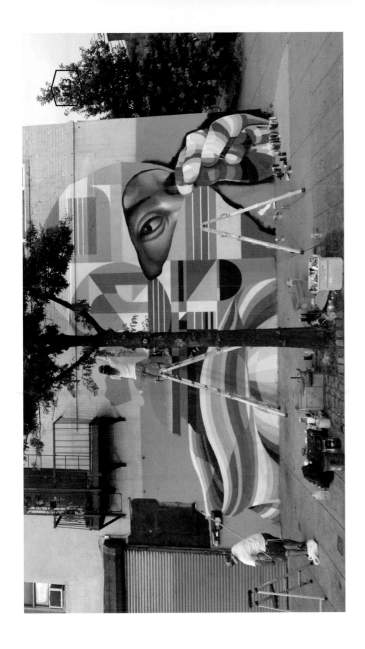

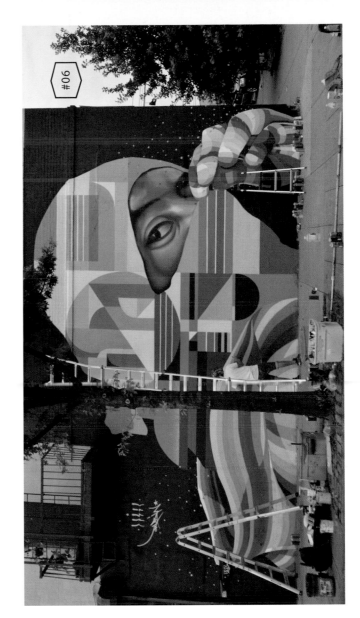

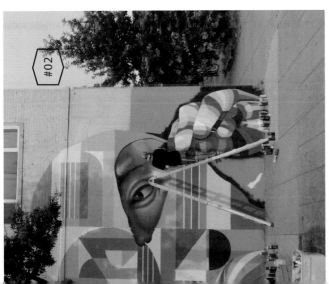

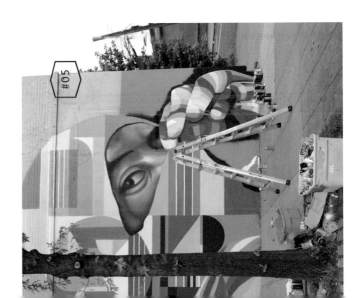

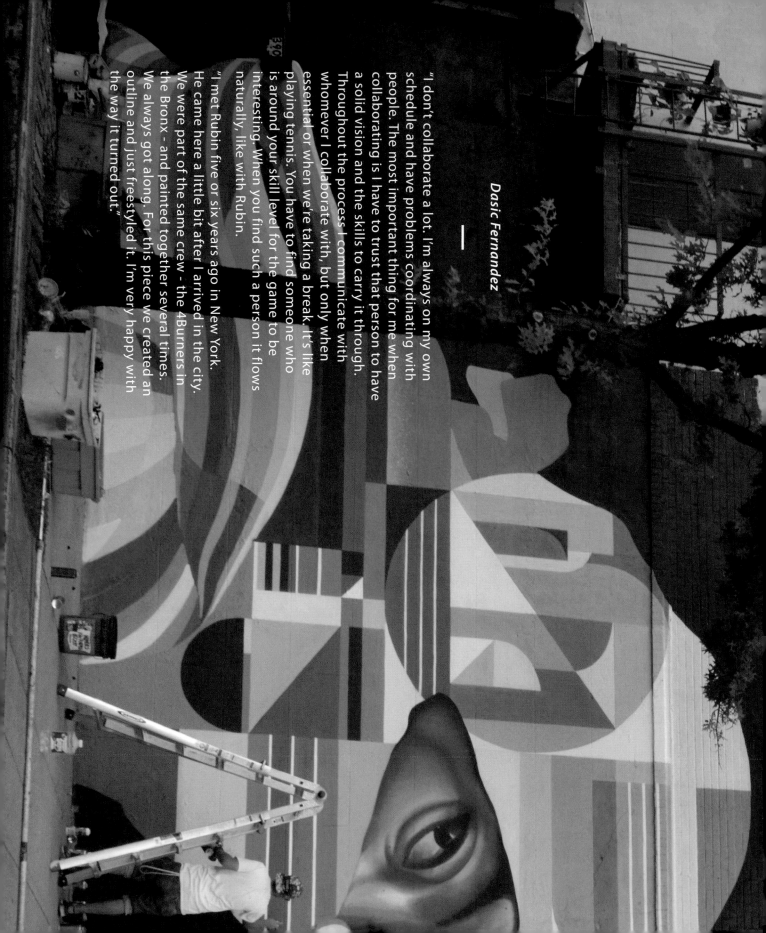

Dasic Fernandez

—

"I don't collaborate a lot. I'm always on my own schedule and have problems coordinating with people. The most important thing for me when collaborating is I have to trust that person to have a solid vision and the skills to carry it through. Throughout the process I communicate with whomever I collaborate with, but only when essential or when we're taking a break. It's like playing tennis. You have to find someone who is around your skill level for the game to be interesting. When you find such a person it flows naturally, like with Rubin.

"I met Rubin five or six years ago in New York. He came here a little bit after I arrived in the city. We were part of the same crew – the 4Burners in the Bronx – and painted together several times. We always got along. For this piece we created an outline and just freestyled it. I'm very happy with the way it turned out."

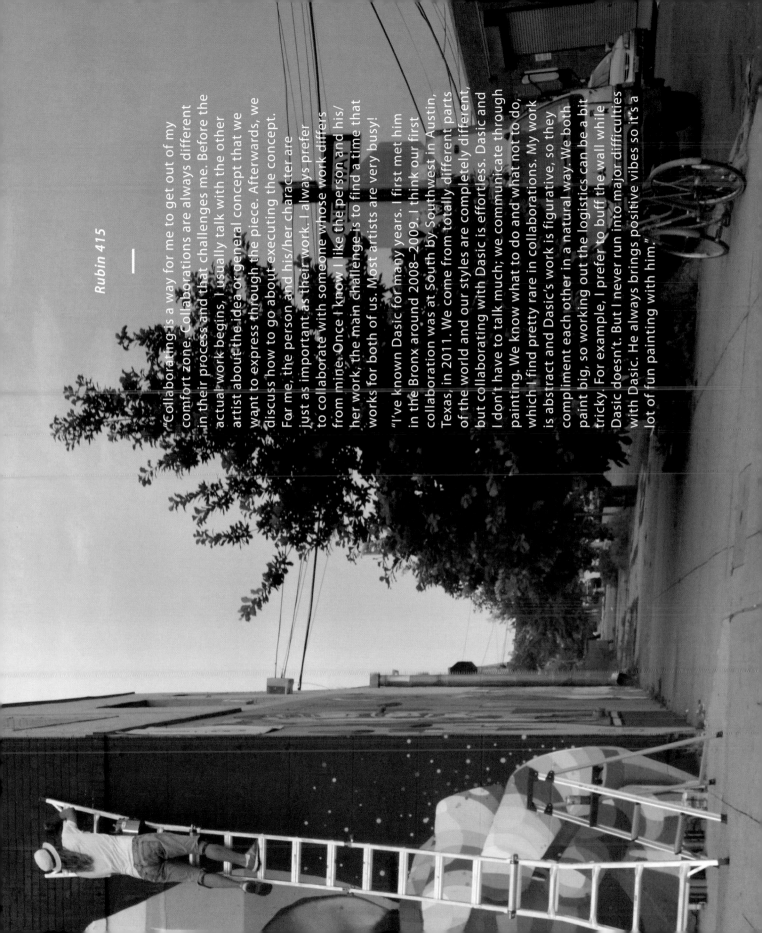

Rubin 415

"Collaborating is a way for me to get out of my comfort zone. Collaborations are always different in their process and that challenges me. Before the actual work begins, I usually talk with the other artist about the idea or general concept that we want to express through the piece. Afterwards, we discuss how to go about executing the concept. For me, the person and his/her character are just as important as their work. I always prefer to collaborate with someone whose work differs from mine. Once I know I like the person and his/her work, the main challenge is to find a time that works for both of us. Most artists are very busy!

"I've known Dasic for many years. I first met him in the Bronx around 2008–2009. I think our first collaboration was at South by Southwest in Austin, Texas, in 2011. We come from totally different parts of the world and our styles are completely different, but collaborating with Dasic is effortless. Dasic and I don't have to talk much; we communicate through painting. We know what to do and what not to do, which I find pretty rare in collaborations. My work is abstract and Dasic's work is figurative, so they compliment each other in a natural way. We both paint big, so working out the logistics can be a bit tricky. For example, I prefer to buff the wall while Dasic doesn't. But I never run into major difficulties with Dasic. He always brings positive vibes so it's a lot of fun painting with him."

"IT'S LIKE PLAYING TENNIS. YOU HAVE TO FIND SOMEONE WHO IS AROUND YOUR SKILL LEVEL FOR THE GAME TO BE INTERESTING. WHEN YOU FIND SUCH A PERSON IT FLOWS NATURALLY, LIKE WITH RUBIN."

Dasic Fernandez

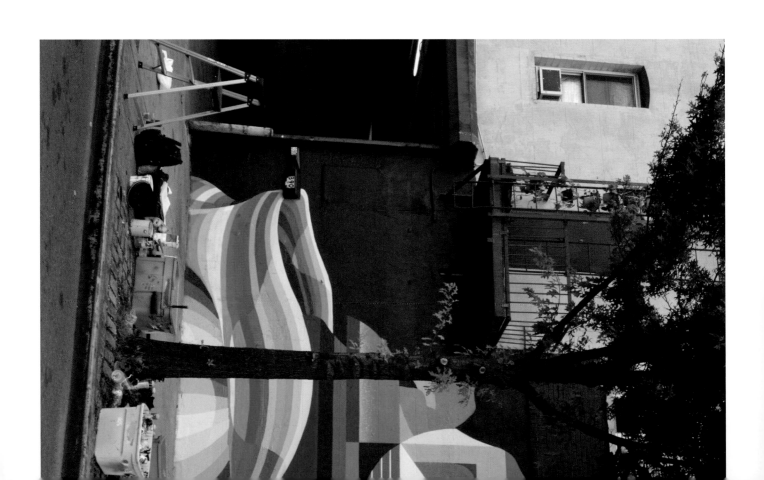

#PULASKIBRIDGEMURAL

"COLLABORATING IS A WAY FOR ME TO GET OUT OF MY COMFORT ZONE. COLLABORATIONS ARE ALWAYS DIFFERENT IN THEIR PROCESS AND THAT CHALLENGES ME."

Rubin 415

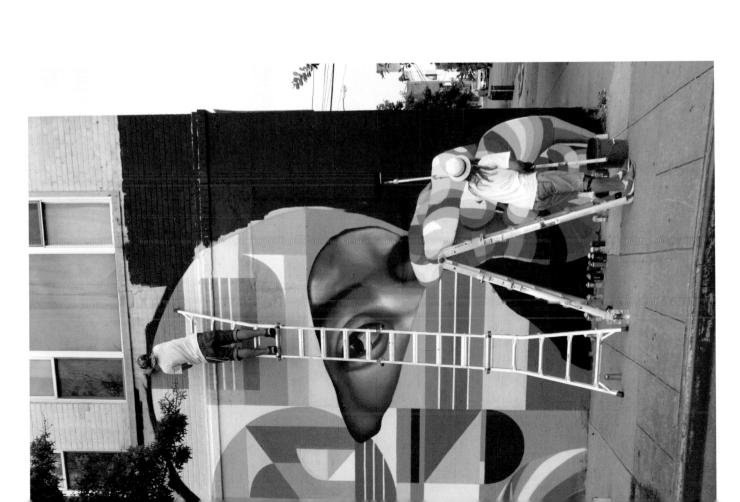

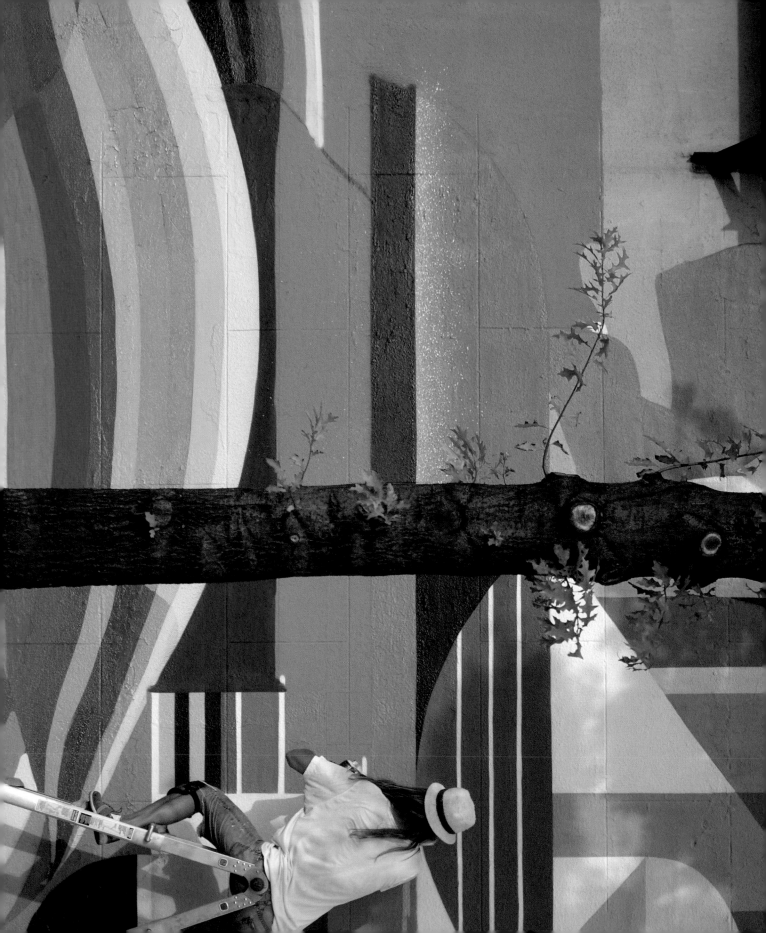

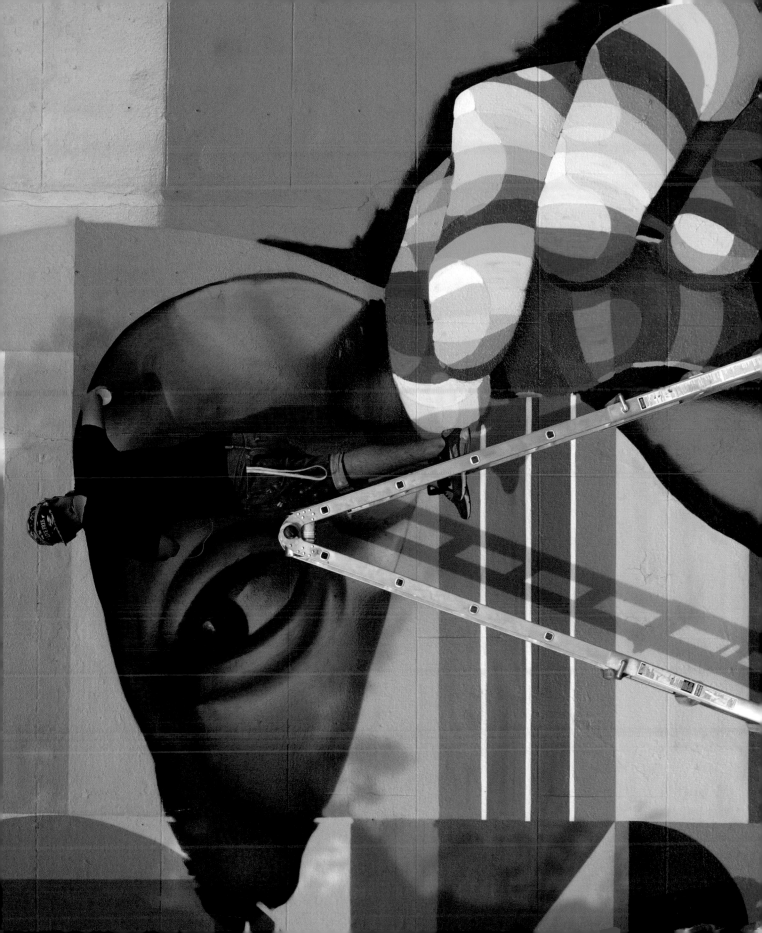

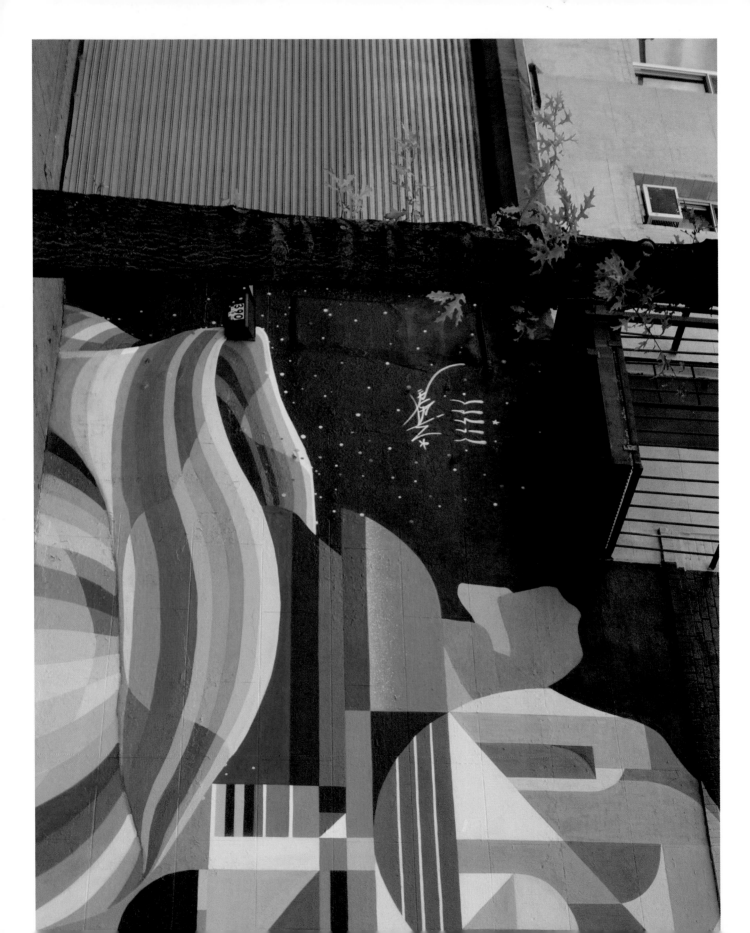

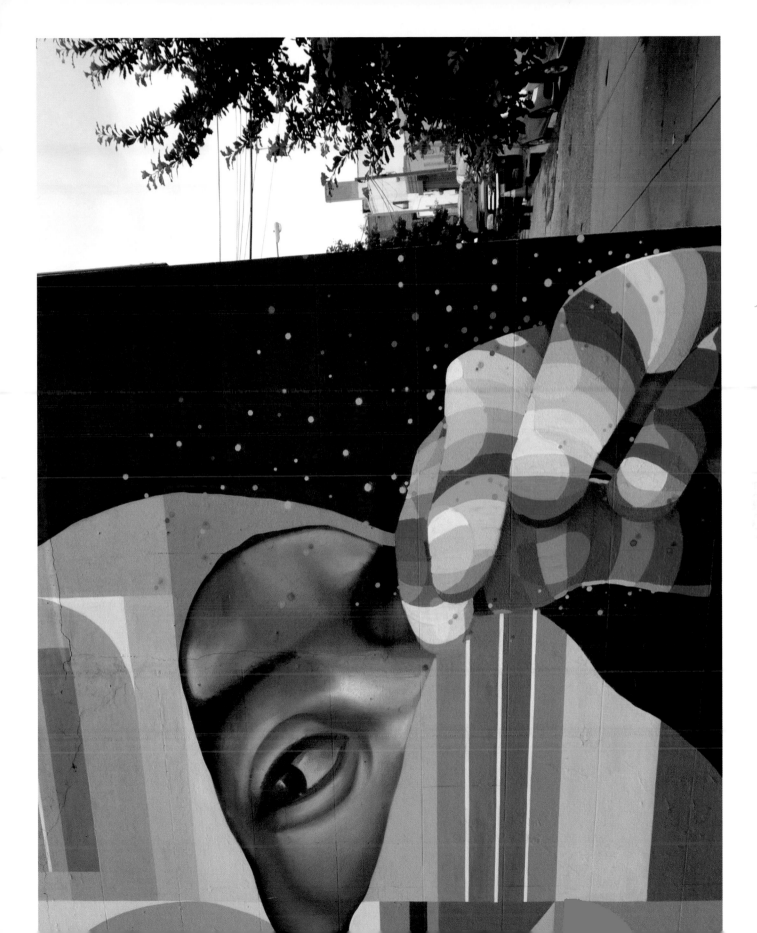

#PULASKIBRIDGEMURAL

Artists
DASIC FERNANDEZ
RUBIN 415

ALICE M

TF
M

Artists
TRAP IF
ALICE MIZRACHI

AP IF

ZRACHI

MASPETH
QUEENS

LOCATION

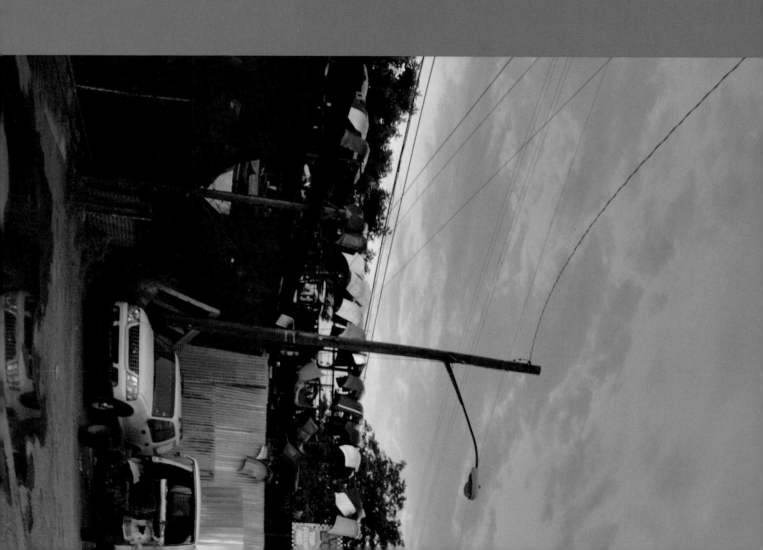

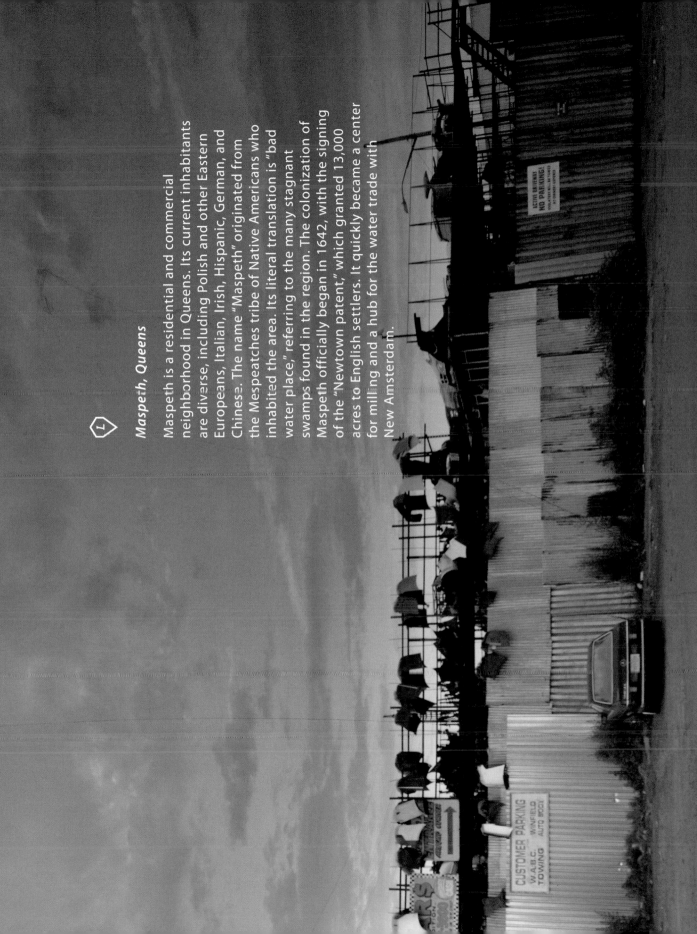

Maspeth, Queens

Maspeth is a residential and commercial neighborhood in Queens. Its current inhabitants are diverse, including Polish and other Eastern Europeans, Italian, Irish, Hispanic, German, and Chinese. The name "Maspeth" originated from the Mespeatches tribe of Native Americans who inhabited the area. Its literal translation is "bad water place," referring to the many stagnant swamps found in the region. The colonization of Maspeth officially began in 1642, with the signing of the "Newtown patent," which granted 13,000 acres to English settlers. It quickly became a center for milling and a hub for the water trade with New Amsterdam.

Early Life and Work

#01

ALICE
MIZRACHI

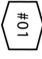

"I was born and raised in Queens by Israeli parents who immigrated from Tel Aviv in the sixties. My older brother and sister were a huge influence on me as a kid. I remember my sister taking me to the *Rocky Horror Picture Show* and my brother throwing parties and DJing at our house. My sister was into disco, soul, and the pop music of her generation, while my brother was a hip-hop head. Although New York was grimy, it was a great time to party and be creative. Those early influences are an integral part of my identity. Nowadays it is easy for me to relate to others who grew up surrounded by these subcultures.

"My household was very DIY growing up; I learned how to be creative at a young age and enjoyed it. My dad is an autobody man and watching him fix cars inspired me. My mom crochets, knits, cooks, and is crafty as well. Their skillfulness gave me the confidence and belief that I could make anything I set my mind to. In addition, my teachers recognized I was artistic and encouraged me. In high school I enrolled in art classes and my art teacher encouraged me to create a portfolio and attend art school, so I did! When I look back now I am very thankful for all the support I was given. That is part of the reason I am currently a teaching artist; I enjoy sharing my skills and experiences with others in the same way they were shared with me.

"Many people inspired me. Of course, graffiti was a big inspiration. I loved the fact it was a new badass form of expression that most adults didn't understand; a new language. And more importantly,

Early Life and Work

"ALTHOUGH NEW YORK WAS GRIMY, IT WAS A GREAT TIME TO PARTY AND BE CREATIVE. THOSE EARLY INFLUENCES ARE AN INTEGRAL PART OF MY IDENTITY. NOWADAYS IT IS EASY FOR ME TO RELATE TO OTHERS WHO GREW UP SURROUNDED BY THESE SUBCULTURES."

...

my friends were writers, so I felt like part of the culture. As a young woman in high school and college I began to study art history and discovered the works of artists like Kienholz, Bearden, movement and other artists from the German expressionist Lawrence, Wilfredo Lam, Klimt, Schiele, Kahlo, Rivera, David Alfaro Siquieros, Francisco Clemente, and so many others. One of the biggest inspirations for me happened in 1993, when I first discovered Basquiat. I could relate to his drawing style and art form as a mix of graffiti and fine art.

"I grew up in a nice neighborhood in Queens that had some beef with other neighborhoods, so sometimes there were issues amongst my friends but I tried not to get too involved. I did learn by watching what not to do within crews as a woman. Loyalty, honesty, and respect were core family values I grew up with and are important with any crew/ squad/circle of friends. In 1994, I was accepted into Parsons School of Design and was happy to be out of my neighborhood. It was great, but I really wanted to find my voice and expand my horizons.

"I follow my own politics by staying positive and keeping on task. I find if I focus too much on what's happening with this or that I lose sight of what I need to be doing. I try not to listen to commercial news too much since most of it is biased, negative, and depressing. But I do focus my narrative within my work on justice and leading life with love."

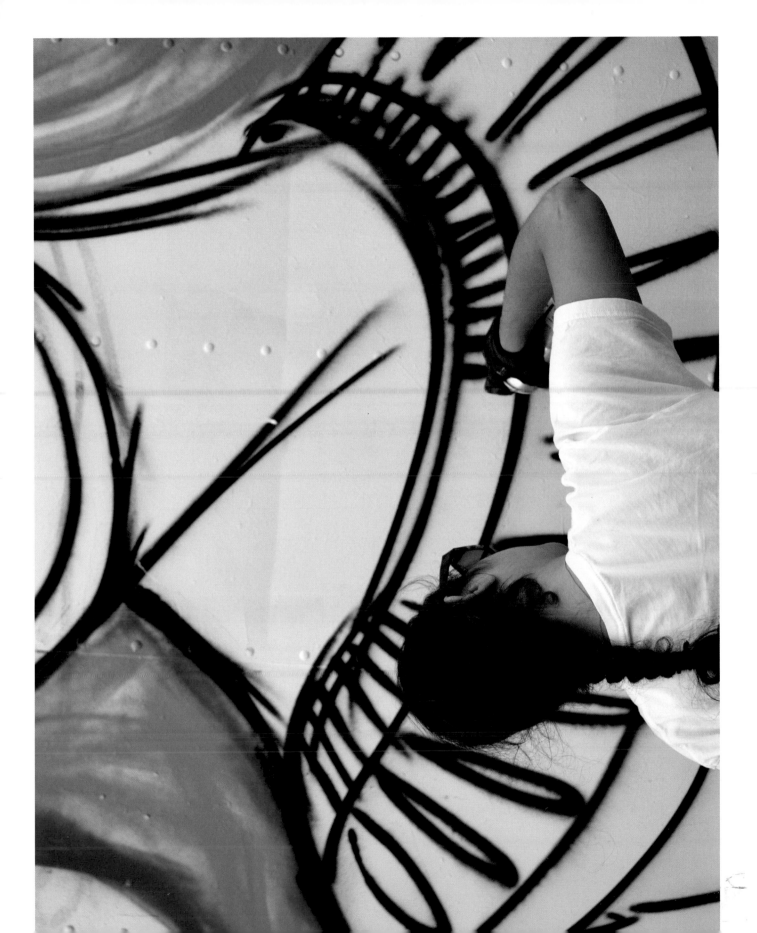

"ART WAS A VEHICLE FOR ME AS A TEENAGER TO HEAL. IT WASN'T ABOUT THE WORK LOOKING GOOD OR BAD BUT ABOUT THE RELEASE AND FEELING THAT COMES WITH CREATION. I STILL ENJOY THAT FEELING TODAY. MY PROCESS IS A CULMINATION OF MY STORY, HOW I FEEL AND WHERE I AM."

"As a teenager art was a vehicle for me to heal. It wasn't about the work looking good or bad but about the release and feeling that comes with creation. I still enjoy that feeling today. My process is a culmination of my story, how I feel and where I am.

"I am a spontaneous creator; I am inspired by the moment and the place I'm in. I have a confident approach, knowing that whatever I create, whether it looks good or bad, is a reflection of my expression at that very moment. When I take on a project I like to think about it, research it, and then come up with a loose idea. My sketchbook accompanies me wherever I go. It is a consistent tool for me to spontaneously sketch out ideas and I often look back at it.

"If it's a commissioned or public piece I feel the location can dictate what can be engaging to that community. I like the work to make sense in its placement. So much of what I create is about my personal story juxtaposed with our universal story. When its complete, I like to watch others react to the work."

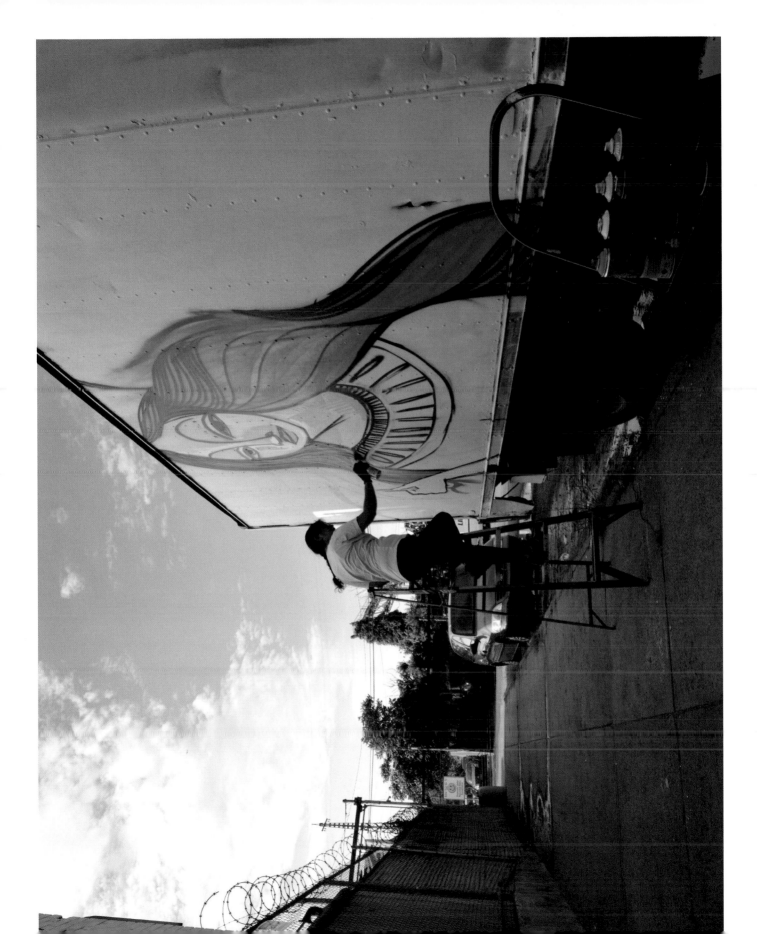

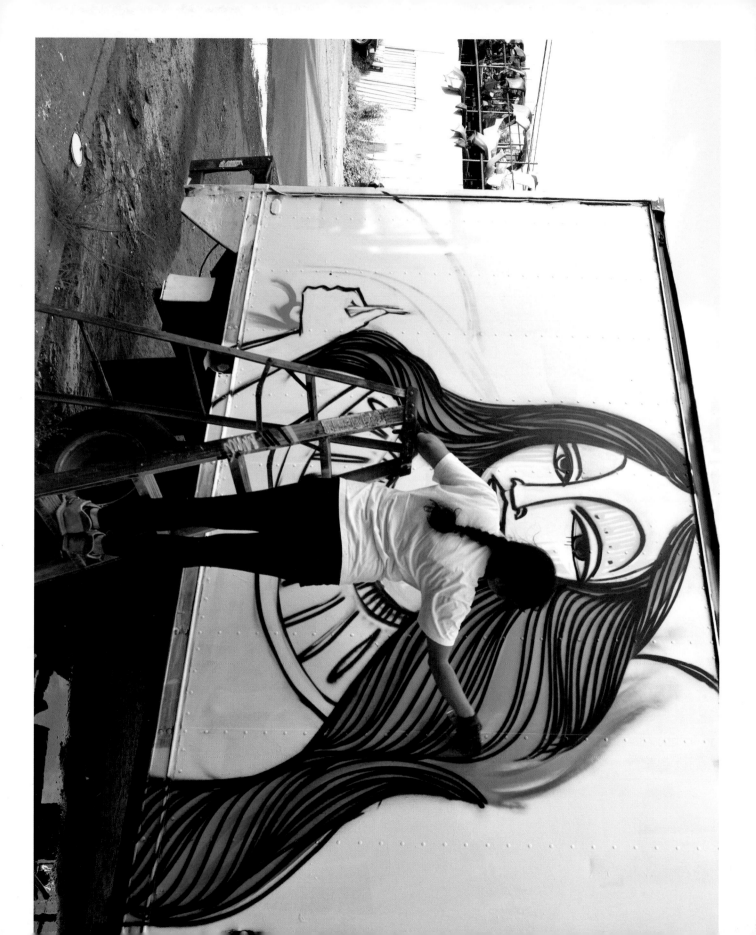

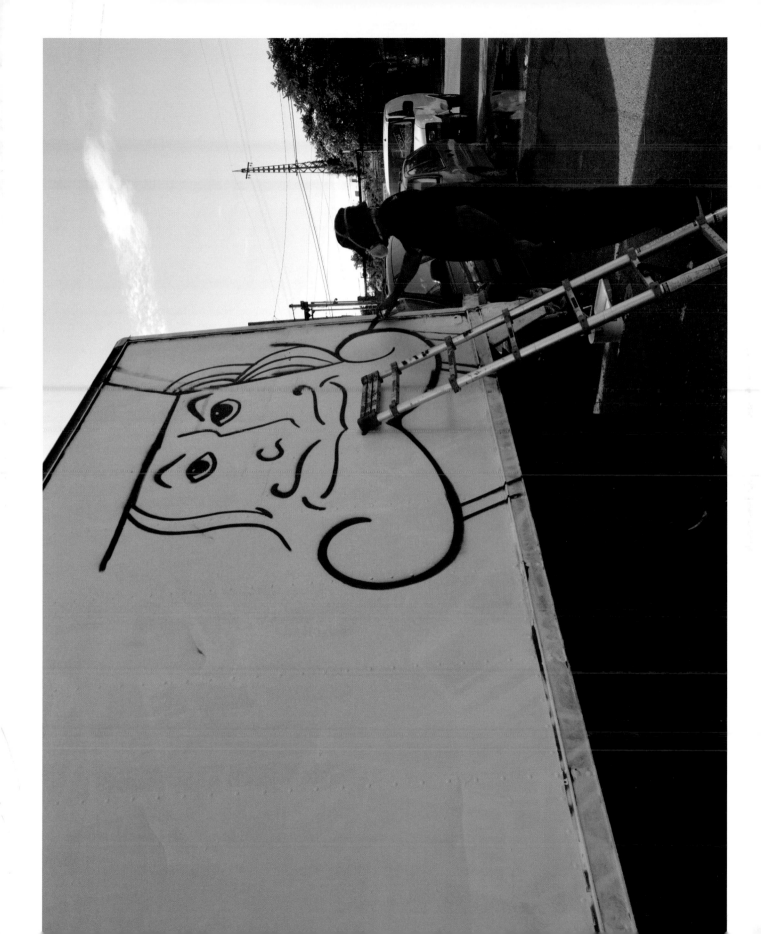

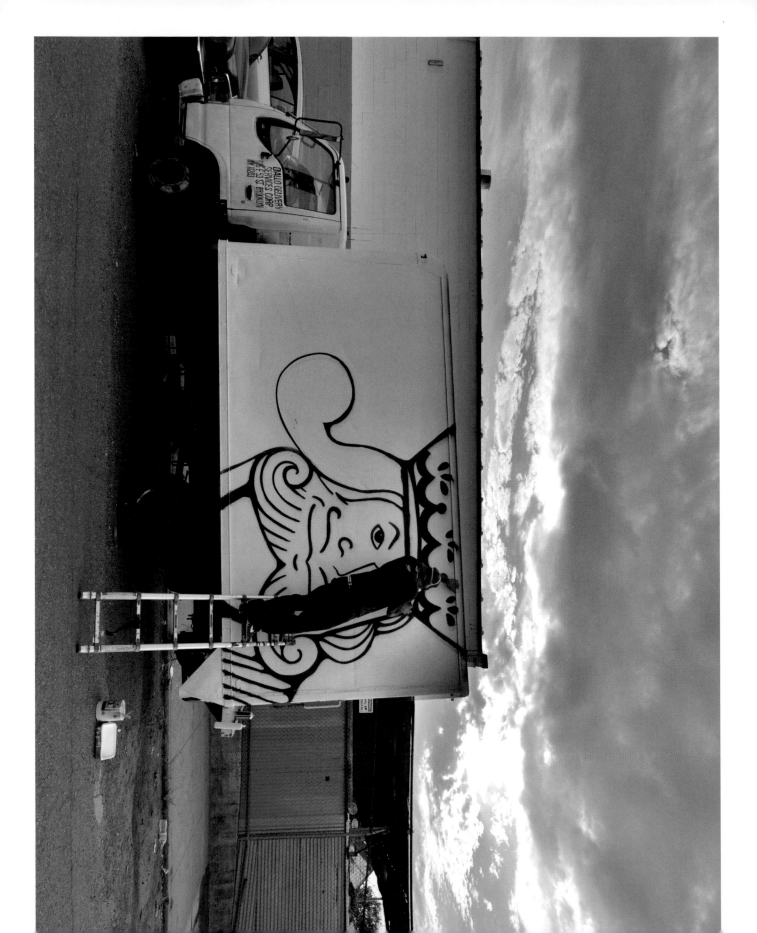

#02

TRAP IF

Ecrly Life and Work

"**I was born** in Washington Heights but was raised in Jamaica, Queens. I was a rebellious kid and spent most of my time outside. Being on the streets a lot meant art and hip-hop culture became my form of escapism. As I developed my style, I practiced more and enjoyed my progression throughout each medium I studied. I felt most connected to graffiti because it was a way for me to express myself without being seen, kind of like a masked superhero.

"At around the age of six I started drawing comic book characters. One day I was grocery shopping with my mom and I asked her to buy me some silver spray paint for an 'art project.' She agreed because she was trying to get me engaged in educational activities. That night I secretly went out and started taking tags on the neighborhood handball courts, mai boxes, and light poles. I instantly felt a freedom that I completely connected with.

"I remember my mother enrolling me in a cartoon class. Though I didn't really enjoy it, when I look back I realize it did benefit me. My environment had a huge influence on me, and my interest in art spawned from some of the writers in my neighborhood, like the South Side TPA Crew and EDGE IF. Those writers were a few of my first influences as a young artist. I took a lot from early comic book greats like John Byrne and Stan Lee and as I got older, I expanded into studying great masters like M. C. Escher, who changed the way I looked and created art. Another major inspiration was simply using public transportation. I remember taking trains to visit relatives and my fascination

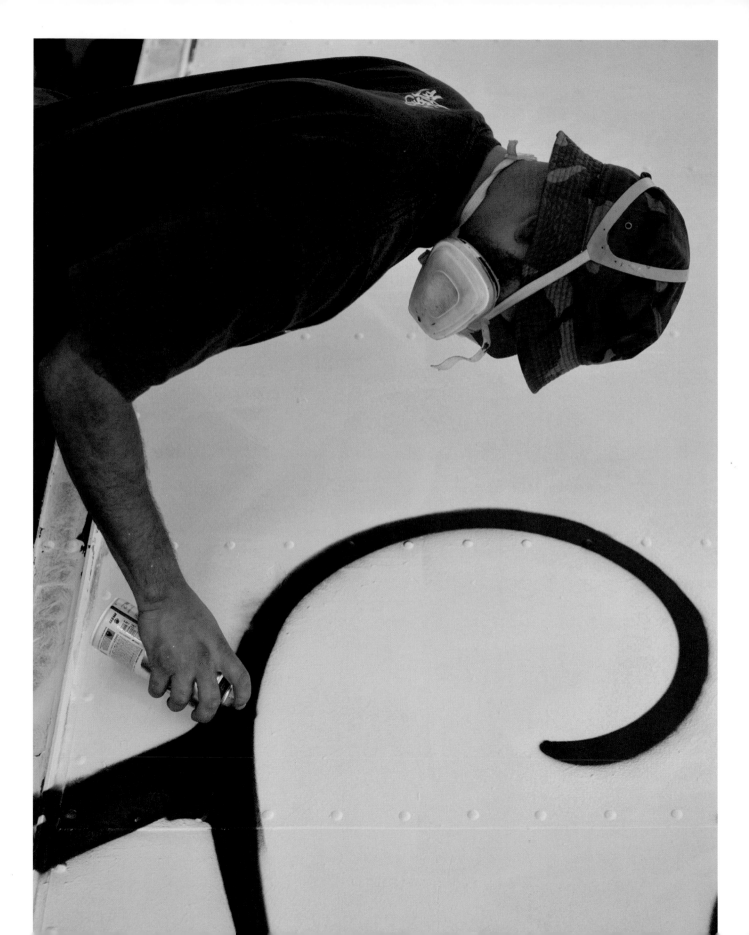

...

with the tags and pieces I saw throughout the city. At the time every street in New York was covered with the tags and pieces I saw throughout the city. At the time every street in New York was covered and there were a variety of styles.

"Growing up in my neighborhood was great until drugs came into the community. Middle class families who were trying to make a difference and establish a better life were greatly affected. Graffiti and hip-hop were lifestyles in most neighborhoods that were struggling. They became expressive outlets for those of us who were creative and wanted to be heard. It was a way to speak out and share what was happening.

"Initially the path I chose mortified my family. I was really young when my mother recognized the drawings in my notebook became tags on our neighborhood walls. She scolded me and realized she enabled me by buying me those first spray paint cans. My friends thought I was crazy, but they also thought it was cool. I quickly discovered that friends are important in my growth as an artist and writer. It feels great to receive love from and share mutual respect with other artists."

"MY FRIENDS THOUGHT I WAS CRAZY, BUT THEY ALSO THOUGHT IT WAS COOL. I QUICKLY DISCOVERED FRIENDS ARE IMPORTANT IN MY GROWTH AS AN ARTIST AND WRITER. IT FEELS GREAT TO RECEIVE LOVE FROM AND SHARE MUTUAL RESPECT WITH OTHER ARTISTS."

Early Life and Work

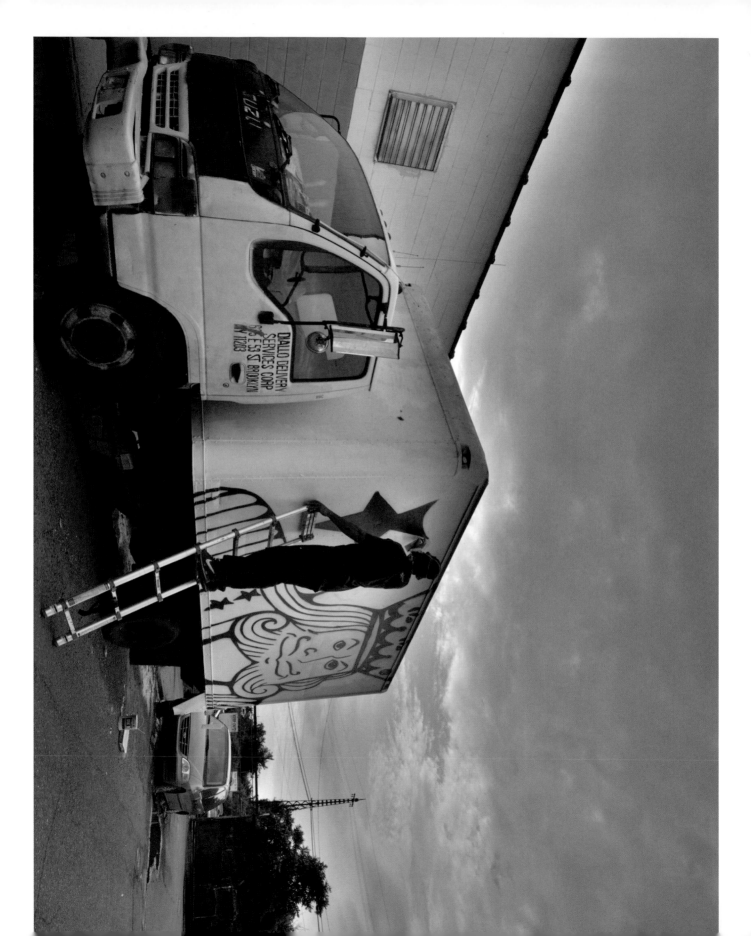

"Every process is unique because of the size, surface area, and materials, but I usually have an idea of what I want to accomplish from the beginning.

"I start with a sketch that is a small-scale version of the completed piece. These days I enjoy the challenge of hard-to-reach spots that are permanent and oddly shaped surfaces.

"I like morphing my pieces into unexpected shapes in interesting places; it takes my idea to the next level. Unless there is a specific color scheme, I like to go with the way I feel at the time and whatever is available. I can pretty much work with any colors I have and like that spontaneity."

"THESE DAYS I ENJOY THE CHALLENGE OF HARD-TO-REACH SPOTS THAT ARE PERMANENT AND ODDLY SHAPED SURFACES. I LIKE MORPHING MY PIECES INTO UNEXPECTED SHAPES IN INTERESTING PLACES; IT TAKES MY IDEA TO THE NEXT LEVEL."

Creative Process

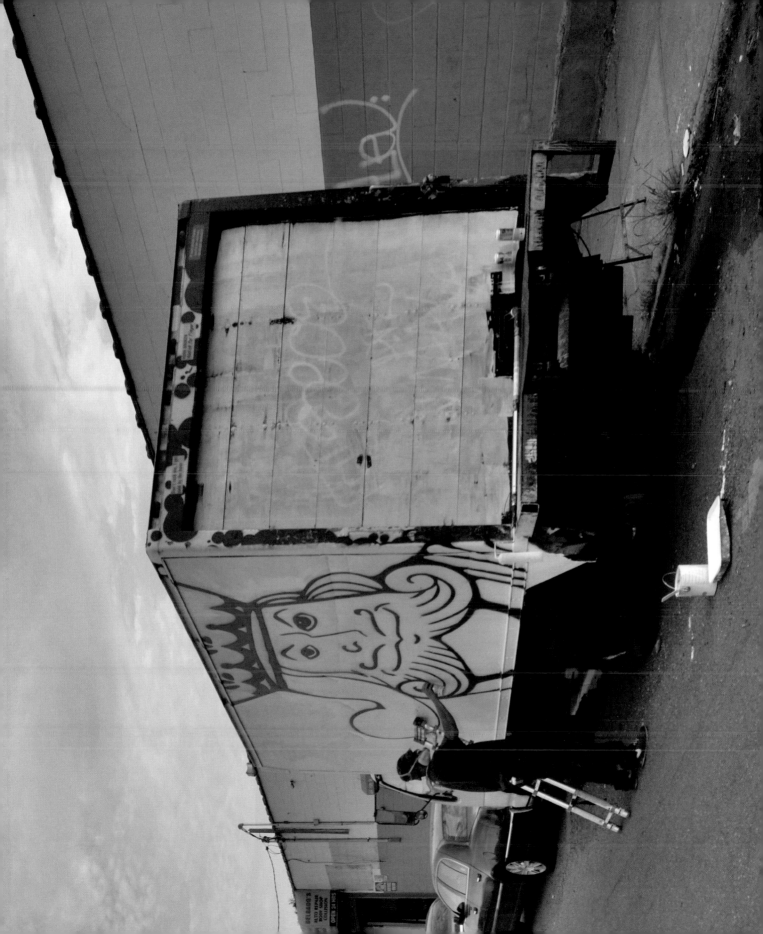

"COLLABORATION ISN'T JUST LIMITED TO THE PHYSICAL WORK OF ART; IT CAN BE A PLAN OR AN IDEA WE ARE MANIFESTING, OR EVEN AN EMPOWERING CONVERSATION AROUND WHAT WE WANT TO ACCOMPLISH IN THE FUTURE."

Alice Mizrachi

#ROYALTYTRUCK

"AT FIRST I THOUGHT OUR STYLES WERE TOO DIFFERENT, BUT NOW I'M STARTING TO SEE WAYS WE CAN INCORPORATE THEM. MY APPROACH IS USUALLY RAW AND UNSOLICITED. ALICE BRINGS HER OWN FEMININE GRACE. OUR STYLES COMPLEMENT EACH OTHER BECAUSE THEY ARE SO DIFFERENT. "

Trap If

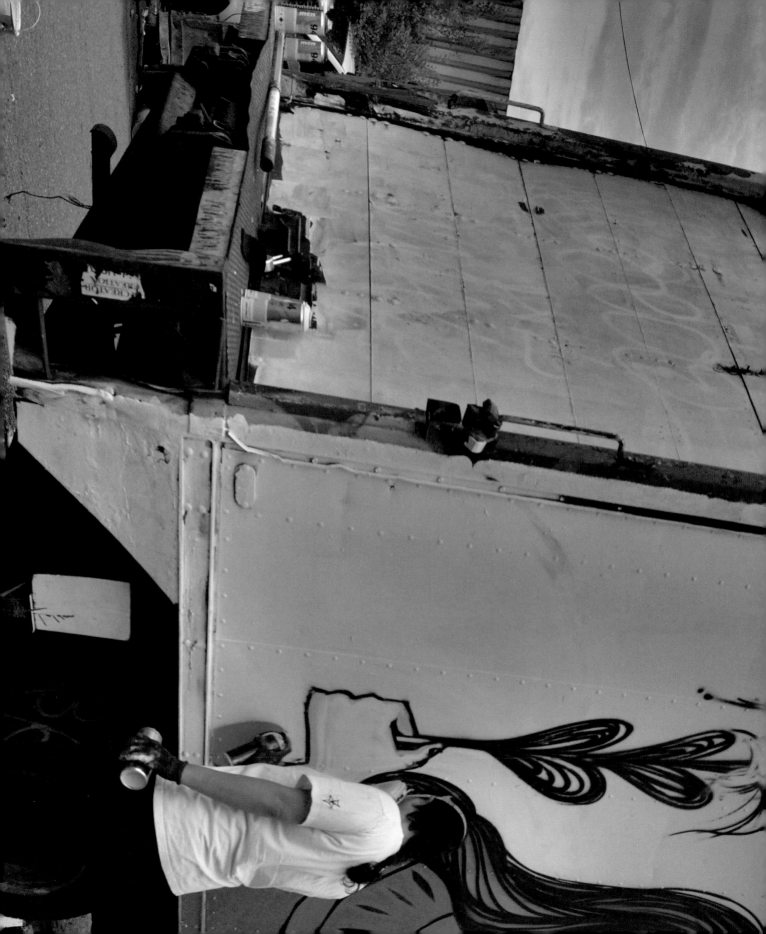

Alice Mizrachi

"I collaborate quite often with artists whom I respect and admire, who inspire me or are my friends. I like working with other artists and feel like each time it's different. It always amazes me when I get to witness different interpretations of similar subject matters. Through the work I can see the artist's vision and his/her origins and life experiences.

"Initially, I like to share my idea and sketch (if I have one) and see what the other artist is thinking: great minds feed off each other. When I work alone the process is different because I move forward in my decision making without consulting anyone.

"In a collaboration I am much more willing to share, compromise, and plan in line with the ideas and skill sets involved so that I can work together with someone to create a great work of art.

"It's also nice and fun to share a creative space, since making art alone can feel isolating. That said, I like having certain boundaries because they increase the challenge. Collaboration isn't just limited to the physical work of art; it can be a plan or an idea we are manifesting, or even an empowering conversation around what we want to accomplish in the future.

"My collaborator for this project is Trap, who is my mar and a great friend. We met in Miami two years ago at an art opening and have been conspiring and working together ever since. Collaborating with Trap is fun and exciting. Sometimes we don't see eye to eye on ideas, but I feel that's a good thing, because it expands our perspectives. At times I feel like I've known him forever; we were both raised in Queens and have similar backgrounds, so it's nice to connect with someone who just gets me.

"In our work I feel like I bring a softer, more feminine perspective. I also bring a more academic approach, since I work with arts organizations and mural commissions. Trap brings an edgier flavor that I love – an approach he's been building by painting on the streets for many years. I think our styles complement each other. We accept and respect each other's personal styles, but if there are suggestions that can improve the whole piece we discuss them. We are both aware of our strengths and try to use them collectively, have each other's backs, and share and exchange notes on our resources and experiences. If difficulties arise we give each other space, talk it out, and other times joke about it to make light of the situation."

Trap If

—

"Even though I prefer working alone, I do enjoy the creative connection that comes from collaborating. It's cool to see what flows and how we can enhance our own work with constructive criticism from friends. With permission walls or commissions, I usually like to share my ideas and see how the art is relevant to the space we are painting. It's great to reflect the day after by taking some photos, checking them out, and going back the next day after I've had time to see what can be improved.

In my youth, I remember going on night missions and looking for highly visible spots. When I was with friends I gained a lookout and someone to chill with. There are also advantages of going out alone: you look less suspicious and you get to choose your own spot. Because I keep my identity secret, I am a bit selective about who I paint with. Back in the day I collaborated exclusively with a crew, but these days I am a bit more open to meeting new artists. If you're cool and humble I can rock with you, but I'd rather paint with people I know who are experienced and talented.

"Alice is my lady. We've been collaborating for almost two years. At first I thought our styles were too different, but now I'm starting to see ways we

can incorporate them. My approach is usually raw and unsolicited. Alice brings her own feminine grace. Our styles complement each other because they are so different. Even though she also brings rawness, it's a distinct quality that works well side by side.

"There are no real difficulties, just challenges and opportunities. Sometimes stepping back and taking a break helps when working on a piece of art, whether it's a collaboration or not. If you just stop to take the time to reflect and look at the piece you can find a way to make it better. In this project I think the challenge was to create something with a concept that would incorporate our styles. We knew we wanted to rock a king, and queen playing card but had different renditions of that concept in mind. Ultimately, it worked because we were able to paint what we wanted in our own way and combine the two elements on the back. So when you drive behind the truck you can see a masculine, hard-edged sword placed next to a feminine, flowing flower. It worked out perfectly!"

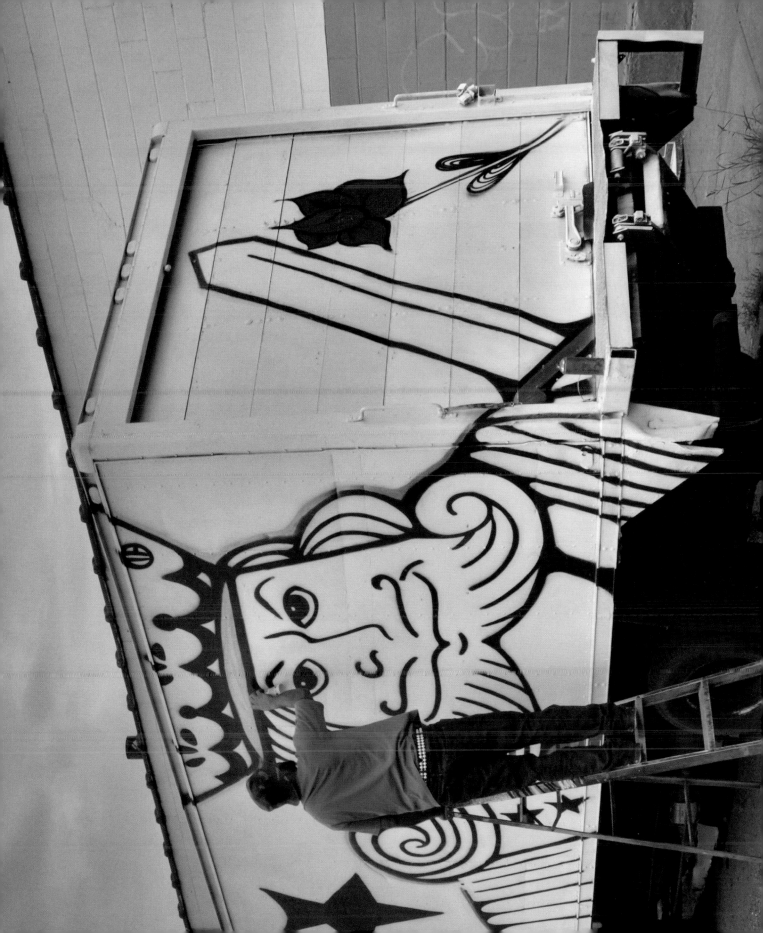

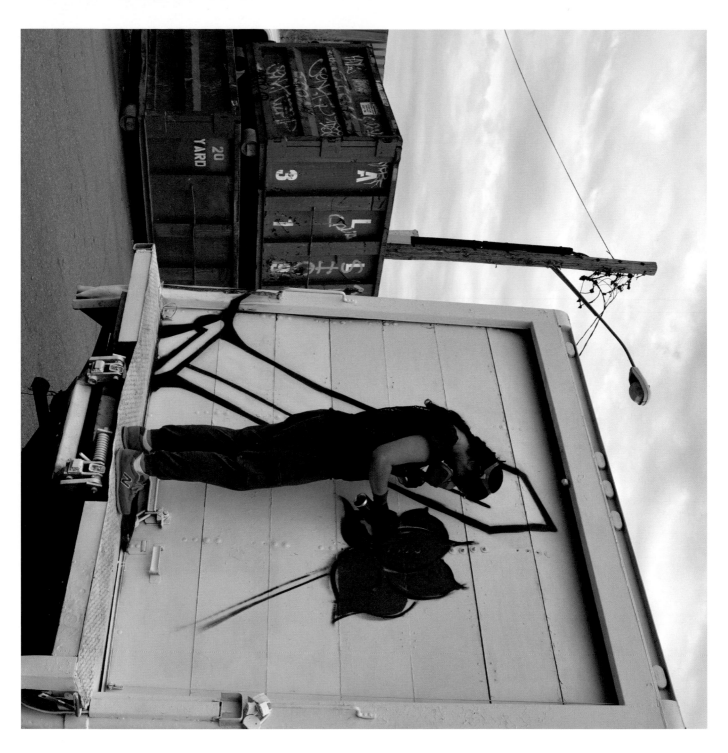

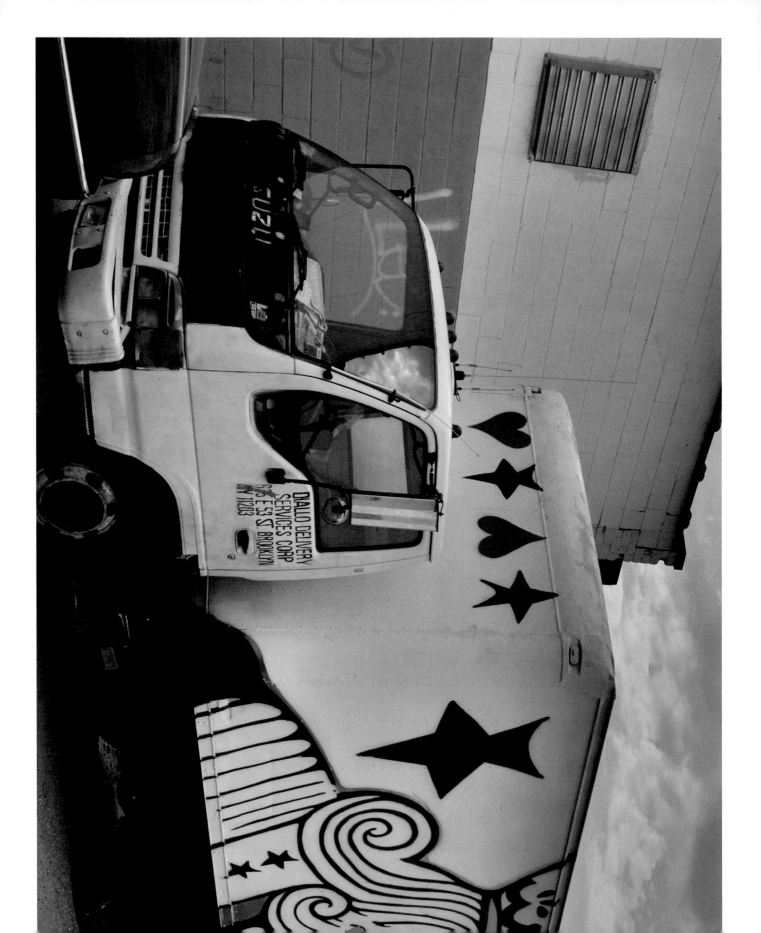

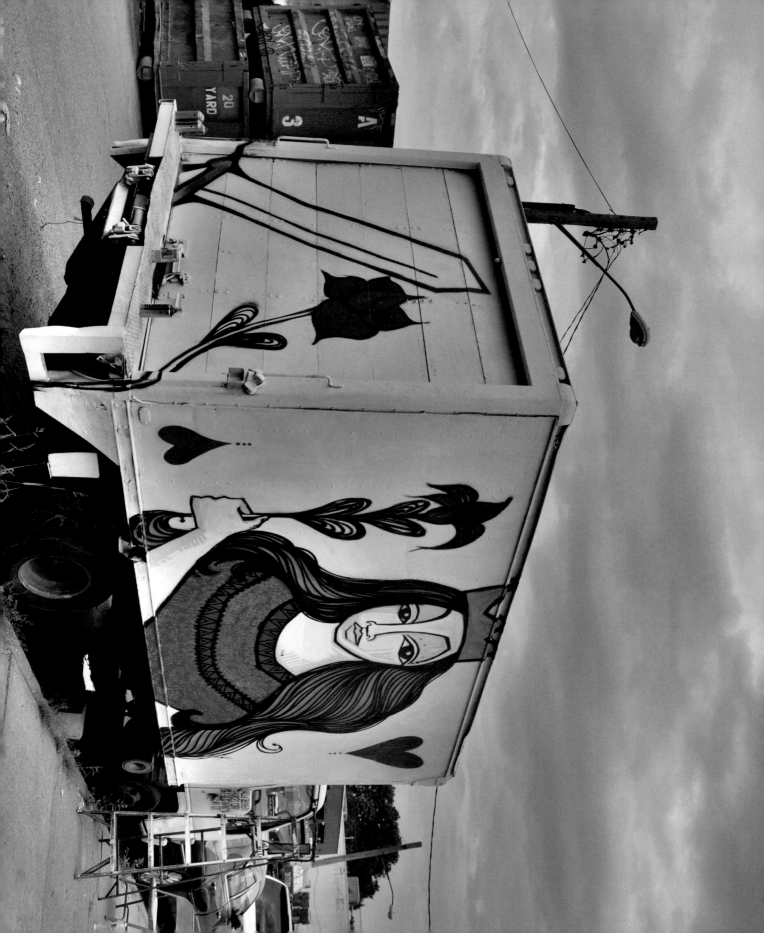

#ROYALTYTRUCK

Artists
TRAD IF
ALICE M ZRACHI

#WILLIAMSBURGCOLLAGE

DAI
S
PE

TIKKKI
ACHES

Early Life and Work

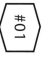

DAIN

"I was born in Coney Island, Brooklyn, and raised in the housing projects of East Flatbush. Flatbush was very diverse back then: there were Italians like me, people from the Caribbean, and some folks from the West Indies. Basically I grew up on lasagna, jerk chicken, and curry, and I loved it! I had friends of all sorts and there was no racism that I was aware of. I grew up on graffiti and started doing it myself when I was eight. It was all around me: on the trains, the streets, the highways, even the garbage trucks.

"I lived on the first floor in the projects and jumped out the window to go tagging with my friends. We would practice doing throw ups and pieces and perfecting our writing styles. During high school in the mid-'80s I was already tagging 'Dain.' We used to go down to the 'dead tracks' - old freight train tracks that ran through Brooklyn. Some of my influences included the guys who were tagging back then: CR Tony was a legend and his crew DOA taught me a lot, and I grew up seeing tags by guys like Sane, Smith, Joz and Easy, Fib, DC, Trap, Cost, and Revs. I loved the area I was brought up in because to me it was so New York, so real, you know? New York is so different these days; I miss the old feeling.

"At some point I got interested in silk screening and about fifteen years ago I opened a clothing store in Williamsburg where I'd silk screen on t-shirts. I had no idea what I was doing, but people loved it! Until this day, I've never had any kind of formal art training. I'm a self-taught artist and I believe people respond to my work because it is so original and different."

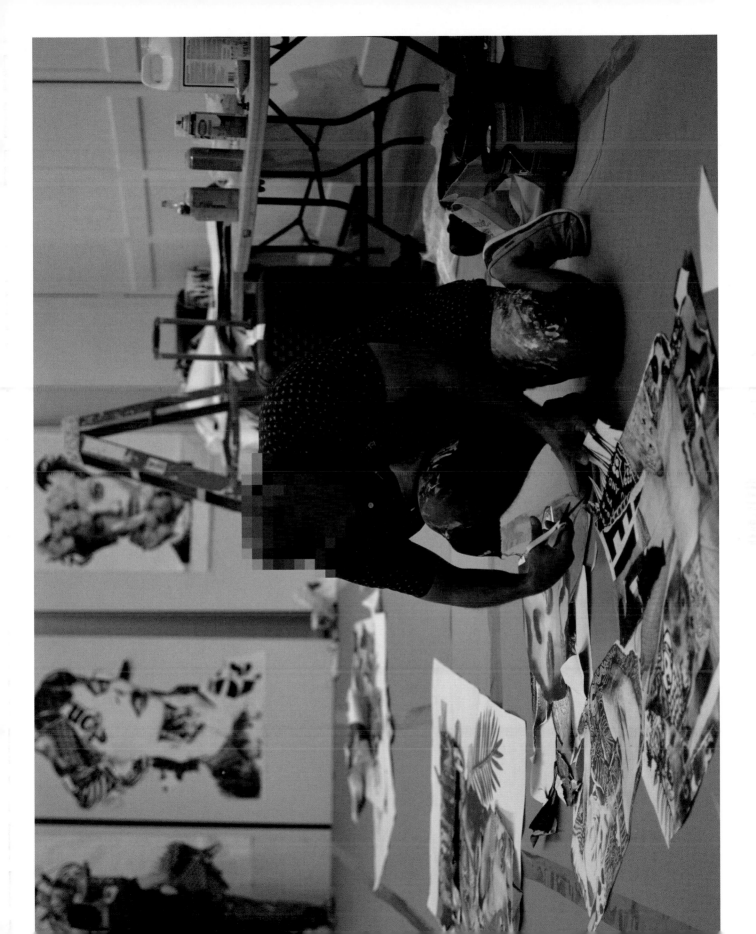

"I GREW UP ON GRAFFITI AND STARTED DOING IT MYSELF WHEN I WAS EIGHT. IT WAS ALL AROUND ME: ON THE TRAINS, THE STREETS, THE HIGHWAYS, EVEN THE GARBAGE TRUCKS. I LIVED ON THE FIRST FLOOR IN THE PROJECTS AND JUMPED OUT THE WINDOW TO GO TAGGING WITH MY FRIENDS."

"My process usually begins with layers of graffiti, using any paint I can find. Then I begin with collage work, where I can manipulate an image very quickly.

"It always begins with a face, around the eyes. I find an image with a captivating stare that resonates with me. I usually pair a woman's face with a man's body to keep the focus point on the eyes. I find the images I use in magazines or newspapers and then I blow them up. From there it's a matter of using spray paint, more collage, and a mixture of different patterns, floral designs, and prints to create the final image. It's all about balance for me: balance in life, family, spirituality, and art. Many times I look at my pieces from all directions, including upside down, and try to feel the balance of colors, shapes, and sizes. It's got to have the right feel.

"My work is about presenting the beauty of a woman without revealing everything. I grew up with classic movies like *On the Waterfront* and movie stars like Marlon Brando and Shirley Temple. Those movies had style. They always made you wonder and forced you to use your imagination. To me there's something appealing about the beauty of a woman who is totally covered up in a man's suit. It takes me back to those classics and ignites my imagination."

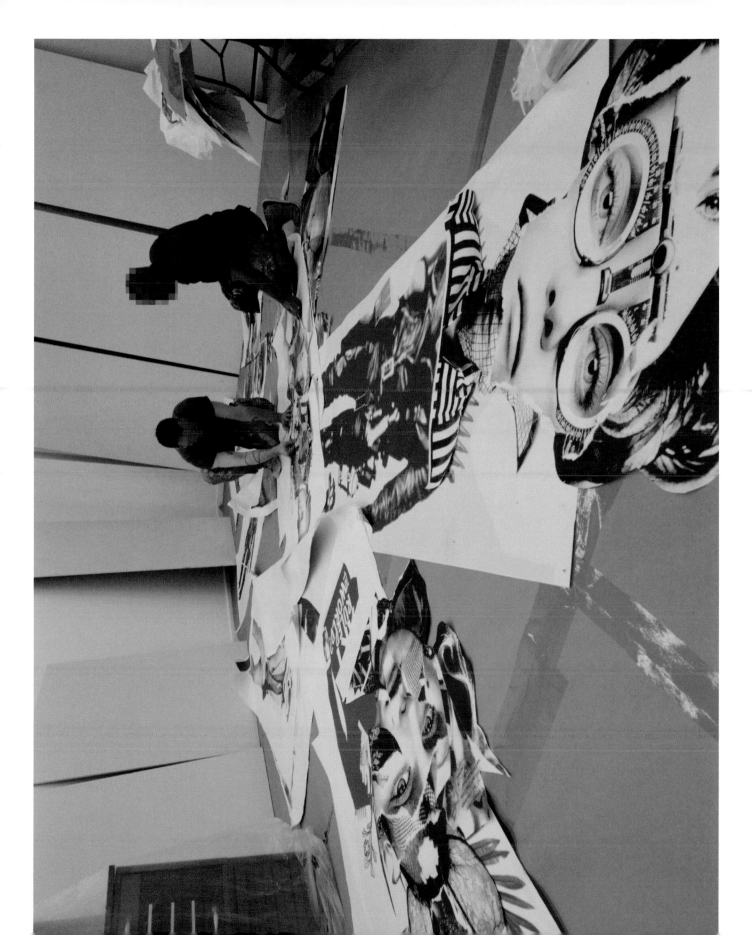

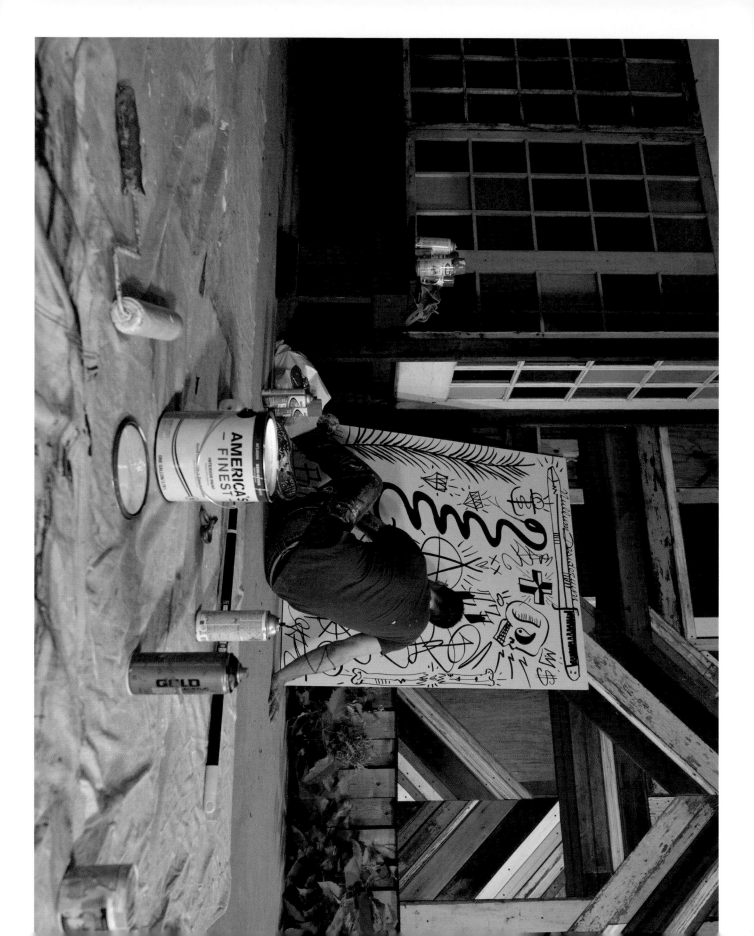

⬡ #02

STIKKI PEACHES

"I was born and raised in Montreal, Canada.
I've been in love with anything artistic for as long as I can remember. As a kid I was obsessed with Saturday morning cartoons. With age my obsession continued, as I watched the cartoons that aired after school hours, such as *G.I. Joe* and *Transformers*. They inspired me and created a distraction that led to hours of drawing, painting, coloring, and sketching, which shaped my style as an artist.

"Both of my parents are creative people in their respective fields: my mom is a seamstress and women's wear designer, and my dad is a traditional tailor for men's suits. When I was growing up there were storyboards, sketches, and patterns of their work all over the house. I used to gather their scraps of paper and notes of rejected ideas and turn them into scrap books, or I'd staple the pages together to make my own animated flip books or comic books. I love looking at those today.

"I love Montreal; it is a very dynamic city. It can literally go through four seasons in one day. The city has taught me to appreciate the power of change, keep up with the times, evolve, and try out new things, and has helped me grow as an artist and person. Montreal is a melting pot of diverse cultures, each bringing its touch of uniqueness to the lifestyle of the city. Also, because of its relative proximity to New York City, the cultures of hip-hop and graffiti have always been influential and popular.

Early Life and Work

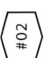

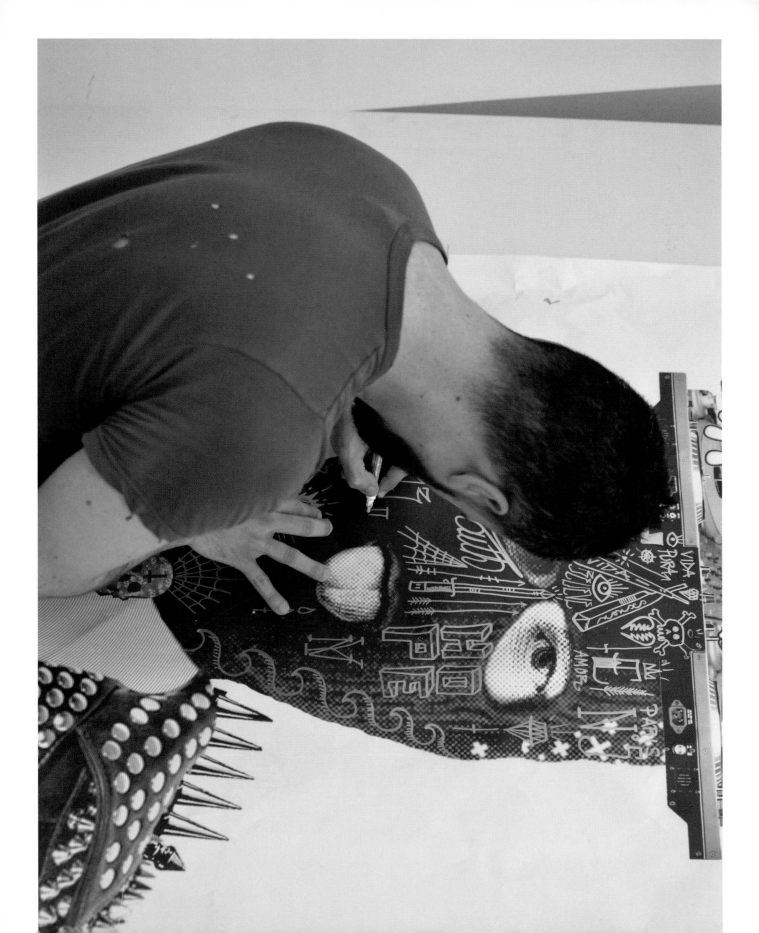

"Politics is something I usually don't get too caught up in. Political issues that shape the world today are often negative, deceiving, corrupt, and glorified, so much so it seems we're all watching a reality show of some sorts. I try to limit my intake of political happenings by concentrating on things in life that aren't stressful. I choose to focus on the positives, and making political statements through my art isn't something that drives or motivates me. There are many great artists that express their political views through their art, and many experience these issues first hand. I prefer to experience political issues through their work, which is researched and informed.

"Half of the work I do is considered 'illegal', at least it was until a couple years ago, when pasting up bodies of work on the side of a building or alleyway could land you in jail for a night or two. Today times have changed; some people encourage artists to place works around their neighborhood.

"The art world is also changing, and as artists we tend to either move with the masses or choose our own path. I find it all depends on what drives you and motivates you as an artist and what keeps that passion and spark alive. I know in order for me to continue to be happy, I need to work with whomever I enjoy working with and share my work with those who appreciate it. It's really that simple."

"AS A KID I WAS OBSESSED WITH SATURDAY MORNING CARTOONS. WITH AGE MY OBSESSION CONTINUED, AS I WATCHED THE CARTOONS THAT AIRED AFTER SCHOOL HOURS, SUCH AS *G.I. JOE* AND *TRANSFORMERS*. THEY INSPIRED ME AND CREATED A DISTRACTION THAT LED TO HOURS OF DRAWING, PAINTING, COLORING, AND SKETCHING, WHICH SHAPED MY STYLE AS AN ARTIST."

Early Life and Work

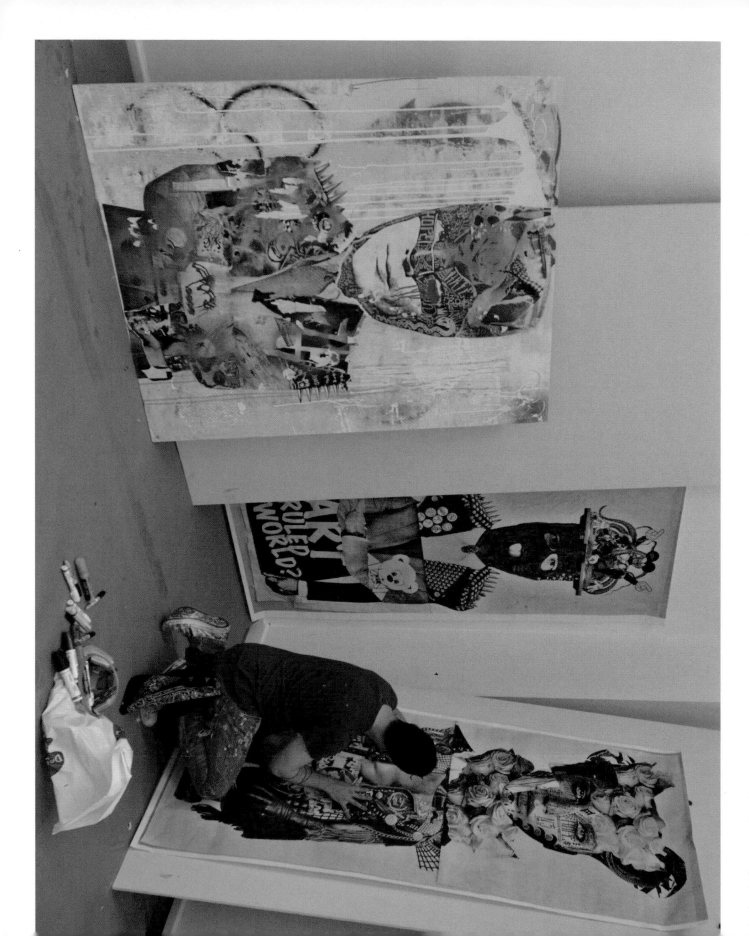

"**My work stems from ideas**, thoughts, and influences from my childhood. Whether pop culture-based or personal references, it all starts from there. The idea is to relive a moment in time and to remember the emotions it stirred up. I attempt to grasp and convey those emotions through an artistic expression of diverse mixed media techniques."

"THE IDEA IS TO RELIVE A MOMENT IN TIME AND TO REMEMBER THE EMOTIONS IT STIRRED UP. I ATTEMPT TO GRASP AND CONVEY THOSE EMOTIONS THROUGH AN ARTISTIC EXPRESSION OF DIVERSE MIXED MEDIA TECHNIQUES."

Creative Process

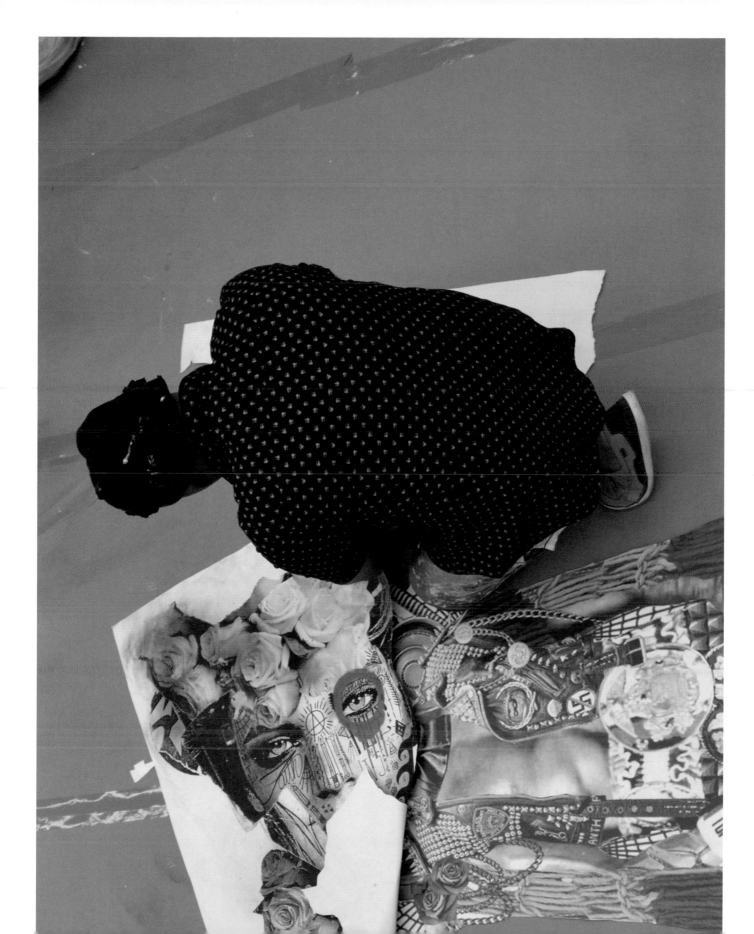

"I FEEL LIKE COLLABORATING IS ABOUT FINDING SOMEONE WHOSE ART WILL MAKE MINE LOOK EVEN BETTER AND HELP BRING OUT A DIFFERENT SIDE OF MY WORK. STIKKI'S TATTOO WORK AND HIS DRIPS BRING AN EDGE TO MY WORK THAT I REALLY LIKE."

Dain

#WILLIAMSBURGCOLLAGE

"I LIKE TO MAKE THE BODIES OF WORK UNFOLD NATURALLY, AND I TAKE THAT TIME TO ASSESS AND SEE WHAT CAN BE DONE BETTER. DAIN, ON THE OTHER HAND, IS GREAT AT PROCESSING INFORMATION, TAKING AN IDEA WE'VE DISCUSSED AND PUTTING IT TOGETHER IN NO TIME."

Stikki Peaches

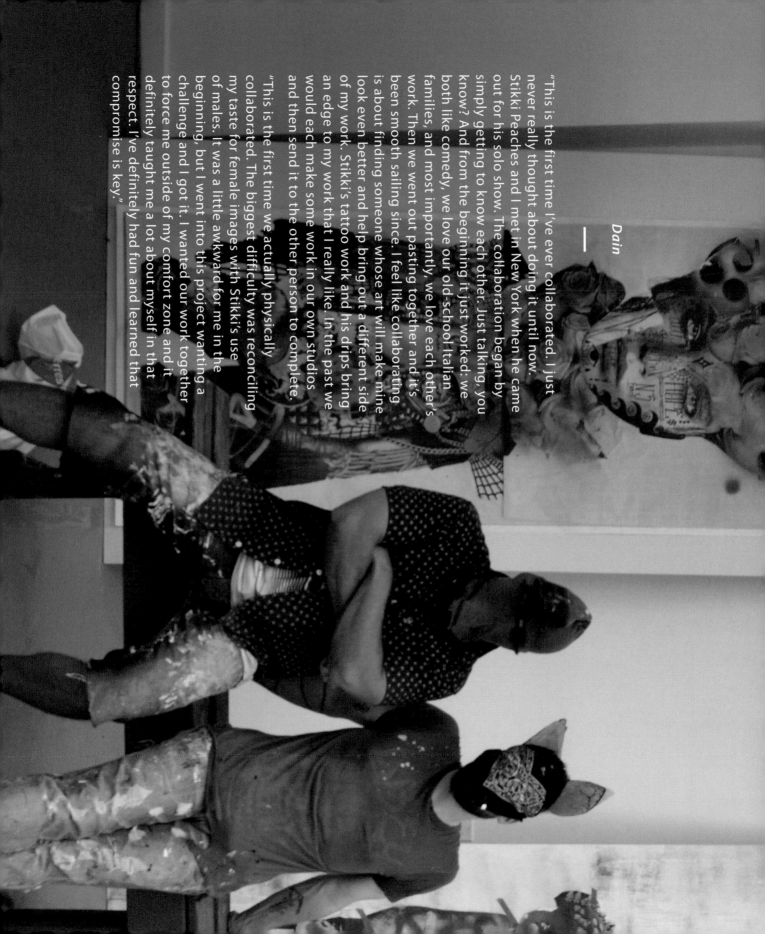

Dain

"This is the first time I've ever collaborated. I just never really thought about doing it until now. Stikki Peaches and I met in New York when he came out for his solo show. The collaboration began by simply getting to know each other. Just talking, you know? And from the beginning it just worked: we both like comedy, we love our old-school Italian families, and most importantly, we love each other's work. Then we went out pasting together and it's been smooth sailing since. I feel like collaborating is about finding someone whose art will make mine look even better and help bring out a different side of my work. Stikki's tattoo work and his drips bring an edge to my work that I really like. In the past we would each make some work in our own studios and then send it to the other person to complete.

"This is the first time we actually physically collaborated. The biggest difficulty was reconciling my taste for female images with Stikki's use of males. It was a little awkward for me in the beginning, but I went into this project wanting a challenge and I got it. I wanted our work together to force me outside of my comfort zone and it definitely taught me a lot about myself in that respect. I've definitely had fun and learned that compromise is key."

Stikki Peaches

"Collaboration is a natural process that just happens for artists. When collaborating, I focus on my end of the task and set up my work so I can be flexible with my process. It's a great way to learn new things, as well as feed off each other, develop new working skills, and evolve together to reach a unified vision: a great-looking piece of art. I gravitate towards other artists that share views or visions similar to my own. I find myself admiring their works for months or years until the right time comes for us to collaborate. It usually turns into an adventure filled with great times and stories. Of course, while collaborating there are some obstacles. Sometimes it can be a question of coordination of locations and times (such is the case here). Moving around and meeting up in different workspaces can get tricky. Aside from that, there is and always should be slight differences in opinions while working together. I truly believe a body of work is never perfect, never complete, and never satisfying until both parties agree it is done. We may even re-visit certain works months after their complet on, just because we think we can do something to improve them.

"I first met Dain about a year ago while in New York City for my solo show. He came to check it out the night before the opening. We quickly investigated the potential of working together and bounced a few ideas back and forth. It was great to see and hear we were on the same page from that first encounter. We later went pasting in the streets of SoHo, which proved that we could also work well together on the level of the street. Things moved pretty quickly after that. We got to sharing ideas and talking regularly. Once a sort of plan was set in motion, the actual preparation in the studio probably took around six to eight months. Our very organic way of collaborating complements the work, as we both know our roles. Dain always tells me 'I'm the 'voice of reason'.' I guess that's a good quality when we're overthinking or maybe trying to rush things. I like to make the bodies of work unfold naturally, and I take that time to assess and see what can be done better. Dain, on the other hand, is great at processing information, taking an idea we've discussed and putting it together in no time. He's an inspiration and his work ethic forces me to keep my 'A' game going. We disagree pretty rarely, and if we do we iron out the kinks and the results only improve. Honesty and communication are crucial! If all was perfect in the way we worked together, I think we'd have some boring ass pieces to look at."

WILLIAMSBURG BROOKLYN

LOCATION

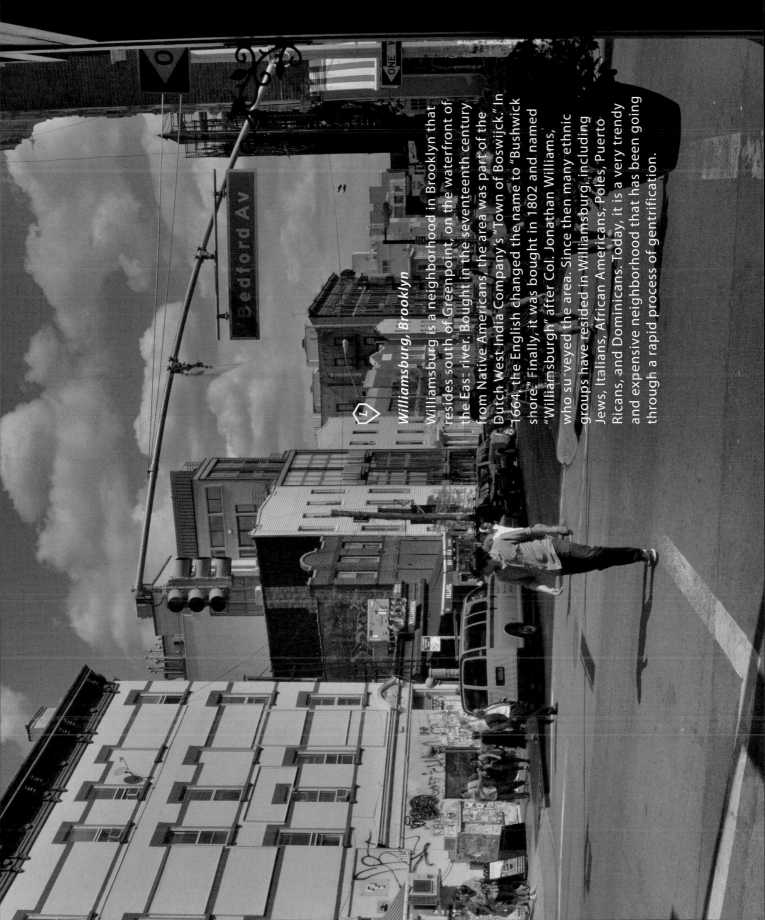

Williamsburg, Brooklyn

Williamsburg is a neighborhood in Brooklyn that resides south of Greenpoint, on the waterfront of the East river. Bought in the seventeenth century from Native Americans, the area was part of the Dutch West India Company's "Town of Boswijck." In 1664, the English changed the name to "Bushwick shore." Finally, it was bought in 1802 and named "Williamsburgh" after Col. Jonathan Williams, who surveyed the area. Since then many ethnic groups have resided in Williamsburg, including Jews, Italians, African Americans, Poles, Puerto Ricans, and Dominicans. Today, it is a very trendy and expensive neighborhood that has been going through a rapid process of gentrification.

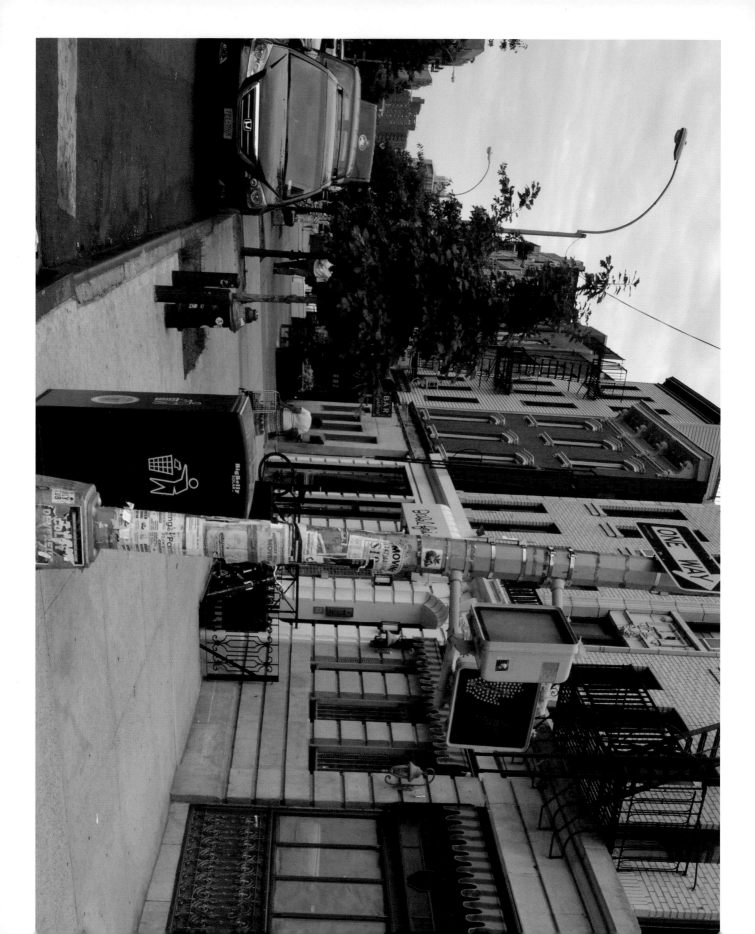

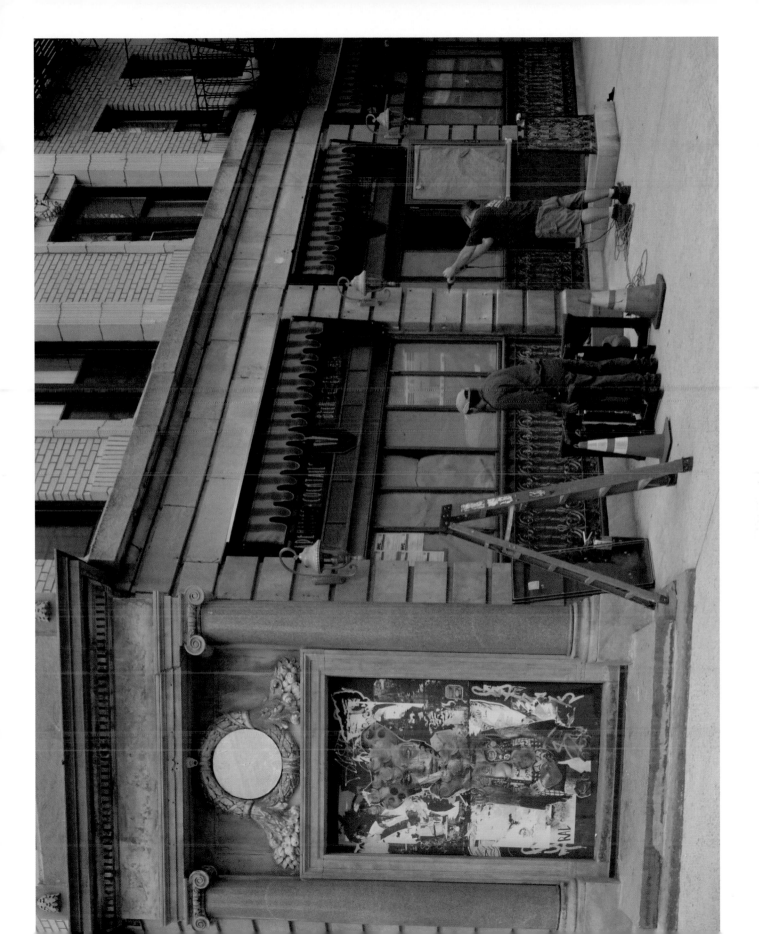

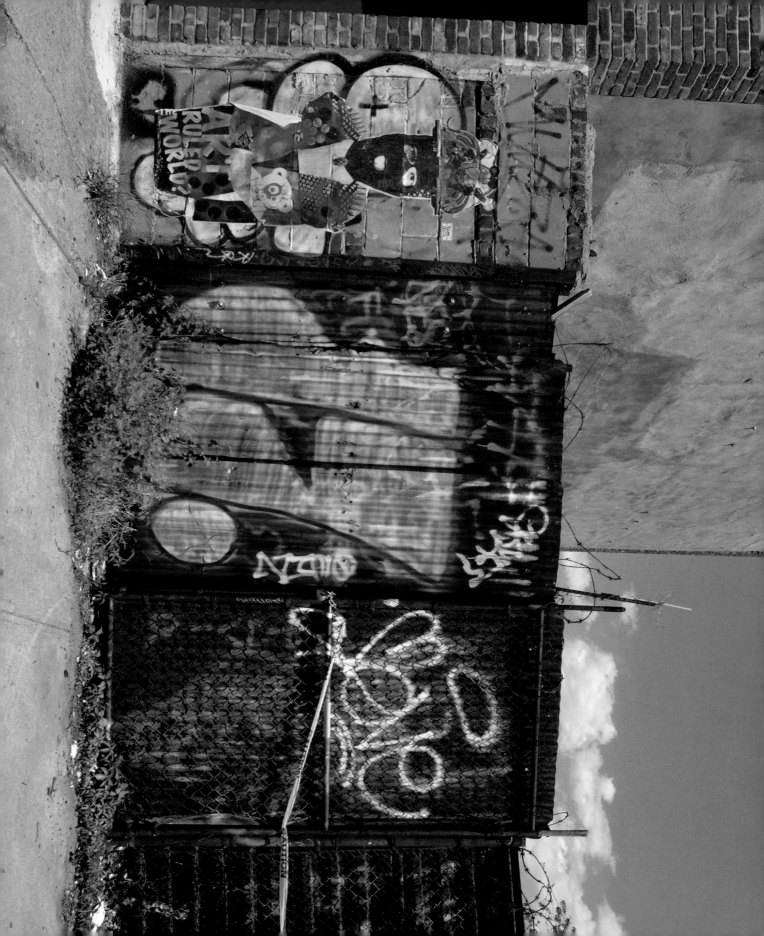

COLLABORATION
#08

#WILLIAMSBURGCOLLAGE

Artists
DAIN
STIKKI PEACHES

#BUSHWICKMURAL

COLLABORATION
#09

bunny M

Artists
bunny M
SQUARE

SQUARE

NEWTOWN CREEK
BUSHWICK

LOCATION

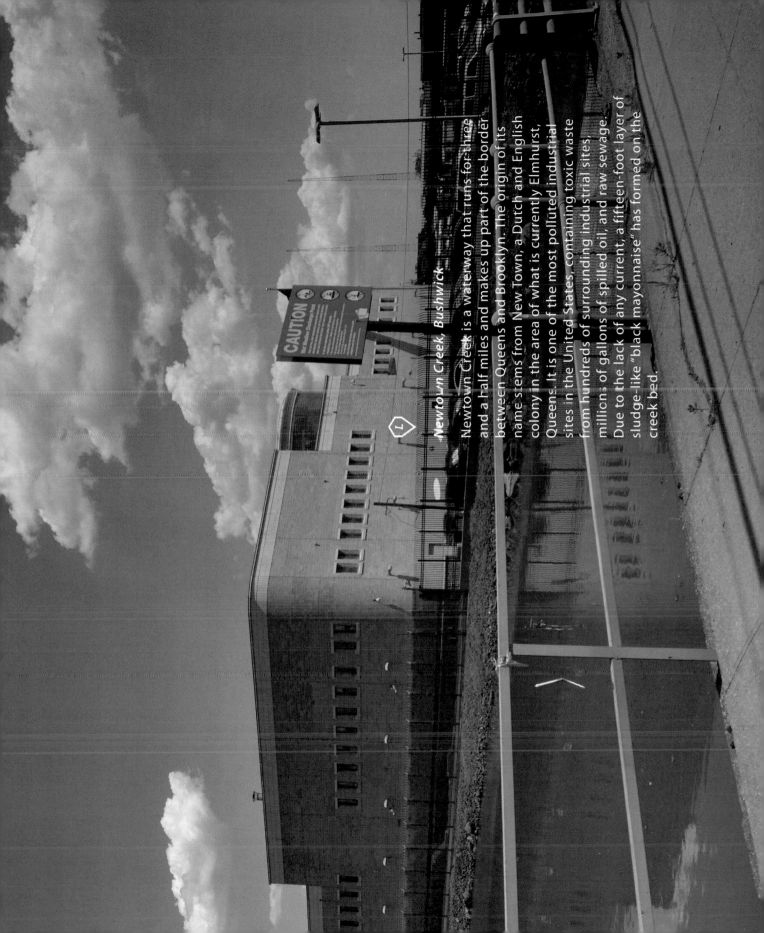

Newtown Creek, Bushwick

Newtown Creek is a waterway that runs for three and a half miles and makes up part of the border between Queens and Brooklyn. The origin of its name stems from New Town, a Dutch and English colony in the area of what is currently Elmhurst, Queens. It is one of the most polluted industrial sites in the United States, containing toxic waste from hundreds of surrounding industrial sites, millions of gallons of spilled oil, and raw sewage. Due to the lack of any current, a fifteen-foot layer of sludge-like "black mayonnaise" has formed on the creek bed.

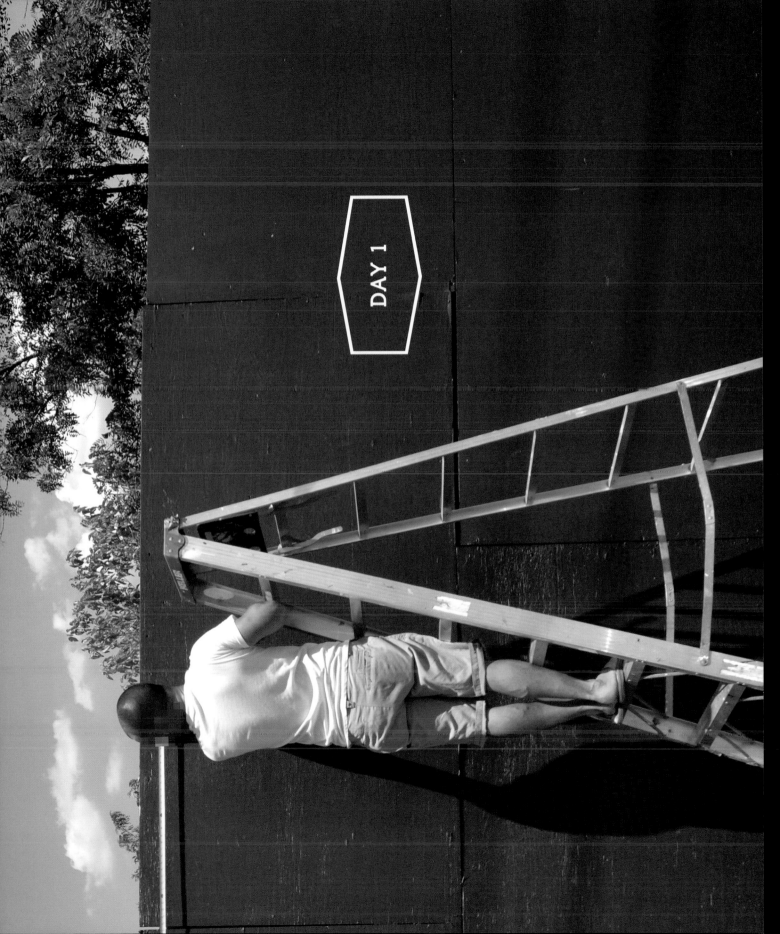

DAY 1

Early Life and Work

bunny M

"In general, my household was very strict and often tumultuous; my father lost his job and as a teenager we moved from place to place a lot. As a child I would often sit at a desk in the living room to draw and color, and if anyone interrupted me I'd get really upset. I remember sitting with my father at the kitchen table. We'd both copy magazine ads with figures of southwestern women holding vases.

"When I was around fourteen I tried to express something personal with color and symbolic imagery for the first time. I was so embarrassed of it afterwards because I felt it was inadequate to what I had in mind. As an adolescent I felt uncomfortable, angry, and defensive most of the time. I spent hours alone getting lost in books, writing and drawing little characters in my notebooks with colored pencils. I tried to make them look like they were spray painted on a wall with a blending stick.

"My grandmother's home inspired me creatively. She was born in Italy and her home in America was decorated to resemble the one she remembered. Entering it was like stepping into a different dimension. Much of it included objects slowly collected from second-hand shops with immaculate attention to detail. It was very baroque, layered, gilded, ancient, mysterious, and dimly lit. Otherwise my influences were minimal and I spent most of my time lost in my imagination. At the time I wasn't researching art or artists and purposely avoided it. For a while I was focused on being a creative writer, though I constantly made mixed media journal entries and bizarre intricate pen drawings.

Early Life and Work

"I GOT LOST EARLY ONE
MORNING RIDING THE
SUBWAY. I REMEMBER
SEEING THE SUNRISE HIT
SOME PAINTED BUILDINGS
IN THE BRONX. I WILL NEVER
FORGET HOW I FELT SEEING
THOSE BUILDINGS. THEY
LOOKED LIKE A FREEDOM
I NEVER KNEW EXISTED."

...

"In school I studied literature and photography.

"When I turned twenty-one, I went to New York City and saw real graffiti for the first time. I got lost early one morning riding the subway. I remember seeing the sunrise hit some painted buildings in the Bronx. I will never forget how I felt seeing those buildings. They looked like a freedom I never knew existed.

"My family never discouraged me from pursuing my love of art, but many times people wondered why I chose such a difficult path. I don't view art as a 'choice' at all; it is just who I am. I found that once I truly accepted myself as an artist none of those concerns mattered. Bottom line is, I will always remember those who have supported my career but also those who didn't."

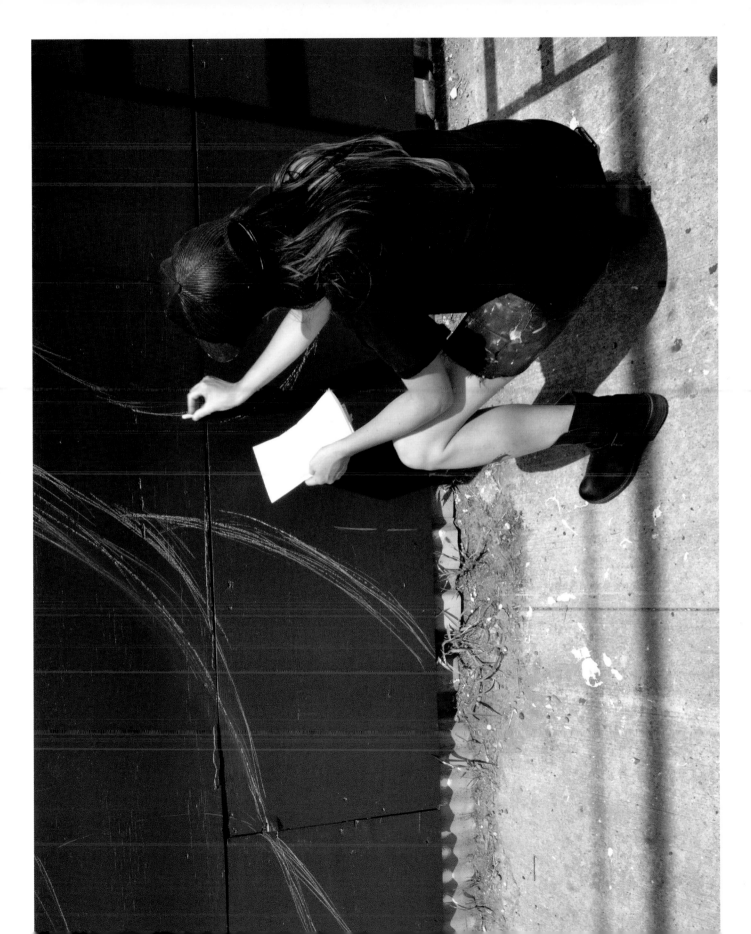

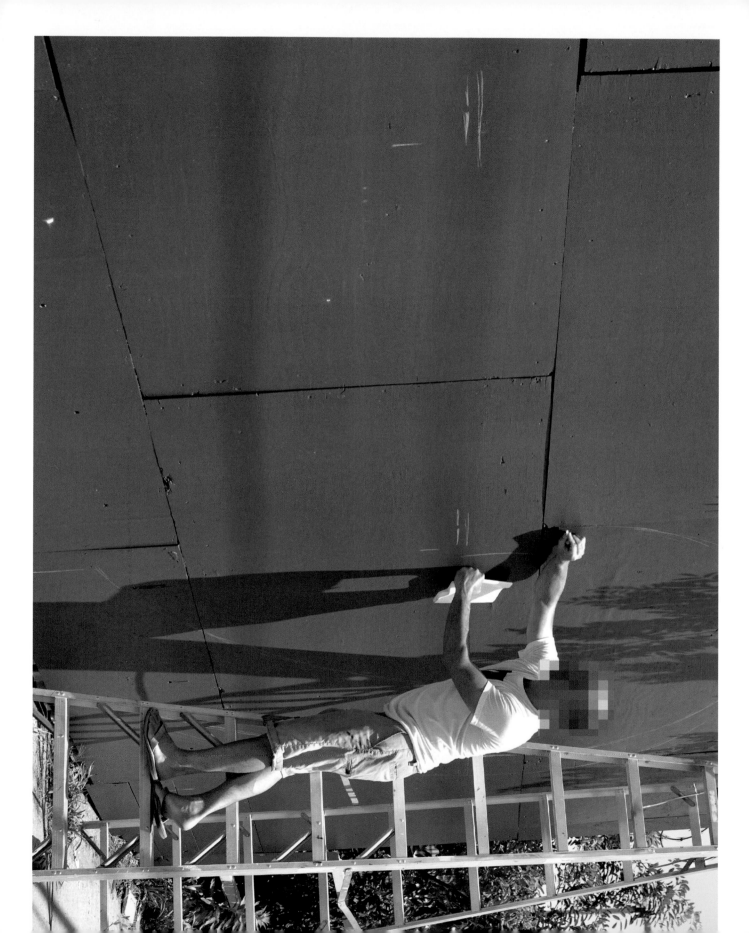

⬡ #02

SQU ARE

"I grew up in a very typical suburban setting where life was neither very exciting nor especially difficult. I knew from a very young age I was an artist, though I was not surrounded by art. Frankly, I never had much desire to be anything other than an artist. Inspiration from other people was minimal; the drive to become an artist came from within. I understood that early on and was okay with it.

"My father was a very talented artist and he gave me my first drawing lessons. It was always more of a hobby for him and he didn't take it seriously. Aside from my dad's initial instruction, I learned drawing at a young age by watching *Commander Mark's Secret City Adventures* and a short time later I learned about paint watching Bob Ross. Once a week I took lessons from a certified Bob Ross instructor taught from the inside of a mobile home. PBS was my Art Students League.

"There was nothing in particular about how or where I grew up that was influential to me as an artist. If anything, I would say it was quite the opposite: my surroundings delayed my artistic development. When I was seventeen, I traveled two thousand miles away to art school and discovered art and its possibilities. It took me a while to develop my skill and love for painting, but it has become an obsession and love affair ever since."

Early Life and Work

DAY 2

bunny M

"It all starts abstract and builds onward from there. Oftentimes I think of my paintings as visitors on earth; they are either first timers here or have come back.

"I begin by imagining some history I have read about, or a vision I had while sitting in a garden. Then I create a representation of a hidden ideal in that event. The actual work can start from a few places. I usually pick up a pencil and begin with my lady's jawline: a line that has always interested me to no end. I enlarge the image by hand from the finished sketch and then paint it. Sometimes I do multiple paintings of the same image to experiment with techniques and color.

"I approach murals much the same way. They can take me a while because I push so many details in them, as many as I can before they become muddled and lost from a distance. I also pick up the vibe of my surroundings and it influences the piece and how it's painted."

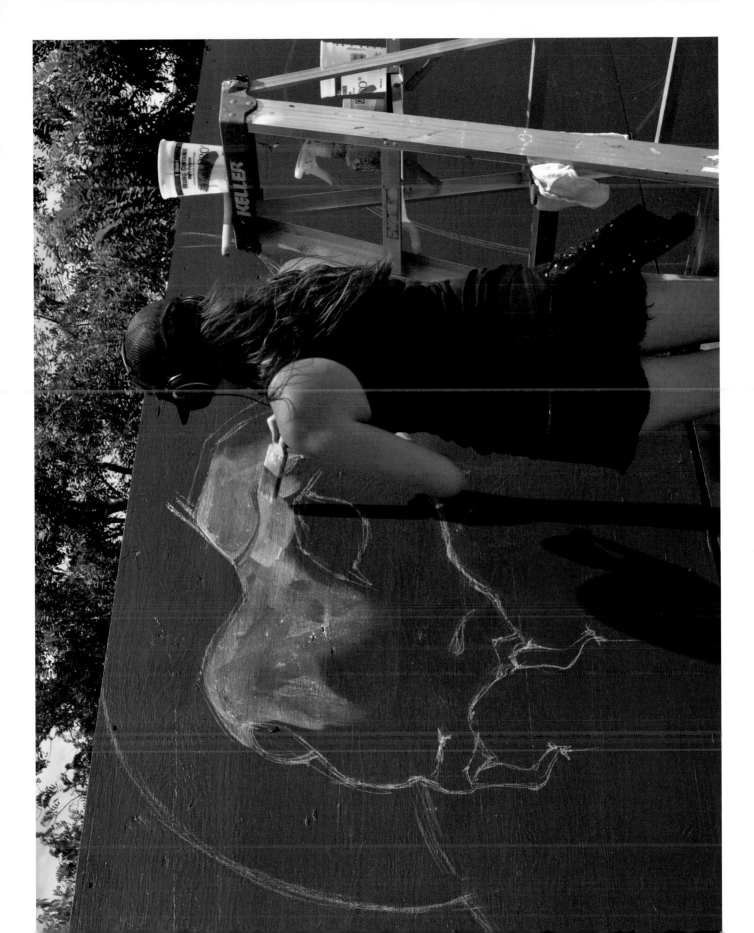

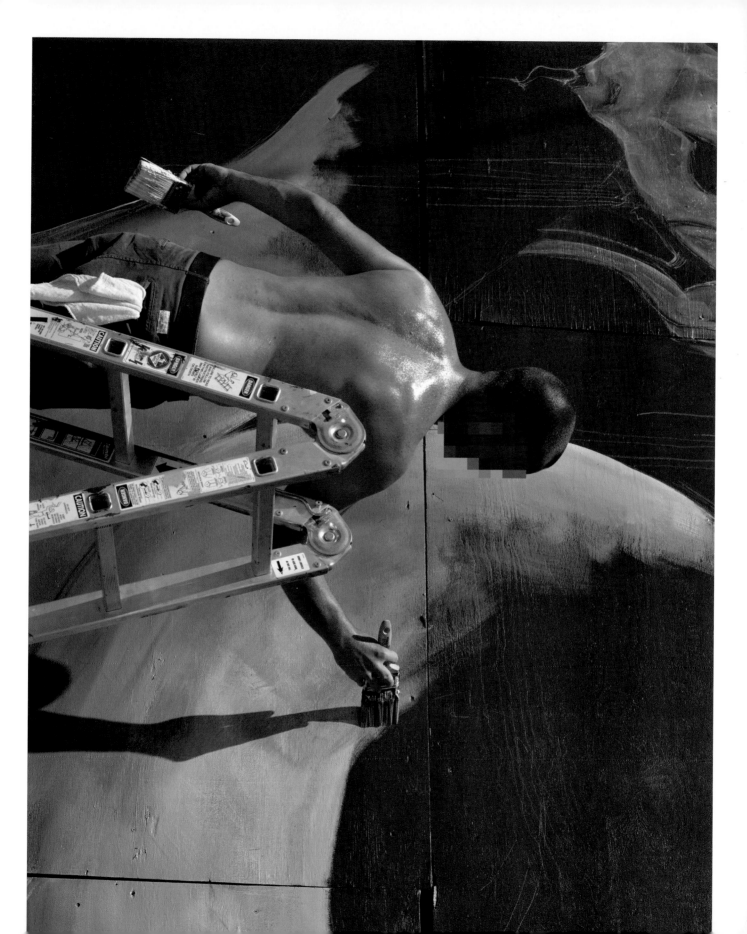

#02

SQU ARE

"My creative process starts with an image of color, light, and shadow, and how they can work together to form a composition. When I walk around and reflect about painting, which I do often, I think about different color combinations and images that would go with the colors I envision.

"The image I choose is important, because I know it will be people's focus, but balancing the image with the background color is just as challenging.

"My passion for painting has always been directly related to color and the paint itself. The physical and chemical nature of paint and the process of applying it fascinate me. The subject matter is important, but it is more a means for me to use paint and color in a way that is not as purely conceptual as abstract art. It is partly because of this love for paint that I use brushes – I often use house paints as well as artist paints, but rarely do I use spray paint. The surfaces I paint on can be canvas, paper, wood, or any type of large wall."

Creative Process

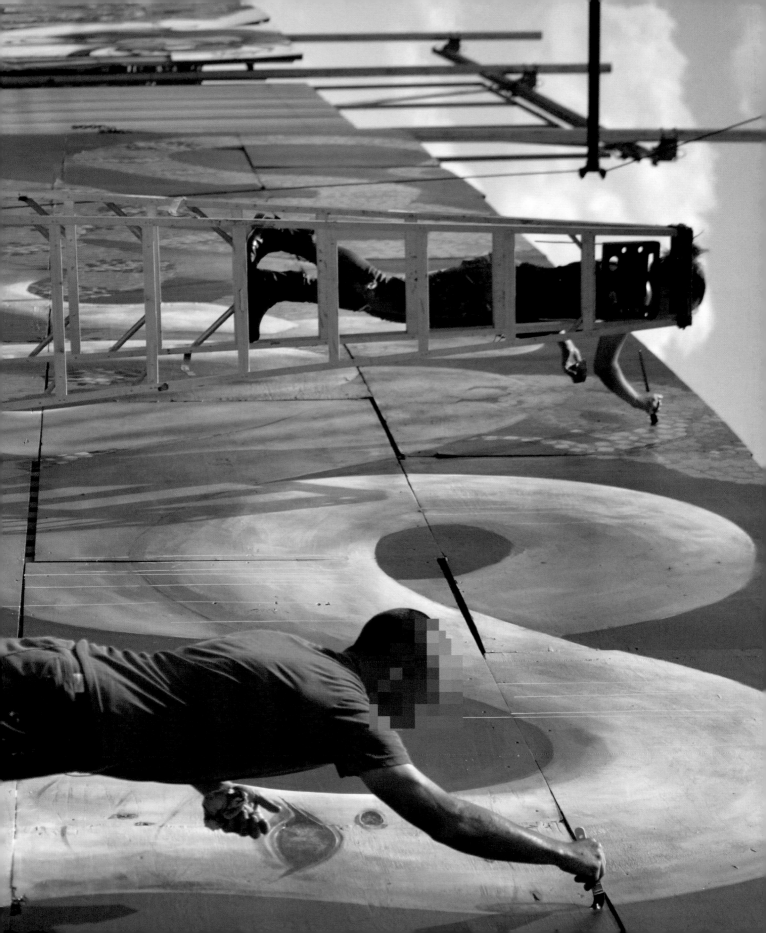

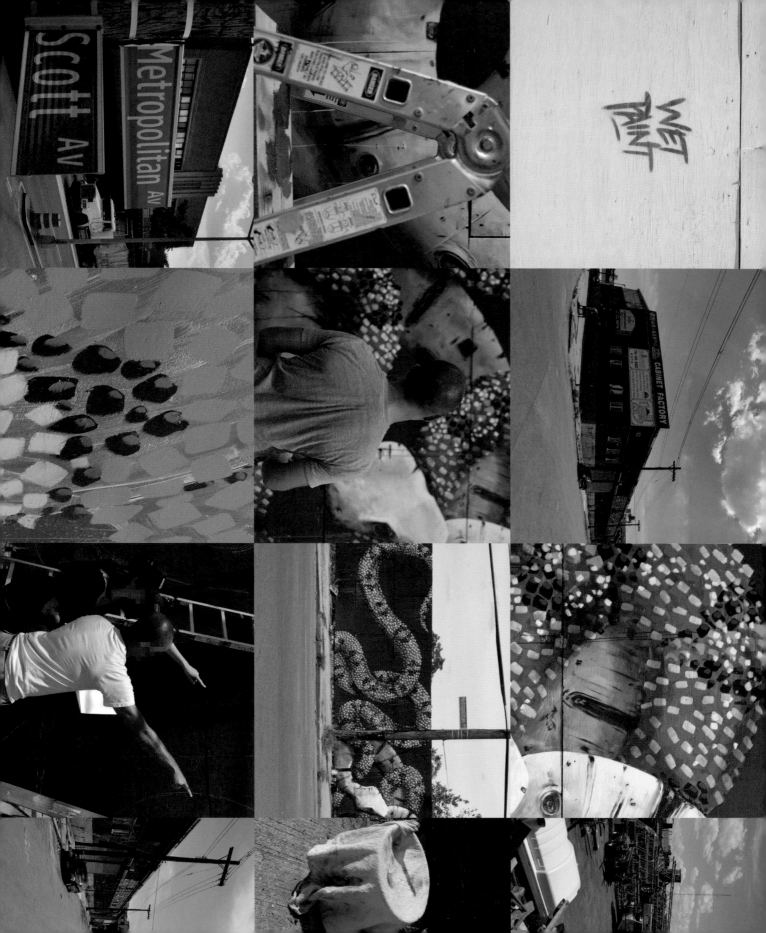

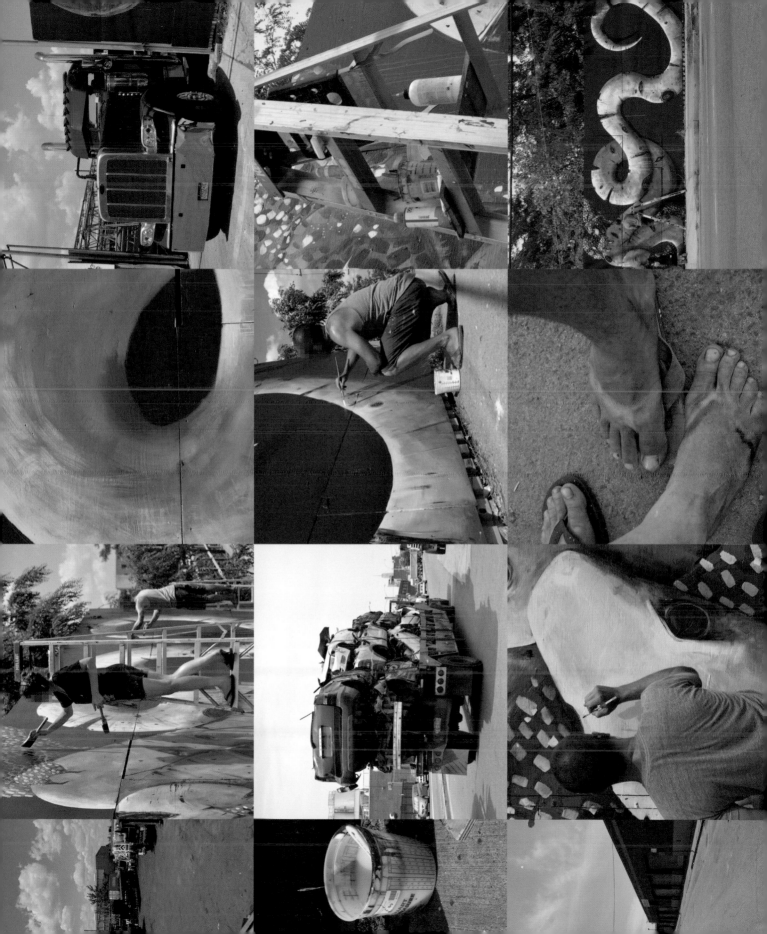

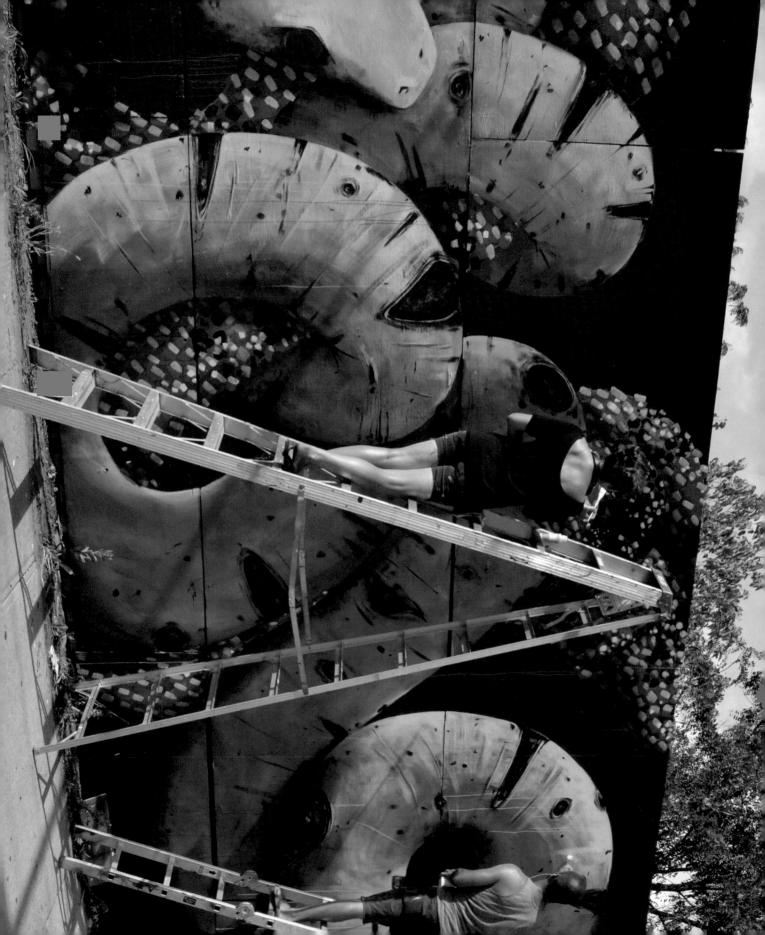

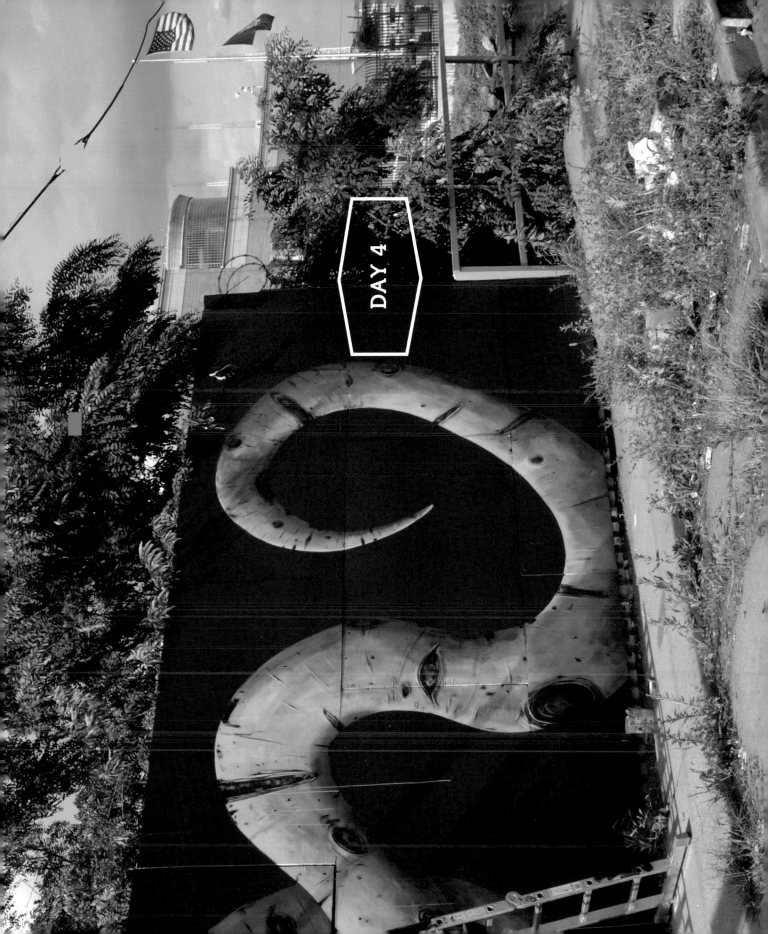

"Since I've developed my particular ways of working, I am used to controlling my vision from start to finish and in private. Square is the only person I've painted with side by side. I have known Square for thirteen years. I met him while carrying my easel into a painting competition in a bar in Denver. We have been collaborating sporadically ever since. I remember my visits to his studio made a strong impression on me. He would usually sit in his armchair, drinking beer in the dark, with the only light in the room illuminating a huge abstract oil painting. He would just sit and observe the piece in that light for hours. Square has a gift for expressing light and shadow in unexpected ways and has the natural freedom and confidence of a true painter. A few times I envisioned drawing my work over the surface of his paintings. I had never meshed my ideas with anyone else's before so I simply went for it and drew on his painting. It led to the most fun night! We discussed art history, our visions of art, the things we are willing to fight for and much more.

"Square and I work differently. We are and always will be very independent painters. Every now and again we decide to collaborate and drive one another a little crazy. I can lose myself while painting, and not always in a good way. I can forget to eat or drink water and won't take a break for hours. I'm averse to too much overlap on my work, I'm stubborn about colors, and I won't compromise on my sketches. These are not good traits for collaborating, but they keep my work honest and complete. I invent my own world and have a relentless drive to improve, both of which come with great energy.

"Square works differently, but is as determined as I am regarding the integrity of his paintings. By now we know each other very well. We are best friends. We are both in love with paint and are obsessed with the relationships and interactions between colors. You can see that in our work together: our styles are distinct without many concessions, but regardless a balance is reached between us. That equilibrium is hard won: we always argue during the process. When we disagree we throw around a few insults, put our headphones on, and keep painting."

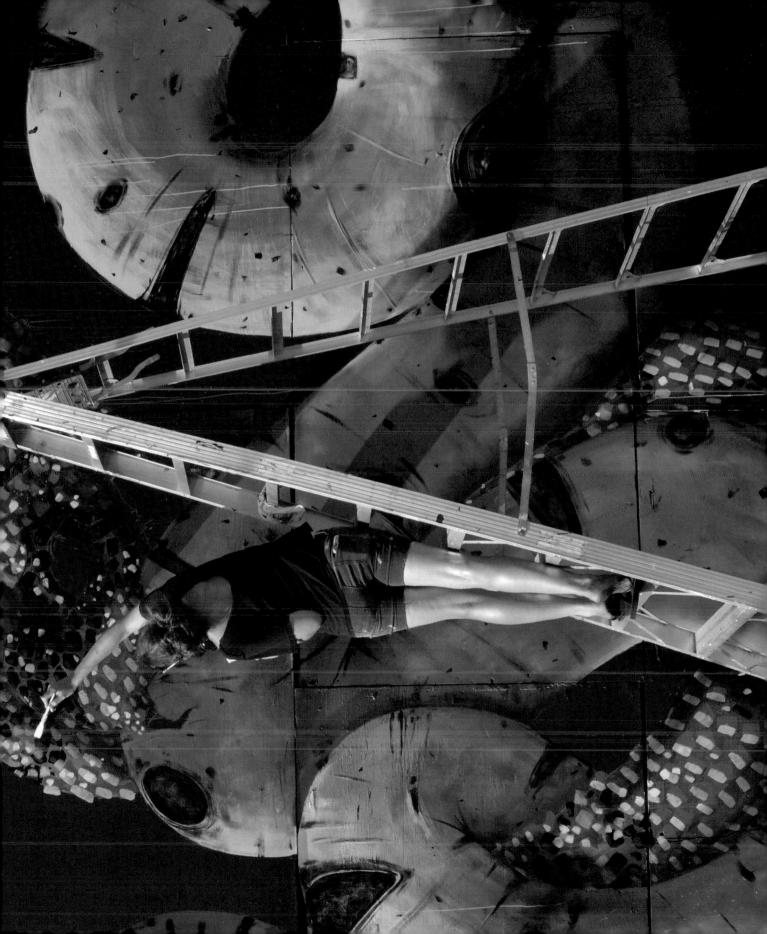

"I don't usually collaborate. On the rare occasion that I have collaborated in the past it was just for fun and I didn't take it too seriously, bunny M is the only artist I've ever collaborated seriously with. I see myself as a solo artist and it's important for me to be perceived as such, so many times it's challenging to work together, even though I fully admire and respect her.

"I met bunny M thirteen years ago when we were both participating in a painting competition. We quickly formed a bond based on mutual respect as artists and people. I had been an artist my entire life, but I never felt close to other artists or formed any kind of meaningful relationships with them. I could see from the first moment I met her that she was a truly unique artist and person. We would collaborate for fun on small paintings in our studios, but our first mural collaboration was about five years ago and we've done a couple large ones since then.

"Collaborating has been a challenge, but the final results have always been worth it. We both see ourselves as independent artists and we

instinctively resist many elements in a painting that are not our own and may misrepresent us. However, the trust and respect we have built for each other dictates the way we work together. We both have very different personalities and very different methods of painting. I paint more loosely and faster than bunny M and she is more detail oriented and meticulous than I am.

"I think when combined properly our styles work very well together. We try to resolve most stylistic and creative differences during the beginning stages of conception because we prefer to figure out potential problems before we start the actual piece. That being said, we have yet to work on a painting together where there wasn't some sort of conflict. Conflict is inevitable. It's not about completely eliminating it, it's about understanding it and not letting it affect the final outcome. I'm pleased we've been able to do that and though it might be difficult at times, there is no artist that I admire more and would rather work with than bunny M."

"BY NOW WE KNOW EACH
OTHER VERY WELL. WE ARE
BEST FRIENDS. WE ARE
IN LOVE WITH PAINT AND ARE
OBSESSED BY THE RELATIONSHIPS
AND INTERACTIONS BETWEEN
COLORS. YOU CAN SEE THAT
IN OUR WORK TOGETHER: OUR
STYLES ARE DISTINCT WITHOUT
MANY CONCESSIONS, BUT
REGARDLESS A BALANCE IS
REACHED BETWEEN US."

bunny M

#BUSHWICKMURAL

"WE BOTH HAVE VERY DIFFERENT PERSONALITIES AND VERY DIFFERENT METHODS OF PAINTING. I PAINT MORE LOOSELY AND FASTER THAN BUNNY M AND SHE IS MORE DETAIL ORIENTED AND METICULOUS THAN I AM. I THINK WHEN COMBINED PROPERLY OUR STYLES WORK VERY WELL TOGETHER."

Square

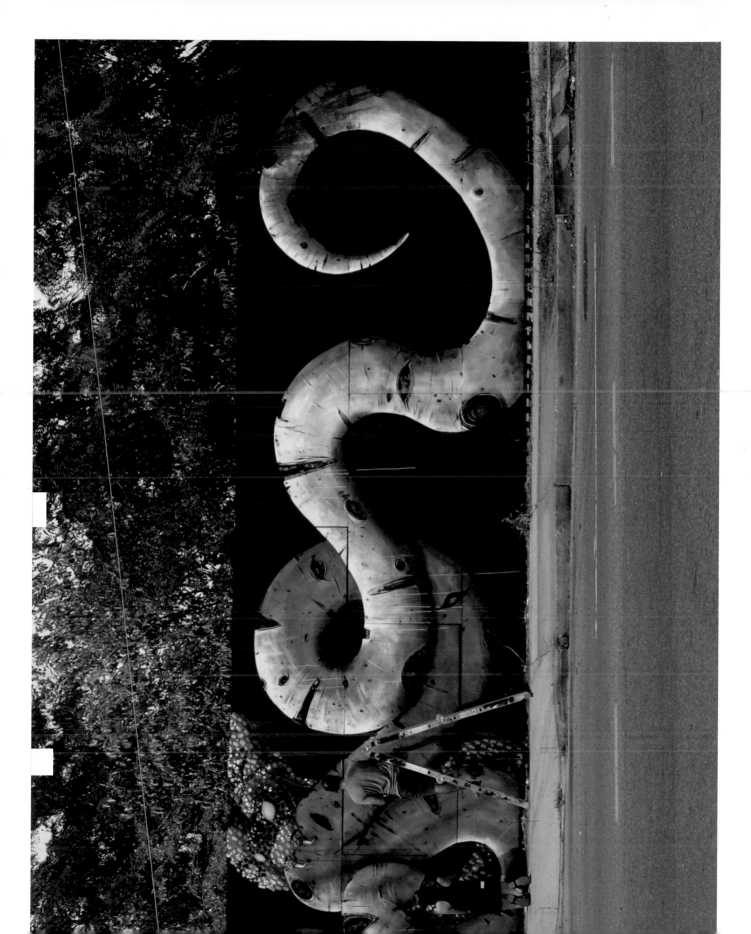

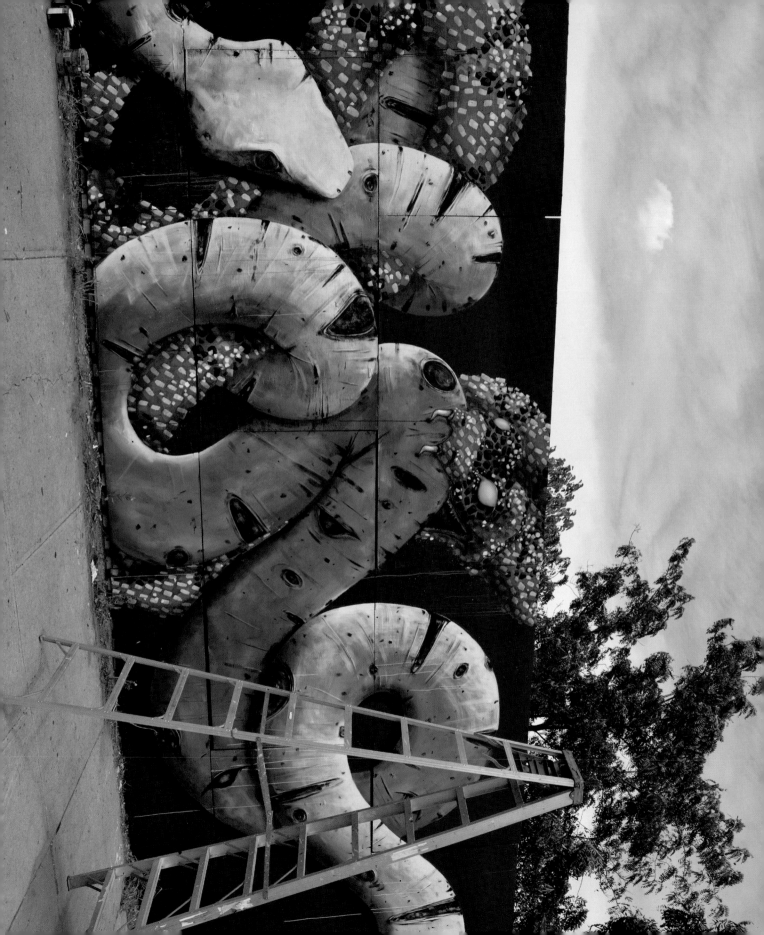

COLLABORATION
#09

#BUSHWICKMURAL

Artists
bunny M
SQUARE

COLLABORATING

EPILOGUE

#creating2create

"DO NOT FEAR MISTAKES—THERE ARE NONE"

- Miles Davis

Author

Yoav Litvin is a New York City–based scientist, photographer, and writer. In his work, he is interested in promoting creative and progressive causes with a focus on documenting urban culture, arts, and peoples. Yoav enjoys the confrontational aesthetic of art displayed on the streets, its humor, and the way it challenges conventions within and outside of the art world. Yoav views his role as a photographer/documenter as an integral component of this transient art form.